ARTIST|ANIMAL

CARY WOLFE, SERIES EDITOR

ARTIST|ANIMAL

Steve Baker

posthumanities 25

UNIVERSITY OF MINNESOTA PRESS

Minneapolis

London

An earlier version of chapter 1 was previously published as "'They're There, and That's How We're Seeing It': Olly and Suzi in the Antarctic," in *Ecosee: Image, Rhetoric, Nature,* ed. S. I. Dobrin and S. Morey (Albany: State University of New York Press, 2009), 153–67. An earlier version of chapter 2 was previously published as "'Tangible and Real and Vivid and Meaningful': Lucy Kimbell's *Not-Knowing* about Rats," in *Animal Encounters,* ed. T. Tyler and M. Rossini (Leiden: Brill, 2009), 197–218. Portions of chapter 6 were previously published as "Contemporary Art and Animal Rights," in *Considering Animals: Contemporary Studies in Human–Animal Relations,* ed. C. Freeman, E. Leane, and Y. Watt (Farnham, Surrey: Ashgate, 2011), 13–28.

Copyright 2013 by the Regents of the University of Minnesota

All rights reserved. No part of this publication may be reproduced, stored in a retrieval system, or transmitted, in any form or by any means, electronic, mechanical, photocopying, recording, or otherwise, without the prior written permission of the publisher.

Published by the University of Minnesota Press
111 Third Avenue South, Suite 290
Minneapolis, MN 55401-2520
http://www.upress.umn.edu

Library of Congress Cataloging-in-Publication Data
Baker, Steve, 1953–
 Artist/Animal / Steve Baker.
 Includes bibliographical references and index.
 ISBN 978-0-8166-8066-5 (hc)—ISBN 978-0-8166-8067-2 (pb)
1. Human–animal relationships in art. 2. Animals—Social aspects.
3. Art–Moral and ethical aspects. I. Title.
N7660.B28 2013
704.9'432—dc23 2012042123

Printed in China on acid-free paper

The University of Minnesota is an equal-opportunity educator and employer.

19 18 17 16 15 14 13 10 9 8 7 6 5 4 3 2 1

To Aly

I trust objects so much. I trust disparate elements going together.

—Jim Dine

... to be good at *not* knowing, as artists!

—Friedrich Nietzsche

Contents

Acknowledgments

Research grants generously awarded by the Arts and Humanities Research Council in the United Kingdom and by the Culture and Animals Foundation in the United States made it possible to bring this project to fruition, as did the support of the University of Central Lancashire.

Most of the discussion of contemporary art in the book draws directly on correspondence and face-to-face interviews with the artists responsible for it, and I am immensely grateful to those artists for their time, their generosity, and in several cases their hospitality. They are Catherine Bell, Mary Britton Clouse, Dave Bullock, Catherine Chalmers, Sue Coe, Robert Filby, Kathy High, Allison Hunter, Elena Italia, Britta Jaschinski, Kim Jones, Eduardo Kac, Sanna Kannisto, Lucy Kimbell, Olly and Suzi, Angela Singer, Snæbjörnsdóttir/Wilson, and David Wood.

Much of the thinking that informs the book has been shaped by the rise and development of the field of animal studies since the 1990s. I have benefited greatly from conversations at innumerable animal-themed conferences and meetings over the past fifteen years, and from the intellectual generosity and critical engagement of the international animal studies community.

More specifically, the friends, artists, and academics whose advice and support have been invaluable at various points in the book's development include Giovanni Aloi, Edwina Ashton, Ron Broglio, Helen Bullard, Jonathan Burt, Bert Clouse, Kate Downhill, Liz Dulany, Martha Fleming, Erica Fudge, Carol Gigliotti, Rosemarie McGoldrick, Susan McHugh, Bob McKay, Garry Marvin, Linden Reilly, Mysoon Rizk, Nigel Rothfels, Julia Schlosser, Stephanie Schwandner-Sievers, Kim Stallwood, Tim Stilwell, Tom Tyler, Jessica Ullrich, Yvette Watt, and Wendy Wheeler. Very much in

my thoughts during the months in which the writing was completed were Bruce Burgess and Jane Graves, two valued friends who died in 2011.

At a crucial stage in the shaping of the complete manuscript, detailed suggestions from David Wood, Cary Wolfe, and my editor, Richard Morrison, helped give the text a significantly sharper focus. Cary and Richard have patiently supported the project for several years, and I cannot speak highly enough of the dedication and enthusiasm of all those at the University of Minnesota Press who contributed to the book's production.

Most of all, and as always, my thanks go to Aly, for everything.

Introduction
The Idiot, the Voyeur, and the Moralist

> The introduction explains things, but clumsily.
> Everything is much quieter and more filled
> with exceptions than how I've presented it.
> —Nicholson Baker, *The Anthologist*

CAN CONTEMPORARY ARTISTS BE TRUSTED with animals, living or dead? Can they be trusted to act responsibly, ethically, when their work engages with questions of animal life? Will they put ethics first, or will they put the interests of their art *before* ethics? Both in and beyond the field of "animal studies" that has burgeoned in the arts, humanities, and social sciences over the past twenty years, these seem widely regarded as pertinent questions. And when they are posed in this form, the answer is frequently *no, artists are not to be trusted*. Here, to begin, are two notably uncompromising expressions of this mistrust and disapproval.

In *Transgressions: The Offences of Art,* a highly original but decidedly idiosyncratic book, Anthony Julius is especially critical of the disturbing hybrid creatures that have become familiar in the "transgressive" art of recent decades. "They are counter-Enlightenment taunts," he writes. "They present the monsters, the taxidermic aberrations, that a humanity unconstrained by moral scruple, basest when least confined, will produce. . . . These man-beasts . . . deny the divinity of the human form that is the premise of Western art." Julius, writing outside the field of animal studies, is almost exclusively concerned with the representation of the human, and he laments the fact that in such artworks "that most fundamental of hierarchies, which places the human above the merely animal, is subverted."[1]

For the animal studies scholar Randy Malamud, it is the harm (whether actual or symbolic) done to animals that is the focus of his concern, in the work of artists ranging from Damien Hirst to Eduardo Kac. "What boundaries or guidelines (if any) are there that mediate what we do with animals? What ethical guidelines? What aesthetic guidelines?" he asks. His answer is that "any extant guidelines are cultural conventions," and the artists of whom he disapproves "show these to be malleable, dispensable in the cause of art." In a familiar rhetorical move, Malamud puts the word *artist* in quotation marks whenever he wants to communicate his disapproval or skepticism, and on occasion he will simply refuse to engage with the work. "One could enter into a long and heated debate" about how Hirst's animal installations "relate to the tradition of art," he acknowledges, before declaring: "But I prefer not to have that discussion, and simply to dismiss him as brutal."[2] Malamud's "interest in prohibitory ethics" has been described as striking "strongly conservative tones,"[3] but while he is more outspoken than many, the mistrust he shares with Julius of artists who seem "unconstrained by moral scruple" finds widespread expression in recent years.

Why should this be the case? There are, of course, influential historical precedents: Iris Murdoch notes that Plato "constantly and emphatically accuses artists of moral weakness or even baseness."[4] Whether that is the basis for contemporary mistrust is debatable. Some of the grander claims made on behalf of contemporary art may understandably be viewed with skepticism, but that's a rather different matter. Carol Gigliotti points in this context to the clichéd assertion "that art is a last bastion for radical thinking," and both she (with an art background) and Lynda Birke (with a science background) have identified what they see as unconvincing uses of that assertion as a rationale to justify art's disregard of animals' interests in its recent engagement with genetic technologies, in particular.[5]

The proposal made in the present book is a different one. It is that art has the potential to offer a distinct way of framing or unframing issues, not an approach that's more radical or open-minded or curious or inventive than the thinking found in other disciplines, but one that simply employs *different* tools for thinking, and one that's sometimes viewed with suspicion because of their unfamiliarity.

So, against the grain of much contemporary commentary, this book presents the case for the importance of trusting artists to operate with integrity in relation to the animals that figure in their work. It argues that in approaching such work, there's much to be gained by setting out with the *expectation* that artists can be trusted to act in this manner. Why does this matter? It matters because the tendency in some quarters to regard artists as opportunistic sensationalists who have no real disciplinary grounding represents a profoundly uncreative aspect of contemporary culture. In *The Whole Creature*, a brilliant study of the wider cultural implications of research on biosemiotics, Wendy Wheeler usefully characterizes creativity as "a state of prepared receptivity"—a phrase equally apt as a definition of trust.[6] And an untrusting, unreceptive creativity seems like a contradiction in terms.

The approach taken here attends closely to how artists work and to what they say about their work. As a character in a Paul Auster novel puts it: "For the moment, our only task is to study the pictures as attentively as we can and refrain from drawing any premature conclusions."[7] The book contends that contemporary art's distinctive contribution to understandings of human–animal relations will be recognized only if artists' practices—flawed and provisional as they may be—are taken seriously. To impose questions of ethics before even attending to the art is, at the very least, to risk failing to take those practices seriously.

The central question to be addressed is simply this: *what happens when artist and animal are brought into juxtaposition in the context of contemporary art?* The title *ARTIST | ANIMAL* deliberately holds those two terms in juxtaposition, without specifying either the characteristics or the consequences of their alignment. Those are what the book explores. Subsequent chapters therefore consider artworks from the first decade of the twenty-first century by a small selection of contemporary artists from America, Europe, and Australasia who engage directly with questions of animal life. These are artists, in other words, whose concern is with the nature and the quality of actual animal life, or with the human experience of actual animal lives. For the most part, at least, their art treats animals as creatures who actively share the more-than-human world with humans, rather than as mere symbols or metaphors for aspects of the so-called

human condition. The spread is nevertheless still fairly wide, running from artists with ecological concerns, to those engaging with the temporary or permanent modification of animal bodies, to those seeking to further the cause of animal rights through their work.

There will be exceptions to this general picture, not least because the symbolic resonance of animals is not always easily separable from their literal presence in the gallery or in art's other spaces.[8] The bulk of this introduction, for example, deals with two troubling gallery-based artworks that undoubtedly paid insufficient attention to the well-being of the animals they used, and where the animals' use was in any case primarily for symbolic purposes. These are hard cases that test to the limit the proposal that artists are to be trusted to operate with integrity in their dealings with animals.

So why is discussion of these two artworks included here? First, to acknowledge the existence of such cases in the canon of recent and contemporary art, and second, to indicate how disconcertingly difficult it is to hold apparently irresponsible artworks at a safe distance from works that deal more explicitly and sympathetically with questions of animal life, of which it may seem easier to approve. The waters are muddied from the start, and arguments for putting the ethics before the art are not going to change that. To express this a little less contentiously, the language of regulatory or proscriptive or "prohibitory" ethics does not look likely to shed much light on these difficult issues, nor to offer much leverage for addressing them and learning from them.

Burning Rats . . .

Consider the case of this old but still-instructive artwork: over thirty-five years ago, on February 17, 1976, the artist Kim Jones presented a performance called *Rat Piece* in the Union Gallery at California State University, Los Angeles. The following pages build up a picture of this complex, controversial piece to point out its historically specific and probably unrepeatable qualities, but also, perhaps more uncomfortably, to point to certain thematic continuities with the concerns of much contemporary animal art. For readers who are unfamiliar with Jones's *Rat Piece*, it involved the burning of living rats: burning them, that is to say, *as a means of making art*.

The initial description of the performance, here, draws both on Martin Harries's useful summary of it in 2007 and on Jones's clarification of specific details in 2011. Harries writes: "Available evidence suggests that *Rat Piece* was a slow, deliberate, even meditative performance. Over about half an hour or so, Jones—lean, muscular, face hidden under a pair of pantyhose—stripped, slathered himself with mud, donned the headpiece and wooden structure of Mudman"—Mudman being the artist's performance identity.[9]

In this guise, walking through the performance space, Jones notes that he "read some statements as to how I feel while doing a performance. There was nervous laughter from the audience." He then removed a white bedsheet covered with numbers that had been concealing a wire-metal hatbox containing three live rats and some paper. He writes: "The performance went from humor to horror when I brought out a small container of Wizard lighter fluid and squirted the rats setting them on fire."[10] Harries comments: "The rats' deaths were gradual: Jones periodically fed the fire with more fluid. The panicked rats scampered up the edges of the cage, ran in circles, and screamed as they neared death. Jones briefly screamed, too."[11]

Jones states that he "poured sand from Venice Beach" over the rats once they were dead. He then covered up the "cage," removed his performance costume, and put his clothes back on over his mud-covered body before leaving the gallery space. He was subsequently convicted of cruelty to animals and penalized with a small fine. Of the conviction, he writes: "They charged me with three counts. One for each rat. A misdemeanor." And of the fine: "My lawyer cost $500. The fine was $190. I was paid $50. The performance was free."[12]

The artist's subsequent reflections on the piece are revealing, if surprising. In a 2005 interview he stated:

> When I did it people went nuts. . . . People still get upset about it. I can understand that because I tortured the animals to death, but it was important for me to have that experience as an art piece . . . to actually have the audience that went to see this experience the smell of death and to actually have control in a certain way. They could have stopped me.[13]

Jones made a similar statement two months after the 1976 performance:

I wanted to see if they would stop me. It would not have stopped the performance it merely would have changed it. . . . I would have struggled physically with them, but not for long, but I would've wanted to [see] it through to that point. . . . They said I was cruel, yet none of them tried to prevent it when they could've.[14]

Jones has related the performance to his experience as a U.S. marine in Vietnam in 1967–68. In an artist statement from 1983 he recalled "our camp covered with rats they crawled over us at night they got in our food we catch them in cages and burn them to death i remember the smell."[15]

Harries states that Jones performed *Rat Piece* only once, but in a 2006 interview the artist himself noted that it "got started as a design project in 1972 when I was at Otis. That was when the whole faculty got very upset with me and they wanted to kick me out. . . . Basically what I did was I burned some rats to death in the sculpture garden and filmed it with a little Super 8 camera." Only later did he get an offer to do such work at Cal State, and as he says, "That's when I did the more-or-less official rat piece. I went out and I bought three male rats and as part of the performance I burned them to death. . . . Half the audience left, half stayed. . . . one woman ran out screaming 'you're sick, you're sick.' I'd have done it even if one or two people were in the audience."[16]

War themes crop up frequently in Jones's work, as does rat imagery in certain other pieces, but this performance is said by the artist to be one of the very few works to refer to his experience in Vietnam. In the 2006 interview he clarified that he had no intention of his work "being a kind of therapy for me or anyone else." However, in response to the interviewer's question about "a strong autobiographical narration" in his work, Jones said: "Oh yeah. It's all about what happened and is still going on in my life."[17] Elsewhere he has said of his work: "I have my individual experiences. They seep out of my art," and he has characterized that art as a reaching for the most "potent images" in his life.[18]

There is, to say the least, a certain tension between Jones's comments about the audience and its failure to intervene on behalf of the burning rats, and his acknowledgment of his own autobiographical motivations. In one sense, Mudman's role in the *Rat Piece* performance is something like a force of nature: the audience, he suggests, could have tried to minimize

the harm caused by this unstoppable force of nature, but the artist himself could not or would not. Their intervention "would not have stopped the performance it merely would have changed it," as he puts it. Looking back, in 1998, on his experience of the rats in Vietnam, and on the relation of that experience to *Rat Piece*, he said to the art writer Linda Weintraub: "I wanted to bring this home, to show it with its smell, screams, and the responsibility for stopping it—not just tell about it. You can't really write about a burning. It does not have the impact of actually seeing something die. It is horrible, to have control over it." He controlled the making of the piece, this seems to imply, but could not himself extend this control to what he calls "the responsibility for stopping it."[19]

It would be very easy to read this as a simple abnegation of responsibility on the part of the artist. But, despite its being irreconcilable with the strong autobiographical references in this performance, Jones seems to have been trying to fashion a role for the artist not as one who judges or moralizes but as one who presents an unadorned reality, of which others can make what they wish. This comes across most clearly in his comment in 1998: "Mudman doesn't have a personality or a mission. I think the audience has a personality. The audience may have a mission."[20]

Harries argues that one distinctive effect of *Rat Piece* in 1976 was that it "made the pain of rats—usually killed out of sight—visible, even shareable, in a rare way."[21] He suggests that the piece has a "doubled force" because "it simultaneously insists on the suffering of these three, particular male rats and suggests a set of powerful and perhaps incompatible allegories—rats as U.S. soldiers, as Vietnamese civilians, as signifiers of a world of mediated suffering to which the witness does not know how to respond." In his view it gains this doubled force by moving between "assigning a human meaning to the suffering of rats and insisting on the suffering of rats as the suffering of rats."[22] He rightly points to just how unusual this was at the time. The philosopher Peter Singer's book *Animal Liberation*, he notes, which played a vital part in the growth of the animal rights movement in the final quarter of the twentieth century, had been published only one year earlier, and Harries suggests that even for Singer the rat was "the limit case," the animal least likely to attract human sympathy.[23]

The purpose of this brief account of this undoubtedly controversial artwork is not to propose a straightforward ethical condemnation of the

artist—"this courteous, reserved man," as Weintraub calls him—or even to condemn the work itself, tempting though that, at least, may be.[24] The fact that the performance happened over thirty-five years ago certainly makes a difference. Like Joseph Beuys's better-known gallery performance with a living coyote in 1974, the juxtaposition of living animals and a rather clumsy human symbolism now seems very much of its time, though Harries is absolutely right to see the gradual emergence of the living animal's role *as itself*—instead of, or at least in addition to animal imagery's more traditional symbolic role—as something of an innovation in the art of the 1970s. As I have argued elsewhere, notwithstanding the British artist Damien Hirst's continuing use of dead animal bodies to address questions of *human* mortality in a striking manner, one characteristic of much post-modern animal art is its refusal of symbolism, its insistence on carving out a space in which the physical body of the animal—living or dead—can be present as itself.[25]

It is not really possible to say that a work such as *Rat Piece* could not or would not be made in the second decade of the twenty-first century, by Jones or anyone else. It's certainly the case that very little contemporary art involves the torturing of living animals—though an alarming amount of that art may still involve animals' deaths, as is acknowledged in the case of three of the artists interviewed for this book, whose work is discussed in subsequent chapters.[26] None of the artworks discussed in those chapters may seem quite as disturbing or contentious as *Rat Piece*, but Jones's 1976 performance nevertheless haunts the book as a warning against complacency and moral self-satisfaction, because in several significant ways it remains highly contemporary in its outlook.

What are these "contemporary" features of the piece? There are four that come immediately to mind. First, there is Jones's concern with *materiality*: the material presence of living bodies, human and animal, awareness of their surfaces heightened by distortion—mud on the artist's body, flames on the rats' bodies. Second, there is the concern with *immediate and direct experience*: actual death, rather than its mere description or representation. Third, there is the artist's *attentiveness to form*: in this case the gruesome detail of feeding the fire with more lighter fluid whenever the flames started to die down. And lastly, there is the question of *not judging*: trying—no matter how unsuccessfully—to shape a form of art practice

that's not about telling people what to think. Those four concerns—materiality, immediate and direct experience, attentiveness to form, and not judging—find more benign expression in the work of most of the contemporary artists discussed in subsequent chapters, but their importance was already evident in *Rat Piece*.

A further point needs to be made about the performance. In 2007, in connection with a major retrospective exhibition of Jones's work that toured university galleries in Buffalo, Los Angeles, and Washington, the volume *Mudman: The Odyssey of Kim Jones* was published. It included four essays on his work by curators and academics, and offered the opportunity to reconsider *Rat Piece* thirty-one years after its only performance. All four essays discuss the piece at some length. However, unlike Harries's short article in *TDR* the same year (presumably prompted by the first showing of the exhibition, in Buffalo), which tentatively places the performance in the complex dynamic of the aftermath of Vietnam, the developing history of performance art and an emerging animal rights sensibility in the wake of Singer's *Animal Liberation,* these essays seem principally concerned to situate (and to justify) the piece only in relation to Jones's experience as a Vietnam veteran.

Two of the essays are particularly forthright in the manner in which they defend the work. Robert Storr, apparently baffled that it could ever have been open to misunderstanding, notes that it "brought down the wrath of people who judged it a gratuitous act of cruelty towards animals when in fact it was a ritual demonstration of the dehumanization of war."[27] In a similar tone, Kristine Stiles, criticizing the art critic Max Kozloff (who in 1976 was also executive editor of *Artforum*), writes: "Lacking insight into a quintessential representation of the Vietnam War by one of its veterans, Kozloff refused to publish images of *Rat Piece,* which he deemed 'cruel theatricalism.'"[28] In this respect Storr's and Stiles's standpoints differ markedly from that (or those) of Jones himself. In the years since the performance Jones has—as already indicated—consistently held a set of inconsistent and contradictory perspectives on the piece, its motivations, and its reception. There is nothing particularly wrong with that (and in a later chapter I argue that to expect consistency from artists is one way to miss the character and the strength of how some of them deal with questions of animal life). But Storr and Stiles seem to suggest that there's a single correct

understanding of this performance and that they have it. Neither seems to think that such certainty might actually diminish a work that they both evidently admire.

More intriguingly, Stiles also records Kozloff's view that *Rat Piece* was "'sensation-seeking rather than art.'"[29] This is a rather unusual instance of a prominent art critic calling into question the art status of a contemporary artist's work. Conceived and performed in the decade after Don Judd's highly influential statement that "if someone says his work is art, it's art"—which remains just about the only workable "definition" of contemporary art—*Rat Piece* may be judged by many (both then and now) a cruel or contemptible work, but it's unclear what is to be gained by challenging its status as an artwork.[30] When Harries writes, "What it means to bound *Rat Piece* as an aesthetic object needs further thought,"[31] he's not expressing skepticism about the art status of the work but curiosity about Jones's determination that he himself should be able to experience and to think about the killing as an art piece.

In this regard, Harries's attentiveness to the specificity of this artwork stands in marked contrast to more abstract discussions of the "ethics" of art. The philosopher Karen Hanson's exploration of the potential "immorality of art," for example, acknowledges that in some instances there may be "ethical perils on all sides":

> The art itself may be immoral, because it puts the audience at a distance; the artist may be judged morally wrong, for producing an object that has this effect; the audience may be judged wrong or inhuman, for taking an aesthetic attitude or remaining still, at a distance, when there is an obligation to intervene.[32]

There is nothing to suggest that Hanson was aware of the work, but each of her objections could of course be raised about *Rat Piece*. Jones's own book documenting the performance and its aftermath includes one audience member's reflections on the performance, published two days later in the university newspaper. It begins, "I am ashamed. I witnessed a hideous murder and did nothing to stop it," and goes on to characterize the audience of which he was part in these terms: "We were Romans cheering on

the lions. We were Christians torching a Salem witch. We were a southern mob lynching a black man. We were the Gestapo gassing Jews."[33]

Does this lend weight to Hanson's dismissal of the idea "that art is somehow beyond the reach of moral criticism"? Not really, because her argument is specifically framed in terms of the question "How bad can good art be?"[34] And that sort of question, binding together aesthetic and ethical value judgments, is one that the artists of Jones's generation had already moved beyond. Speaking in 1968, John Cage encapsulated a more contemporary perspective as follows: "Why do you waste your time and mine trying to get value judgements? . . . Value judgements are destructive to our proper business, which is curiosity and awareness."[35] And as Donna Haraway has noted more recently: "Curiosity is not a nice virtue, but it does have the power to defeat one's favorite self-certainties."[36]

Harries articulates what he regards as the achievement of Jones's work in a manner that goes beyond the terms of Hanson's argument, arguing that "it is only as art, only as a performance for an audience that does not intervene, that *Rat Piece* succeeds. . . . The success of the performance relies on the failure of the audience, its failure to intervene."[37] How does this failure define the work's "success"? Harries writes: "This unhumanitarian nonintervention is crucial to understanding *Rat Piece*. Not to intervene is what it is to be an audience. Audiences do not intervene, or when they do intervene the members of this group become something other than an audience." Had they intervened, the audience would also have been "asserting a morality putatively superior to that of the artist who killed the three rats."[38] Harries himself doesn't make the point explicit, but the logic of his argument seems to suggest that the artist, by finely judging the aesthetic provocation of the piece, has enabled his audience to resist the closure of an ethical judgment of the piece. The audience is in that sense *with* the artist, who insisted to Weintraub that he is "not moralistic."[39]

From the perspective of animal advocacy, that kind of convoluted argumentation may look self-serving and unconvincing. The first time I spoke about Jones's performance in a conference keynote, one internationally prominent scientist and animal advocate in the audience had no hesitation in branding the artist a "pervert." When animals come into the picture, artists, curators, and advocates all too often find themselves talking

past each other, with little understanding of each others' expectations, priorities, and terminologies—a pressing issue that I address more fully in chapter 4.

What is Jones's own current view of *Rat Piece*? On reflection, the question seems unproductive. The philosopher of science Isabelle Stengers states bluntly that "there are no good answers if the question is not the relevant one."[40] Addressed to Jones, "What do you think of *Rat Piece* now?" could only really be taken as a clumsy invitation to him either to mount a repeated defense or explanation of the performance, or else to distance himself from the piece, to apologize for it—to put ethics before art, in other words.[41] A more challenging question for the work's contemporary audience might be to ask what would follow from a conscious decision, over thirty-five years later, to *attend* to the work but neither to condone nor to condemn it.

. . . and Blending Goldfish

The use of the living animal in art is perhaps at its most *arresting* when that animal is caught somewhere between life and death, between reality and representation. Whether or not viewers regard artists' use of living animals as in any way justifiable, the resulting work is almost always difficult and uncomfortable, and can prompt complex ironies and unlikely alliances when art and animal advocacy come face-to-face.

Mark Dion, whose own art installations have included living animals (ranging from African finches to piranhas) on a number of occasions, contributed "Some Notes towards a Manifesto for Artists Working with or about the Living World" to the catalog of the Serpentine Gallery's exhibition *The Greenhouse Effect* in 2000. It is an earnest set of handwritten notes that eschews the irony found in much of Dion's work, and it includes this uncompromising declaration: "Artists working with living organisms must know what they are doing. They must take responsibility for the plants' or animals' welfare. If an organism dies during an exhibition, the viewer should assume the death to be the intention of the artist."[42]

The statement could certainly be applied to Marco Evaristti's now notorious installation, *Helena*, first exhibited in the Trapholt Art Museum in Kolding, Denmark, in February 2000. Ten kitchen blenders—Moulinex

Optiblend 2000 Liquidisers, to be precise—were placed on a single table in the gallery space and were visibly connected to the mains. Each blender was filled with water, in which a single living goldfish was swimming. Visitors to the exhibition were free to switch on any blender, "transforming the content to fish soup" as one report flippantly put it. At least one visitor chose to do so, killing two goldfish. After complaints from Friends of Animals, the blenders were unplugged, but the installation (and the goldfish) remained on display. The piece has come to be seen by some as exemplifying art's cynical manipulation of animals, but it has also been the subject of other more generous readings. Pressed for a comment by a writer in the *New York Times* in 2000, Peter Singer responded in apparent defense of the work, stating that "when you give people the option of turning the blender on, you raise the question of the power we do have over animals."[43]

Singer, questioned in 2001 as to the accuracy and context of this remark, which seems to put an admirable trust in the artist's integrity, replied as follows: "The quote is accurate as far as it goes, but if I recall correctly I also said negative things about the idea." Summarizing from memory, he suggested that the remark was preceded by "something like: 'It's obviously cruel to keep goldfish in a small sterile container like a blender, and it's horrific to think that people might choose to grind them up on a whim. Nevertheless, I can see that the artist could be making a point about our relations with animals.'"[44]

In much the same way that the critical stances taken in 2007 on Jones's 1976 performance were particularly revealing, Evaristti's installation from 2000 came under intense renewed scrutiny in 2008, and the nature of the positions adopted (many of which were less trusting than Singer's) provides valuable insights into the ways in which art and ethics are currently understood in relation to each other—especially in animal studies. In January 2008 Giovanni Aloi, editor of the online journal *Antennae*, posted an announcement on the H-Animal online discussion network. He had secured an interview with Evaristti for *Antennae*, and he invited H-Animal subscribers to pose questions for inclusion in the interview.[45]

The discussion thread that this prompted had a lively first few weeks, and the first two posts set the tone of what was to follow. One posed the question "Is it ethical to use animals in art?" and the other asked, "When do you consider a piece of artwork . . . that involves the unnecessary death

or cruelty to animals, not art?"[46] The first direct response to the "Is it ethical?" question came from the artist Bryndís Snæbjörnsdóttir (who works collaboratively with Mark Wilson as Snæbjörnsdóttir/Wilson). She wrote:

> For me and many other artists that engage in socially engaged art, art is a serious tool of investigation and a powerful lever to instigate social change. It is therefore impossible to read the question "Is it ethical to use animals in art?" without thinking "Is it ethical to use animals in science," "Is it ethical to use animals in cooking?"[47]

Carol Gigliotti wrote in reply: "The connection between the uses of animals in art, science and cooking is not a trivial one. It links three of the most prevalent uses of animals: use as food, use as tools and use as metaphor or cultural mirror." It was the common theme of "use," in her view, which prompted "the need for the question of ethics."[48]

Much art has indeed used (and continues to use) animals and animal imagery "as metaphor or cultural mirror" for humans, and this is an entirely reasonable characterization of what Evaristti's installation was doing. But this is a very different (and far weaker) account of what art is and does than Snæbjörnsdóttir's conviction that "art is a serious tool of investigation and a powerful lever to instigate social change." It is a point that calls for further discussion in later chapters, because a key argument of this book is that contemporary animal art can be more, *and other*, than metaphor and cultural mirror.

Back in the discussion thread, in response to one speculative attempt to distinguish between a work of art that invites people to think about the implications of pushing the button on the blender and a work that allows them to push that button, the philosopher Ralph Acampora wrote: "A moral agent is responsible not only for her own actions, but also (albeit to a lesser degree) for creating conditions that can foreseeably result in adverse consequences." Another respondent similarly insisted that "ethics is indispensable to art" and that "art is produced with morally relevant presuppositions and intentions."[49] The contemporary artist, from this particular perspective, is first and foremost "a moral agent." Exceptions or alternatives do not seem to be countenanced.

Few posts directly challenged the art status of Evaristti's installation, but there was considerable discussion of what kind of art it could be said to be, and some of that discussion again betrayed a mistrust of artists and a misunderstanding of their practices and motives. Marion Copeland observed, "I prefer art for animals' sakes rather than for art's sake."[50] Nigel Rothfels's response to this (echoing Singer's remarks in 2000) veered not toward mistrust but toward a rather generous assessment of the artwork and its impact:

> the artist . . . clearly posed an important and provocative series of questions to his audience. . . . Doesn't the very starkness (or brutality) of this exhibit ask people to examine all the ways they have trivialized the lives of animals? Can't this work also be conceptualized as "art for animals' sakes"?[51]

Boria Sax's skepticism was altogether more typical of other responses: "Artists today may rationalize their work with claims to inspire social change, but we pretty well have to take these on faith."[52]

In terms of the relevance of this whole discussion thread to the present book, however, it was one of Acampora's interventions that exemplifies the kinds of perceptions and preconceptions that hinder recognition of contemporary art's contribution to ways of thinking about animal life, and hinder that contribution being taken seriously. Thinking, perhaps, of a 2003 news report that quoted the Trapholt Art Museum's director defending Evaristti by saying, "An artist has a right to create works which defy our concept of what is right and what is wrong,"[53] Acampora wrote: "The issue was mentioned whether, in effect, morality is binding on art(ists). I don't see how it can't be. . . . Practically (and indeed conceptually) morality is an all-or-none proposition. If anybody is outside its purview, then everybody has to be—otherwise nobody would rationally submit to its norms." Morality is based on "norms"—norms to which everyone is required to "submit." The language, at least, seems to evoke a system based on fear, and one that cannot envisage a creative input into ethical thought and action. This impression is reinforced by the extraordinary sentence that Acampora placed between those quoted above, which read: "If artists are allowed to suspend ethics for the sake of aesthetics, then in short order we should not

be surprised to find many/most transgressors excusing their misdeeds as instances of performance art."[54]

Given the general drift of many of these comments about art, it's little wonder that no one chose to respond directly to the lone voice of Kari Weil, who observed: "Of course all this begs the question as to whether art, or the artist, needs or even should be ethical. But that is a different question."[55] Different it may be, but it is also an entirely relevant question.

The Limits of Trust?

When the *Antennae* interview with Evaristti was published a month or so after the H-Animal exchanges, it drew from the artist his least ambiguous statement about the role of the goldfish in the *Helena* installation. Commenting on the adverse reactions to the deaths for which he had set the stage, he observed:

> To be honest people's harsh reactions surprised me as we, in my opinion, are surrounded by problems that are so much more serious that we encounter every evening watching the news. It worries me that we are passive in front of these news [*sic*] and that my art piece created such a stir instead. If people find that my use of live goldfish in my art piece is unethical, I would invite them to have a closer look at themselves and the world we live in.[56]

The goldfish-in-blenders scenario enabled the artist to "place people before a dilemma: to choose between life and death," as he had previously put it,[57] but the fish themselves were evidently of little account in comparison to "problems that are so much more serious."

Before the cases of Evaristti and Jones are set to one side, it's worth remarking briefly on their similarities and their differences. It is clear from their own comments that neither artist was motivated primarily by a concern to alleviate the condition of rats and goldfish. Both seem concerned to face their audiences with the reality of witnessing death, but the deaths that seem to concern them (though neither artist states this explicitly) are those of humans. Jones's piece took a small detail of his own Vietnam experience—"we set rats on fire . . . it was something we did when we were

bored"—and spun from it a performance that was presented only once to an audience.[58] In contrast, the specifics of Evaristti's installation have no evident personal resonances for the artist, and the installation was restaged on several occasions in different art institutions.[59] For both artists—though not necessarily for their audiences—the animals in these works are symbolic (serving as something like Gigliotti's notion of a "cultural mirror") *and* real. However, for both artists it could probably also be said that the animals' reality matters only in the sense that it lends an *edge*, a certain grittiness, to the creatures' symbolic function in these two works. This, crucially, is where both works differ from most of those discussed in the present book. With few exceptions, the works central to the chapters that follow have been made by artists with a conscious and immediate concern for questions of nonhuman animal life—even when, on occasion, they seem drenched in messy compromises.

One thing that continues to be of particular interest about *Helena* is Evaristti's tripartite categorization of the viewers of this installation: in his words, "The idiot, who pushed the button, the voyeur, who loves to watch, and the moralist."[60] His point seems to be that as ways of looking at animals in contemporary art, *none of these perspectives will do*.

There is a wonderful remark that the artist Jim Dine made in the 1960s about the centrality of trust to his own working method. He said: "I trust objects so much. I trust disparate elements going together."[61] The working methods of Jones and Evaristti certainly seem to do something rather different, bringing together disparate elements that don't, and that *shouldn't*, go together: rats and fire; goldfish and kitchen blenders; the idiot, the voyeur, and the moralist. Yet Jones's insistence that he is not a moralist, and Evaristti's cool mockery of the idea of the moralist,[62] allow them to hold open (or at the very least to attempt to hold open) aspects of their work in a manner that does, in a sense, seem *trusting*. This is not intended as a defense of either *Rat Piece* or *Helena*. But simply to condemn such works is to learn nothing from them. It is to undermine the very notion of art, to prefer compliance to creativity, for fear that animal abusers might get away with mischievously "excusing their misdeeds as instances of performance art."

It is hard to see how limits can effectively be put on trust. And there are certainly no points at which it's in any way useful to declare harmful or

cynical work *not* to be art. Why not? Because Snæbjörnsdóttir's conviction that "art is a serious tool of investigation and a powerful lever to instigate social change"—a conviction shared by most of the artists discussed in this book—emerges from broadly the same set of tacit approaches to working with materials and ideas (and the materialization of ideas) that enabled Jones's and Evaristti's works to take the form that they did. Art is what artists make. And as the painter Stephen Farthing has rightly observed: "The question of what is, or is not, art is seldom raised among artists."[63]

On the other hand, the manner in which that art is characterized does matter. Is it important to know that Jones used Wizard lighter fluid and that Evaristti employed a particular model of Moulinex blender? What does that have to do with the animals whose deaths they brought about? Nothing, perhaps, at the level of ideas, but the very mundanity of the branded object lends singular weight to the rooted-in-unglamorous-materiality of these works. It is this that establishes their continuity with the currency of contemporary art (and older art too): an art grounded in objecthood, objects, things, stuff—the tangible, embodied stuff of the world. It is this sense of the vivid and the tangible that Iain McGilchrist particularly values when he quotes these words from Viktor Shklovsky's essay "Art as Technique": "'Art exists that one may recover the sensations of life; it exists to make one feel things, to make the stone *stony*.'"[64] This is the work undertaken by writing, as well as the work undertaken by art.

The aim here, therefore, is to articulate what might loosely be called the "voice" of some contemporary artists whose work engages seriously with questions of animal life. It's that voice, that distinctiveness from the work of other disciplines, that the H-Animal thread on "Is it ethical to use animals in art?" showed to be insufficiently recognized. The book's contention—which it may or may not be able persuasively to demonstrate—is that artists working in this field are well placed to devise forms of responsible practice: critical and improvisatory and material forms that sidestep a rule-bound or unduly judgmental notion of ethics.

Most of the chapters that follow draw on interviews with artists that were undertaken specifically for this book. Rather than try to "theorize" these artists' work in a rather abstract manner that can too easily prompt unproductive lines of inquiry, the complex interplay of their work and their words is used as a tool that's always already to hand for exploring

their practice. This approach might be thought of as deconstruction undertaken with a relatively light touch: the artists' words working on, working against, working away at their work; and the work working on, against and away at the words—another case, it might be said, of trusting "disparate elements going together."

The last of the seven main chapters puts forward three distinct exploratory perspectives on the manner in which animals figure in the works discussed in the preceding chapters, and in a number of newly introduced examples. The first of these perspectives concerns *place*: more specifically, animals' location and dislocation in works of contemporary art. The second investigates the distinctive *form* of the "animal-object-in-art." And the third considers whether the animal itself could be said to be the *medium* in which these artists are working.

Scattered between the book's seven chapters are half a dozen short critical reflections, touching on topics such as intention, attention, and the tensions between creative practice and certain kinds of ethical demands or expectations. The more substantial afterword then offers some remarks on how the recognition of contemporary artists' contribution to the wider project of the posthumanities might challenge the view held in some quarters that it is primarily the field of philosophy that "is able to hold open the possibility that thought might proceed otherwise in regard to animals."[65]

1

An Openness to Life
Olly and Suzi in the Antarctic

> Art happens at this point of contact.
> —David Wood, "Mirror Infractions in the Yucatan"

AT FIRST GLANCE there is little more than a scribble, a diagonal of scratchy pen and pencil marks across the small sketchbook page. The marks are the beginnings of a response to the grayscale image on a computer screen showing the interior of an asp's jawbone, magnified around five hundred times by an electron microscope. In the basement of London's Natural History Museum, working with Alex Ball, the museum's electron microscopist, the British artists Olly and Suzi take a break from "navigating the machine"—having found an image that intrigues them—and start to draw.

Given the remote locations in which most of their work has been made since the early 1990s, this is a rare opportunity to see the artists at work: to see how the drawing happens, how the marks get made. They sit a long way back from the screen, Suzi with a pencil and Olly with a ballpoint pen, drawing in a manner that seems indifferent to the extraordinary abilities of the sophisticated equipment surrounding them. It's about observation, not technology, and the object of their attention could as easily be a living animal in the wild as a magnified fragment of bone on a computer screen. They do indeed draw "hand over hand," as they have always said, but the procedure is more complex than that simple phrase suggests. The drawing has to find its own pace. Sometimes two hands make the marks, sometimes one. At times one of them will draw continuously for a while,

the other contributing only an occasional line. It is, quite apart from anything else, an exercise in trust.

And in this slow, thinking, unpredictable process, what is witnessed is an active figuring out of *what it is to draw*. The match between the image on the screen and that on the page may be hard to discern, but photographic verisimilitude was never Olly and Suzi's intention. This is something closer to drawing at its least self-conscious, but at its most revealing and direct. The end result doesn't look remotely like a "finished" drawing; it's a bit of thinking made visible, a point of contact being established, an encounter recorded. The drawing was made one morning in 2001, at the time of their exhibition at the Natural History Museum, and was the only occasion on which—as the fourth person in that basement room—I've been able to watch the artists at work, from only a few feet away. I'm not even sure that I'd recognize the drawing if I saw it again, but it provided a vivid glimpse of the nature of Olly and Suzi's collaborative practice.[1]

Four years later, in the early part of 2005, the artists traveled to Antarctica for the first time to spend three weeks making a visual record of their impressions of wildlife in the region, drawing everything from krill to leopard seals, and from jellyfish to penguins (Figure 1.1). Seeing themselves, broadly speaking, as environmentally conscious artists, Olly and Suzi have worked collaboratively since the late 1980s and are best known for painting and drawing endangered predators in their natural habitat at the closest possible quarters—whether tarantulas and green anacondas in Venezuela, wild dogs in Tanzania, or great white sharks underwater off the coast of Capetown.[2] The two of them work simultaneously on each piece, in conditions that can be both inhospitable and dangerous, with the aim of conveying as directly as possible not only the beauty of these creatures but also the extent to which their lives and habitats are under threat.

In a valuable overview of animals in twentieth-century visual art, covering everything from performance art to conventional wildlife painting, Jonathan Burt has argued that "Olly and Suzi represent a very important moment in the history of animal art because of the scale and ambition of their project."[3] In 1993 they abandoned studio work altogether, and the following ten years of worldwide expeditions to make artwork in the wild are extensively documented in their artists' monograph, *Olly & Suzi:*

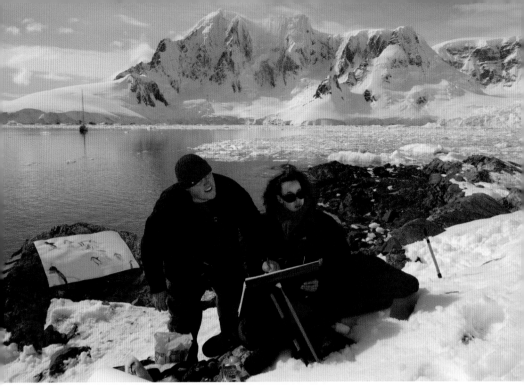

Figure 1.1. Olly and Suzi drawing on Hovgard Island, Antarctica, 2005. The drawing *Penguins Sliding* can be seen on the rock at the left of the photograph. Photograph courtesy of the artists.

Arctic, Desert, Ocean, Jungle. The fact that each of them had a young family by the time of its publication led them to decide to limit the number of expeditions undertaken each year, and to explore the scope for making a certain amount of studio work again. This had to be done, however, in a manner that would not compromise their commitment to bringing to life the directness of their own experience of remote habitats in the eyes and minds of their viewers. This chapter charts this shift in their thinking, paying particular attention to the artists' own account of how they've put this new approach into practice.

Looking at Animals

There has been a renewal of interest in the topic of humans looking at nonhuman animals, with writers from a number of disciplines seeking to

think more clearly about what's involved in that looking. Garry Marvin has made the important point that John Berger's classic (and still widely cited) essay "Why Look at Animals?" not only "approaches the visual encounter between humans and animals as though this were a mono-visual or one-dimensional process between the subject and the object,"[4] but also neglects to consider *how* people look at animals by focusing only on the question of "why" they do so.

Marvin's point is that there are many ways of looking, and he proposes "a continuum from unengaged to engaged" looking, briefly working his way through the idea of seeing, looking, watching, and observing nonhuman animals. He's quite explicit that his concern, and his emphasis, is on "the direct experience of the empirical animal rather than encountering an image" of it, though he also argues that from his anthropological perspective "a squirrel is represented the moment when recognized by us as a squirrel."[5]

In terms of thinking about *representations* of animals—the concern of this chapter, but not of Marvin's essay—there are two difficulties with his argument. One is the implication that to represent is necessarily to classify, to judge, and to narrow rather than to open up human understanding of or engagement with the animal. It's a view with which most contemporary artists, and certainly Olly and Suzi, would find themselves out of sympathy. The other difficulty is that the terminology of looking itself differs according to whether the looked-at thing is the animal or an image of that animal. *Watching* a squirrel may indeed involve "a more attentive viewing" than merely looking at it, and observing may be a more "concentrated, attentive viewing guided by a particular interest" in the animal,[6] but neither watching nor observing are terms that can usefully be applied to the viewing of drawings or paintings of animals—as if these flighty images might somehow vanish from the gallery wall if the viewer's attention was momentarily distracted. Notions of attention and attentiveness to animals and their habitats are central to this account of Olly and Suzi's operation as artists, but they call for a rather different vocabulary.

In *Ecosee*, their interesting collection on ecology and visual rhetoric, Sid Dobrin and Sean Morey consider the use of images (including images of animals) "to create alternative ways of seeing nature and environment"—ways of seeing that might, broadly speaking, have a greater

ecological integrity than much contemporary mass media imagery.[7] However, in proposing the study of a "visual eco-language" of "econs" and "ecotypes" that may have discernible "semiotic rules," Morey perhaps unwittingly calls on something uncomfortably close to the techniques of mass media communication and thus underestimates the importance for contemporary artists of working in a more exploratory manner that is neither rule-bound nor particularly language-like.[8]

The problem with bringing language-like ambitions into the realm of contemporary animal art is thrown into sharp focus in Cheryce Kramer's highly critical reading of the ubiquitous animal images of the photographer Tim Flach. Flach's photographs are regarded as "art photography," but much of his work is made for Getty Images, one of the world's two largest commercial image banks, which between them "are said to supply 70 percent of the images we see." Kramer quotes a previous managing director for Getty as saying that as a result of their influence "the language of images" is becoming "ever more uniform."[9] Getty management apparently regards Flach's animal images as "directly 'on brand,'" and (having worked with him on one of his exhibitions) Kramer says that Flach "would say he is 'formulating a visual language structure'" with his photographs; her own damning assessment is that "a Flach image is comparable to an *emoticon.*"[10] Drawing as it must on "an extant order of symbolic relations" through which all concerned are able to "make sense of the world," such imagery inevitably impoverishes the animals it depicts for wholly human ends and constitutes "a distancing mechanism that instrumentalizes the animal form."[11]

The approach to image making described by Kramer—if it is taken as a reliable account of Flach's practice—could not be further from that of Olly and Suzi. Their concern is to devise ways to record the immediacy, specificity, and *intense unfamiliarity* of each new animal encounter. As Ron Broglio puts it, their works "leave the mystery of the animal and its world intact while calling attention to its existence."[12] Here the idea of being "on brand" seems meaningless. This is not to say that the artists have no commercial ambition, but rather that they convey a sense of having to forge afresh and render urgent each new communication of their experience of the joys of the more-than-human world. There are neither econs nor emoticons to be found here, and any understanding of the attentiveness of

their outlook is likely to be found only in a corresponding attentiveness to the particularities of their practice. The broader contention of the present chapter is that attentiveness to the form of an artist's practice may make it difficult—and perhaps even counterproductive—to try to draw more general conclusions from it. What is called for is (to borrow Donna Haraway's words) "something full of grappling hooks rather than something full of generalizabilities."[13]

Picturing Animals

Olly and Suzi's own views about their work are often expressed with a disarming directness and simplicity: they don't see it as their role to theorize their practice. In what follows here, no particular effort is made to establish a critical distance from those views, because the distinctiveness of their practice can in certain respects best be understood by taking seriously the manner and the terms in which they choose to describe it.

In conversation in 2005, Olly reiterated a point on which Olly and Suzi have insisted throughout their career: "Working in the wild is the very core of what we do." Speaking of the work made in their studio since 2003, he emphasized that there too the work "is nothing without the experience, it is nothing. We cannot make this stuff unless we've been there." Asked about how they would describe themselves, Suzi answered: "Maybe we're trying to be messengers." This emphasis on *being there*—which undoubtedly includes a continuing echo of Romanticism's concern with authentic experience—is therefore very much tied up with the idea of bringing something back in the form of a message of importance: a message about endangered wildlife, endangered habitats, the connectedness of things, and the beauty that will be lost if environmental degradation is allowed to continue.

The particular visual form of that message, however, is everything. Suzi articulated this rather clearly, contrasting their experience of working in the wild *as artists* with her own experience of taking typical tourist photographs of big game during a family holiday in Africa, not long before the Antarctic trip: "I suddenly realized quite how difficult what we do is. The *urgency* that I have with Olly when we're in the bush," she reflected, includes everything down to the mundane panic of

"who's-got-the-sketchbook-and-where-are-the-pencils" in that "intense moment" when the animal fleetingly appears.

The materials matter, not because pencil and paper are superior to or more authentic than the photographic record, but because they do a different kind of work (Figure 1.2). Throughout their career these artists have used both. On most of the trips documented in their 2003 monograph, the photographer Greg Williams had traveled with them to document the interactions with animals in their natural environments, principally in photographs but also in film footage. Some of Olly and Suzi's most striking and best known images—not least that of the great white shark surfacing to take a bite out of the artists' painting of that very creature (an image reproduced as a huge banner outside London's Natural History Museum at the time of their 2001 exhibition there)—are in fact photographs taken by

Figure 1.2. Olly and Suzi, *Penguins Sliding,* Antarctica, 2005.
Caran Dache pencil on paper.

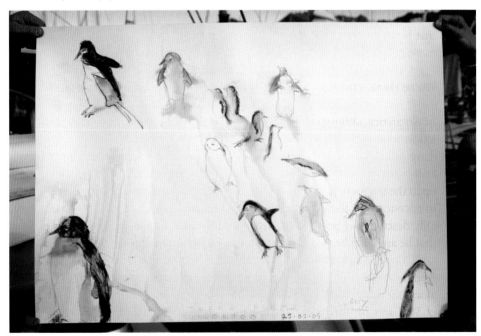

Williams.[14] But Olly and Suzi had begun increasingly to take photographs themselves, individually, as part of their collaborative work, so any distinction between their art and their own photographic documentation of that art is not easily drawn.

Much the same is true of Williams's contribution to their work. Like many contemporary artists with environmental concerns, whose work simply could not be made without the direct involvement of local guides, assistants, and expertise on their various expeditions, and whose subject matter is recorded in a variety of media, Olly and Suzi make no hard and fast distinction between images they make themselves and images made by others in terms of what counts as their "art." Asked about how decisions were made about which pieces fell within the scope of their collaborative work, Suzi explained that as far as Williams's photographs were concerned, the three of them "all edited them together." Similarly, in relation to their own recent photographs, she and Olly "edit them together" to decide "whether it's his one or my one that says what we want it to say, so it's actually pretty similar to the drawing and painting, in that if he's done a better line, or the line that describes the back of a bear better than I have, then we go with that line." The remark gives a sense of the fluidity with which the artists move across and between these media.

We're Here, and It's All Happening Now

In Antarctica, although theoretically protected against commercial exploitation, it's not just individual species but the environment itself that is endangered, not least because of a significant increase in the harvesting of the krill that constitute a vital part of the food chain for other animals, right up to the ten-foot-long leopard seals that the artists were most dramatically to encounter on that trip (Figure 1.3). The leopard seals are predators that Olly described as being as imposing and intimidating as the polar bears that he and Suzi had encountered on an earlier Arctic expedition.

On the Antarctic trip on the *Pelagic Australis* (a seventy-five-foot Antarctic sailing yacht with a crew of three), Olly and Suzi were working alongside the underwater photographer George Duffield—taking the place of Williams on this occasion—and the wildlife filmmaker Doug Allan, who was operating both as expert guide and as underwater cameraman

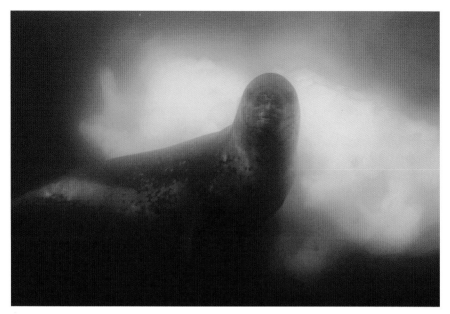

Figure 1.3. Olly and Suzi with George Duffield, *Leopard Seal,*
Antarctica, 2005. Custom framed C-type photograph.

filming material for a documentary on Olly and Suzi's work. Anchored off
Hovgard Island, the dives they made to find, paint, film, and photograph
the region's solitary leopard seals were the most trying part of the expedi-
tion (Figure 1.4). Not least of the problems was the intensity of the cold,
and the artists' ill-advised decision to try out so-called dexterous gloves to
aid the process of painting underwater—gloves that proved wholly inad-
equate for the job.

 Talking to them subsequently about *what it actually felt like* to be
working underwater in that environment drew out some of their most re-
vealing responses. Despite the intensity of their physical discomfort, and
concern for their fingers ("we were in a lot of trouble," Olly acknowledged),
they seem not to have lost their sense of purpose. As Suzi explained:

> At that moment it feels like I've come all this way, all these things have
> happened for us to be here, and I may be really cold, or my ears may be
> hurting. . . . I remember one dive we did and my ear was killing me, Olly

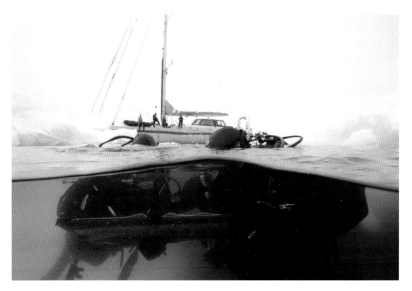

Figure 1.4. Olly and Suzi swimming away from the *Pelagic Australis,* carrying underwater drawing materials, Antarctica, 2005. Photograph courtesy of the artists.

was going, you know, pointing up, do I want to go up? And my reaction was no, I want to stay down, I want to get this done, because we're here, and it's all happening *now*, so we've got to do it, otherwise what have we come all the way out here for? And I think that feeling often overrides everything else at that moment.

The whole situation was complicated by their having to take into account Allan's need to document their work and their interactions with the seals for the film. In particular he was eager to get "the locking shot": a shot of Olly and Suzi with one of the leopard seals. Describing the limited visibility in which a seal's presence became apparent only when it was already very close, Olly continued:

We took some chances on a few occasions, in deep water with these leps. I remember hanging on, I put my hand into an ice hole, gripped on, and Suzi was on my right, and my buoyancy was all over the place because

we were in this swell, and the lep poked his head around this iceberg and he just came around within inches of us and it was like—whooo—we're holding the drawing board and trying to draw it, and we know we've got Doug on the back of our shoulder, trying to get it all right, they call it the locking shot.

Pushed further on the question of how, in the face of the distractions of extreme temperatures, risk, physical discomfort, and lack of dexterity, they nevertheless managed to attend both to the animal and to the drawing, Suzi responded:

The nice thing about that is that it's what we've been doing for so many years, and it's actually the easy bit, it's the bit that *I* like, because it takes my mind off everything else, like I hate this, and am I going to drown? and all those fears in my head. If I'm concentrating on a drawing, that's what I'm really happy doing, so I'm completely relaxed in that sense, and while this animal's whizzing around I'm just trying to get as much information down as possible. That actually is the easy bit.

The gathering of the information is the key thing. Olly described his elation at their encounter with the looming seal, regardless of the difficult and rather frightening circumstances: "I remember just thinking to myself, great, now we can do a thousand paintings about leopard seals, it really doesn't matter, because *we've seen it, there*." The issues raised in this whole exchange say a great deal about the artists' attitudes and values, and deserve to be contextualized more fully.

Attentiveness and Creativity

The relation of attentiveness and creativity (including attentiveness to the more-than-human world) has been explored in Wendy Wheeler's book *The Whole Creature*. She contends that creativity "lies in being able to 'disattend from' the logic and rules of grammar" and of other rule-bound forms of meaning-making or understanding, "in order to 'attend to' the perfusion, and disorderly profusion, of many signs which aren't supposed to count

as legitimate" if understanding is thought about "only in linguistic rule-bound terms." She continues: "This 'attending to' is both conscious and unconscious—a kind of free-floating attentiveness . . . which poets have long described as waiting for the muse to descend."[15]

In one sense this delicate balance—of disattending-from rules in order to attend-to what those particular rules render illegitimate or irrelevant—doesn't quite match Olly and Suzi's account of their own attentiveness (both to the animal and to the drawing) in extreme conditions. But there are certainly forms of disattending-from in order to attend-to at the heart of their practice. At the most obvious level, it's their attention to the demands of the mark-making process that allows them to disattend from all the distractions pressing in on them. At another level, like any artist with concerns for the environment and for nonhuman life, their thoroughgoing attention to endangered creatures and habitats is itself a committed disattending from Western culture's broadly anthropocentric and inward-looking value system. When Wheeler characterizes "a spirit of continual curiosity and attentiveness to what's going on" as "an openness to life,"[16] she finds a phrase that could hardly be bettered as a description of Olly and Suzi's outlook.

Wheeler would almost certainly recognize and be sympathetic to another aspect of Olly and Suzi's description of how they work. In the urgent moment of capturing something of the animal's presence, *while in its presence*, the distractions from which they must disattend are a vital part of the experience of attending. This is why their own accounts of their physical circumstances and states of mind seem so pertinent: not to privilege some notion of the "artists' intentions" or to reduce their art to the story of its making, but rather because it seems clear that they're describing a bodily or *embodied* attentiveness.

Building on Michael Polanyi's work in the 1960s on tacit knowledge, Wheeler sees the knowledge on which any form of creative practice draws not as abstract, rule-bound, and rationally acquired but as something more slowly and thoroughly gathered, learned, and embedded: she calls it "the tacit experiential knowledge which lives in the bodymind." Drawing also on her wide reading in complexity theory, she suggests that organisms (including human beings) can only ever be understood in relation

to their environments, and that this kind of thoroughgoing connected-ness—whose ecological implications are clear enough—makes it entirely meaningful to speak of "body-mind-environment systems."[17]

Olly and Suzi's repeated emphasis on the importance of their first-hand experience of the wild ("no experience, no art") and their descrip-tions of how their bodies dealt with that experience seem closely to echo Wheeler's notion of a creative, skillful, and generously inclusive reaching-out for new knowledge and new experience: "We incorporate it in our body—or extend our body to include it—so that we come to dwell in it," she writes.[18]

Accuracy and Beauty

Olly and Suzi frequently comment on the beauty of the animals they draw and paint, but asked whether that beauty had to be conveyed through making their own work beautiful—whether beauty had its own pictorial work to do, in other words—Suzi reflected: "That's a really good question and I don't know the answer." Thinking about their work on sharks, off the coasts of both South Africa and Mexico, she expressed the view that "we should be trying to show people that they're not just big scary ani-mals. They *are* beautiful, so it's my place to show other people that they are." Asked again whether this had to be achieved by making the image itself beautiful, she answered: "I think the image needs to be as *accurate* as it can possibly be." At this point Olly offered an important clarification: "But that's accurate to *our* experience. It's got to be as accurate as possible to our experience of being in five metres of choppy swell in a crappy cage with each other banging around and this thing trying to eat us. That's our interpretation of what's real and beautiful."

Three specific examples of this embedding of their own embodied experience into the image can be offered from the Antarctica trip. One of Duffield's photographs of the leopard seal subsequently won him a BBC Wildlife Photographer of the Year award in the underwater photography category. It was, however, another of his photographs of the same animal (Figure 1.3) that the artists and photographer had selected to count as part of Olly and Suzi's output because, Olly explained, that particular one summed up the "ominous vision that we best remember."

A second example concerns a drawing made onboard the *Pelagic*. It was based on several drawings they had made "from life," face-to-face with creatures encountered over the preceding days (Figure 1.5). The drawing is made up, Olly explained, of "images we'd been toying with previously": a crabeater seal, a pair of penguins, and a jellyfish that Suzi had seen and drawn underwater.

Here, as the word *toying* may itself suggest, notions of accuracy, beauty, and pleasure stand in a complex relation. Characterizing this kind of composition as something of "an experiment" for them, Suzi described her thought process: "I'm just drawing this yellow ribbony bit of jellyfish and thinking, well, I don't really know if it was in that position but I want it to go like that, so I'm using my imagination, having a great time, not worrying that it's actually accurate." Speaking of the editing of earlier drawings that led to this particular composition, she explained: "We chose three things that we thought were really important in Antarctica—important

Figure 1.5. Olly and Suzi, *Cycle of Prey,* Antarctica, 2005. Caran Dache pencil on paper.

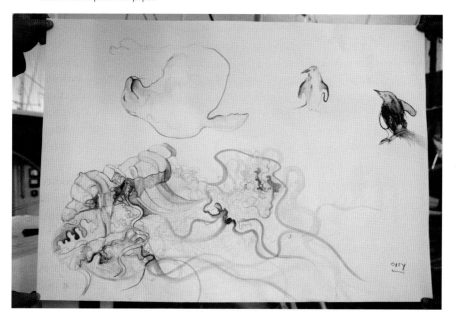

because we'd seen them." They both acknowledged that in the abstract, at least, it might have seemed important to include an image of krill in such a composition, on account of its centrality to the life of the region. But there's only so much that can go into a successful drawing, and, Suzi remarked, "visually we wanted to use our jellyfish because we love that image, and it's a beautiful thing to draw."

The third example concerns a simple linear image of a pair of seals, drawn on a map that the artists had been given by the skipper on the boat (Figure 1.6). As Olly pointed out, "It's the role of our drawing and painting to focus," and often all that's needed is a very "spare drawing": "Drawing is decision-making; we can only do so much, we can only use so many colours, or we might just as well take a photograph. So to try to do too much with your drawing and painting would I think be a mistake." Suzi added: "But it's also nice, with this one on the map, just to draw the seals very simply down there in the corner, on the blank bit. That sort of says enough: *they're there, and that's how we're seeing it.* In the three weeks we were down there, we saw such a tiny part of what there is down there, and that's what we came back with."

The drawing on the map—which at least gives the seals a schematic geographic location—points to a rather unusual feature of the vast majority of Olly and Suzi's drawings and paintings. Given their very clear environmental concerns, it's striking that their images of animals are generally placed on the blank ground of the white or cream paper they typically use. The landscape is left out. In the drawing of penguins playfully skidding and sliding down a snowy incline (Figure 1.2), admittedly, the white ground almost inadvertently stands in for that little patch of Antarctic landscape, but that really is something of an exception.

Olly and Suzi made two points in relation to this observation. One was that always to draw the animal in its habitat would undermine the distinct role of the photographs that also form part of their body of work. The key thing is to use each medium to its best advantage: to know what works. Their second point was that there is no shortage of more conventional wildlife art that places animals in the landscape, where "it's always the tiger in the bush or wolves tracking across the hills," as Olly put it. He wanted less to criticize the comforting associations of much of that popular art than to emphasize his and Suzi's singular focus on the animal: their

Figure 1.6. Olly and Suzi, *Here Be Mermaids*, Antarctica, 2005. Aquarelle on old Antarctic chart.

attempt visually to sum up "the spirit that *we* took from the animal." "Not," he adds, "that any of these drawings define a species, not at all." They are simply the attempt convincingly to capture "a very brief second that we might have seen." But as Suzi frankly acknowledged, there was also the practical matter that whenever they *have* placed the animal in its landscape in a drawing, "it's never worked."

The Whole Chain

Pressed as to why these animals matter, and more particularly as to what would be lost if they were no longer there, Suzi's simple response was "Our world." Olly answered more fully:

> There'd be nothing to venture for, nothing to keep us on our toes. If you're walking through the Arctic tundra . . . not having to worry at the back of your mind about polar bears, you're left with a very severe habitat with not a lot going on. And it's got massive ramifications for us as humans, because then suddenly all it really is about is exploiting it: if there are no animals left, the lobbyists can't whine, so let's rape it, drill it, mine it, build on it, tarmac it. And then we've really lost something.

Quite apart from the issue of commercial exploitation, they both emphasized the ecological interdependence of species and their habitats. Olly offered a rather detailed hypothetical account of the environmental consequences if caribou were to disappear from the Brooks Range in Alaska, and Suzi used this as an opportunity to relate their environmental concerns to the priorities of their own image making: "You start understanding the whole chain, and why each thing is vital for the next thing, and that's why it's important not just to focus on one big scary creature. The whole essence of the place would be nothing without all those hundreds of little pieces of the jigsaw puzzle." Yet, as she acknowledged, it's never possible in any single drawing or painting "to show the enormity of the situation."

Suzi's comment about big scary creatures certainly reflects her extreme frustration at the extent to which the 1997 "shark bite" photograph discussed earlier has continued to dominate public perception of their work. Dramatic and effective as that photograph of an animal interacting

with its own painted image may have been, Olly and Suzi are wary of being expected to produce sensationalist imagery that may only reinforce popular misconceptions of the wild. The artists' acute and growing awareness of "the whole chain" in the ecosystems they visit is, of course, no guarantee that their artworks will effectively contribute to preserving the links in any of those chains. Writing from the perspective of complexity theory, Thomas A. Sebeok contends: "The *more* we understand the complexities of a system, the *less* we should be confident of our power to manage it."[19] But as Wheeler points out, "with that strange forward directedness of life itself" that might be said to characterize any creative outlook on the world, artists rightly go about their work with "a general confidence."[20]

That confidence in embodied skills is what Francisco Varela calls the intelligence that guides action, but that does so, crucially, "in harmony with the texture of the situation at hand, not in accordance with a set of rules or procedures." This seems an apt enough description of Olly and Suzi's approach, as does Varela's account of a creative outlook as "a journey of *experience* and *learning*, not . . . a mere intellectual puzzle that one solves."[21] Readers and viewers will draw their own conclusions about the effectiveness of the images and strategies employed in Olly and Suzi's work, but even to ask a question along the lines of "does their work *work*?" may be to ask the wrong kind of question, because it's simply too closed a question. Better, perhaps, to return Marvin's continuum of humans seeing, looking, watching, and observing animals, and to think about where a creative attending-while-disattending—the manner in which artists might look at animals, in other words—would fit on that continuum. In a sense, of course, it doesn't fit; it's more like an interruption of it. And this is the modest claim that can be made for art such as Olly and Suzi's: that once in a while, at least, and without the artists necessarily even recognizing that it's succeeded in doing so, this art puts into place a creative interruption of the ways in which humans habitually look at animals.

On Drawing an Aardvark

THE ART HISTORIAN James Elkins argues that artists "have to watch the world in a particular way." His example is an unexpectedly appropriate one. "This was made clear to me," he writes, "after I had seen a stuffed aardvark in a natural history museum. It's a strange animal: this one was huge and intensely muscular, like a monstrous rat with rabbit's ears. It had long, sparse white hair, deep wrinkles, and gigantic yellow nails, as if it were constructed out of close-ups of an old man's body."

Elkins's point is that most people don't look at animals with the seriousness and attentiveness that artists generally do. He writes of the stuffed aardvark: "I was captivated by it, but when I went home and tried to draw it, I found I couldn't start. I couldn't remember how the legs went—did they come forward or back? What shape were its eyes? Was its nose black or gray? I had forgotten—or to say it more accurately, I had never seen." These and other bits of necessary but missing knowledge prompt him to acknowledge a vital but seldom commented-on aspect of the specificity of artists' seeing: "As you look, you have also to be thinking of drawing . . . it requires some idea of what a drawing is and how it might work, and that idea has to be brought into play while seeing is taking place." It could hardly be further, he rightly notes, from what he calls "the kind of glazed attention I give animals who gallop by on television nature shows."[1]

It's part of the constant battle against the complacency of seeing, and even of image making. Sue Coe, whose uncompromising image making in the cause of animal rights is discussed in chapter 6, is constantly wary of what she calls the "facility" of her own drawing skills and of the inattentiveness of looking that the easy employment of those skills might allow. "I'm always trying to sabotage my instincts," she has said in this context.[2]

In her fine book *The Sovereignty of Good*, first published in 1970, Iris Murdoch elaborates an everyday philosophy in which both attentiveness and art are presented as relevant forms of ethical action (though she tends to use the adjective *moral* rather than *ethical*). She writes: "I have used the word 'attention' . . . to express the idea of a just and loving gaze directed upon an individual reality." Like Elkins, she sees it as a quite particular way of watching the world: "The task of attention goes on all the time and at apparently empty and everyday moments we are 'looking,' making those little peering efforts of imagination which have such important cumulative results."[3]

She articulates its ethical consequences in the following terms: "If we consider what the work of attention is like, how continuously it goes on, and how imperceptibly it builds up structures of value round about us, we shall not be surprised that at crucial moments of choice most of the business of choosing is already over." She continues: "The moral life, on this view, is something that goes on continually, not something that is switched off in between the occurrence of explicit moral choices." And she concludes: "One might say here that art is an excellent analogy of morals, or indeed that it is in this respect a case of morals."[4]

Explaining that her approach "does not contrast art and morals, but shows them to be two aspects of a single struggle," she explicitly criticizes those who see art "as a quasi-play activity, gratuitous, 'for its own sake,' . . . a sort of by-product of our failure to be entirely rational. Such a view of art is of course intolerable." And she insists that "aesthetic situations are not so much analogies of morals as cases of morals. Virtue . . . in the artist . . . is a selfless attention to nature."[5]

Giving an ethical twist to Elkins's account of the specificity of artists' seeing, Murdoch asserts that "to contemplate and delineate nature with a clear eye, is not easy and demands a moral discipline." This is not, however, a matter of dreary earnestness: "Art invigorates us by a juxtaposition,

almost an identification, of pointlessness and value." And in a rejoinder to those who doubt artists' motives but take for granted philosophy's worthiness, she sums up her view as follows: "Art then is not a diversion or a side-issue, it is . . . a place in which the nature of morality can be *seen*."[6] Even if the language sounds a little dated, there's a singular importance and a continuing relevance to Murdoch's ideas. She articulates with clarity and conviction the manner in which artists can operate with integrity without tying themselves to externally imposed rules or standards.

2

Cycles of Knowing and Not-Knowing
Lucy Kimbell, Rats, and Art

> Following a line of least resistance is not just a question of
> avoiding problems, but rather being guided by them.
> —Martha Fleming, *From Le Musée des Sciences to the
> Science Museum*

A CARD, AN INVITATION, around four inches by six, printed on both sides.
On the pink side, in a typeface sprouting elaborate arabesques, are the
words *One Night with Rats in the Service of Art*, and smaller text identify-
ing this as the title of a "performance lecture" to be given by Lucy Kimbell
at Camden Arts Centre in London on the evening of August 31, 2005. In
it, she proposed to share "the results of her aesthetic experiments with rats"
and announced: "Raising issues about ethics and aesthetics, this event will
appeal both to those disgusted by rats and those disgusted by experiments
on rats" (Figure 2.1). On the black side of the card, in the same typeface,
where the glossy black arabesques seem to mimic rats' tails, was the an-
nouncement of a *Rat Fair* in the same venue four days earlier. But this ac-
count already risks getting ahead of itself. The "rather beautiful" invitation
card, as the artist rightly calls it, seems nevertheless to be an appropriate
place to start because it's one of the few tangible artifacts relating to this
complex and fascinating but highly elusive art project.

Kimbell describes herself as "an artist and interaction designer"
whose recent work "disturbs evaluation cultures in management, technol-
ogy and the arts."[1] *One Night with Rats in the Service of Art* is in fact her
only animal-themed project to date, though the project's concern with
how rats get enmeshed in human evaluation cultures certainly connects

41

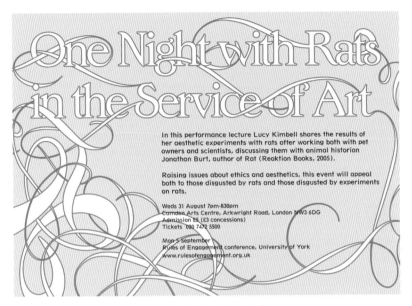

In this performance lecture Lucy Kimbell shares the results of her aesthetic experiments with rats after working both with pet owners and scientists, discussing them with animal historian Jonathan Burt, author of Rat (Reaktion Books, 2005).

Raising issues about ethics and aesthetics, this event will appeal both to those disgusted by rats and those disgusted by experiments on rats.

Weds 31 August 7pm-830pm
Camden Arts Centre, Arkwright Road, London NW3 6DG
Admission £5 (£3 concessions)
Tickets 020 7472 5500

Mon 5 September
Rules of Engagement conference, University of York
www.rulesofengagement.org.uk

Figure 2.1. Lucy Kimbell, *One Night with Rats in the Service of Art,* invitation card, 2005.

it to other aspects of her art and design practice. After the initial delivery of the performance lecture in August 2005, versions have been given on at least four other occasions.[2] The interview with the artist on which this chapter draws was conducted immediately after the version delivered at Goldsmiths College, London, in 2006.

The performance lecture is in part a description of the nature of Kimbell's art practice, and of the ways in which it figured in this particular project.[3] Having to explain in meetings and telephone conversations with all manner of people with an interest in rats that she was "a practice-based researcher"—hardly the most self-explanatory term to those not involved in the contemporary arts—she summarized her side of such conversations as follows: "The outcomes of my research might be performances, events, yes, artworks. These can be art. No, no drawings, no photographs, no paintings, no sculptures. No, no installations." For the benefit of the lecture audience, she explained:

In previous projects I have referred to what I do as "somewhere between Bad Social Science and live art." Social scientists in particular seemed to appreciate what I did because it resembled what they did, but using bastardized methodologies, using humour and failure. Instead of the problematic but currently dominant category "sci-art," I could say I make social-sci-art. I create unregulated process.[4]

Like a lot of her interactive projects, *One Night with Rats in the Service of Art* was very much "about showing the entanglements," as she puts it, between its various elements.[5] In this case those elements included her encounters with rats and various groups of humans, from laboratory scientists to the so-called ratters who keep and display fancy rats as a hobby, as well as animal rights activists and art audiences. What would happen, she wondered, to her understanding of the widespread human distaste for rats as she moved between these people's spaces, bringing together "different kinds of knowledge, desire and disgust"? This was to be her "aesthetic experiment."[6]

A Poem, and the First of Several Drawings

Disarmingly, Kimbell's performance lecture begins with a forty-two-line "cute" poem about one of her early visits to a mouse and rat show, the tone of which is clear enough from the first four lines of the final stanza:

> And this is what I took away
> The sound of rats, the sound of play
> People playing, with each other
> The rats a sort of rodent cover[7]

Its principal formal purpose in the lecture seems to be to wrong-foot any and all of its likely academic audiences, as cute rhyming couplets have no more legitimacy in the discourse of contemporary art than they do in that of science.

From **there, however,** the lecture moves to the first mention of a particular drawing—a drawing by an artist who proposes to make "no

drawings, no photographs, no paintings." Kimbell introduces it as "a piece of work I want to make but have not yet been able to make":

> It's called the *Rat Evaluated Artwork* or REA. I did this drawing more than a year ago and I imagined it as a gallery piece, sitting on tables, with many tubes and wheels, a closed environment for rats and for the spectators who might watch them, offering diversions and decision points for rats, and diversions and decision points for humans.[8]

The rats' decisions, as they selected which routes to take through this enclosed maze, were to include aesthetic evaluations as to whether this artwork was *itself* something "beautiful," or "mildly interesting," or "sensationalist" (Figure 2.2). Simultaneously flippant and serious from the outset, this was another example of her working, as she says, "somewhere between Bad Social Science and live art."

Here, as in so many other instances of contemporary art with animal concerns of one kind or another, it is important to hold back from judging too quickly any "ethical" (or unethical) stance that the work may seem to adopt. In this particular case, it's important to understand both the place of the *Rat Evaluated Artwork* in the overall trajectory of the *One Night with Rats in the Service of Art* project, and the journey through her ideas and experiences on which Kimbell will take her audience in the course of the performance lecture. To ask whether the project is actually about rats, or merely about art, is to ask the wrong kind of question.

The drawn, collaged, and written elements that make up the REA "drawing" date from early or mid-2004. Over the next two years, Kimbell's ideas for the realization of this artwork hardly changed at all, other than realizing that she couldn't bring herself to make it. In conversation, she described it thus:

> The *Rat Evaluated Artwork* is conceived of as a gallery installation which is physical in form, perhaps with some digital add-ons or bits of electronics that apparently measure or track a rat's movement within it . . . but it's really conceived of as a visual art piece, so it *is* an artwork. It requires, in that conception of it, a live animal or live animals to be in it, to move through

Figure 2.2. Lucy Kimbell, *Rat Evaluated Artwork* (detail), 2005.

the tubes and various decision-points while an audience is there . . . to observe those movements and decisions, and also to see these faintly ridiculous attached meanings, and I still want to do it in a way—that's my lack, or loss, that I can't quite bring myself to do it.

The acronym REA is, she acknowledged, a deliberate punning reference to the RAE, the national Research Assessment Exercise that at that time evaluated all academic research in British universities and funded it accordingly. And the role of the "ridiculous" in her REA's strategies of evaluation would undoubtedly have struck a chord with her audience's experience of the RAE's attempt to regulate knowledge, inquiry, and creativity.

Punning aside, Kimbell's account of this projected artwork raises important themes that will each call for attention in due course: the nature

of art's distinctive contribution to cultural knowledge about animals; the circumstances of living animals in works of contemporary art; the role of the ridiculous in formations of knowledge; and the work of loss.

Knowing about Not-Knowing

Kimbell's attentiveness to her working methods allows her to be surprisingly forthright about the limitations of her knowledge. In the performance lecture she announces early on that "I knew nothing about rats other than that they were both objects of disgust and fear in Western culture and objects of respect—as survivors, fast breeders, quick adaptors."[9]

At the point where she started contacting scientists, however, she was fully conscious that the two-year university fellowship and the research council funding she had secured to support the project were seen as validating her inquiry, even when expressed in terms such as these: "Hello, I just want to know what you know about rats. Hello, I don't even know what I want to know exactly but will you let me be here and watch and ask some questions?" It was essentially this same open and wide-eyed (but far from naive) approach that paid off in Kimbell's early contact with some of the ratters. In the autumn of 2004 she paid several visits to the home of a woman in Essex who owned some rats: "She had agreed to let me try to train them aesthetically. Neither of us was clear what this meant."[10]

Reporting on these early contacts with both ratters and scientists, Kimbell tells her audience:

> I had noticed myself using the term "experimental" as in . . . "I'm not sure what I'm doing—it's a kind of experiment." It was a way of avoiding saying what I *was* doing, since I didn't know what that was, and so far, no one had challenged me. Within practice-based research, you can get away with quite a lot. You are allowed not to know, for quite a lot longer than you are elsewhere in the world.[11]

In reality, of course, this has nothing to do with "getting away with" anything. As an artist operating without confident access to the skills and traditions of a conventional artists' medium (such as painting or photography),

her projects have no obvious formal starting point: "In a sense, like anyone else, I'm just trying to understand the world, or look at the world and create some meaning for myself . . . and because I have always crossed disciplinary boundaries, I kind of feel that I don't have a claim to any one knowledge." Finding herself sixteen months into the two-year fellowship before she felt clear as to what she was actually doing, she reports: "I was quite anxious through this project, it wasn't easy being in this place"— although, at the same time, "sometimes I loved it."

Getting into Other People's Worlds

One Night with Rats in the Service of Art repeatedly reflects on the nature of Kimbell's own practice: "I seemed to have this liberty as a practice-based researcher; but what was it that I was researching, other than my ability to get into things, like buildings with animal rights protestors outside?"[12]

Part of an answer might be that she was researching her way around obstacles such as the need to conceptualize and articulate the project— "probably too early on"—to secure funding for it. One early funding application included the explanation: "By setting up activities that resemble (but differ from) the activities of scientists and breeders, the artist wants to illuminate the ambiguities within rat breeding and experimentation and reveal philosophical questions about what makes us human and rats animals." Its philosophical and hierarchical presumptions exemplify her tendency to operate in what she engagingly calls "Stalinist super-project mode" in the early stages of research.

To move on from this rather defensive and calculating manner of operating, a casting-off of confidence and preparation was necessary. In its place came something more open. As she explains:

> This is the thing about practice: once I started actually forcing myself *to do* something, like going to that woman's house in Essex, where I just forced myself to go, it made it tangible and real and vivid and meaningful, through practice. . . . I was just *doing a thing*, and seeing what it was like. And that moves you forward, not the design, not the conceptualization of it.

The refrain of doing something simply *to see what it was like*, to see what happened, is an important reflection of Kimbell's curiosity-driven approach. Without reading anything specific into the coincidence, the words call to mind Jacques Derrida's famous observation about the striking manner in which his own cat, free of philosophical agendas, seemed to look at him: "just *to see*" [juste *pour voir*].[13]

Seeking to explain why her research for the rat project took her both into scientific laboratories and into rat shows, Kimbell's immediate response was: "It seemed important to go and be in both and see what happened." Of both of these environments, she has observed, "I was amazed about how far people let me go into their worlds." She found the ratters' world "a closed community although quite welcoming," and also found the scientists she encountered to be helpful, especially the experimental psychologist Rob Deacon, who works on rodent behavior and became actively involved in aspects of her project. Asked about whether these different worlds shared any of their knowledge, she responded:

> I don't think they do, very much, which was why I did very quickly become interested in the *practices* of these two groups that I looked at in depth. . . . I was particularly struck when talking to the ratters by how much biological knowledge they had, and some home-made animal psychology. Some of those people breed rats, and try and bring out particular lines, in the way that dog breeders do. So there's a sort of homespun science. I did interview somebody about this, and I said, so, where do you find out about things? She said "from the literature," and what she meant was rat journals, not scientific journals.

According to Kimbell, Deacon, on the other hand, was "actually very interested in, and recognized, the kinds of intimacy and knowledge that owners and breeders would have."

In contrast to her work with scientists and ratters, Kimbell's involvement with animal rights activists was slight. Because of her discussions with Deacon, who was based at Oxford University, and her awareness—in the light of the SPEAK group's sustained campaign opposing the building of a new animal lab on that city's South Parks Road—of what she perceived as the "likely or possible risks to animal scientists who explicitly

experiment on animals," she felt somewhat uncomfortable about how to engage with activists "as somebody not making clear a critical position." Eventually she decided to attend a SPEAK rally in Oxford in July 2005 that had been organized to mark the one-year anniversary of the university's decision to stop building work on the proposed animal lab.[14] She reports that she "felt very mixed there, because I was there ambiguously, a bit like I was at the other events":

> So on the one hand I was very moved, in particular by one of the speakers who was talking about his experience of working in an animal lab with primates, and it was very upsetting, it was very distressing to hear what happened to those animals, and the way he described it you could not but be moved by these stories. But at the same time somehow it wasn't an open debate. So I didn't come away feeling resolved about what I thought, but I knew I had somehow to make that present in the project.

The last point is in many respects the crucial one: "I knew I had somehow to make that present in the project." Her expectations were perhaps unrealistic (an animal rights rally is not the most likely forum for an "open debate" weighing the arguments for or against animal experimentation), and her actions (taking notes and photographs) apparently caused some concern. Asked whether she was a journalist, her reply that she was an artist may not have been the most reassuring one, and she was probably wise to resist saying (as she had to the ratters and scientists) that she was interested in conducting "aesthetic experiments" with rats! Nevertheless, the point of the research was to feed into her work, to make those ideas "present in the project."

As with many aspects of the performance lecture *One Night with Rats in the Service of Art*, this is done with both a lightness of touch and with surprising shifts of tone that betray little if anything of her discomfort. "I joined the rally to hear what was being said," she begins. "It was like a summer fete where the cakes were all vegan." Within half a dozen lines, however, the lecture's language has changed markedly:

> Here we are, our bodies protected over the years by vaccinations and drugs most of which were probably tested on animals. . . . My body, your bodies,

are a charnelhouse; stacked in it are the corpses of millions of rats and mice and guinea pigs and fish and birds and cats and dogs and primates used by doctors and scientists over hundreds of years.[15]

These shifts of tone, and the jolts that they can occasionally deliver, are made possible by the episodic and almost epigrammatic structure of the lecture. Its circlings, refrains, and juxtapositions belie the artist's clarity of purpose.

The Rat Fair . . .

Early on in the lecture, Kimbell asks in relation to her proposed *Rat Evaluated Artwork*: "Could it be beautiful as well as disturbing, as well as problematic, as well as funny, as well as politically incorrect, as well as entertaining as well as compelling as well as unusual as well as shocking as well as all the other things that projects like this can be?" Its complexity and instability were simultaneously its strength and its weakness. And returning to the REA midway through the lecture, its precariousness becomes more apparent: "If these visits to labs and rat shows and protests were research, the knowledge I was producing was rapidly erasing the *Rat Evaluated Artwork.*" As her worldly advisers from various rat worlds had advised her, the problems with having busy decision-making rats scurrying around a tubular maze in front of a gallery audience were multiple. Rats are nocturnal and "'not known for having a Protestant work ethic,' as one scientist put it." She also began to question whether it was "acceptable to have live animals on display in a gallery for the consumption of audiences," quite apart from the question of what she would do with the rats after the show.[16]

The idea for a more ambitious project with rats "came directly out of the *Rat Evaluated Artwork*" and prompted Kimbell's early visits to rat shows and conversations with scientists. "I was initially thinking there would be a live event, a performance lecture live event with some rats in it," she has said, but a series of conversations with Camden Arts Centre led to an invitation to stage some kind of rat event as part of its plans to draw in a wide public on a summer public holiday weekend. This was to be the *Rat Fair*, an event distinct from but directly related to the performance lecture.

The *Rat Fair* drew about 450 visitors who, between them, brought along forty of their own rats. A kind of affectionate spoof on rat shows, it was reviewed in positive terms by the editor of the National Fancy Rat Society's magazine *Pro-Rat-a*,[17] and attended not only by ratters but also by a wider public that was by no means limited to the center's usual audience. Intended to be "more fun" than a typical rat show, where "the major activity . . . is *judging*, having a table with a white-coated judge and having this system of evaluating each of these rats,"[18] the *Rat Fair*'s attractions and activities included rat face painting (on human faces), a Rat Beauty Parlour (Figure 2.3), and a "Where's the nearest rat?" map of Camden. Items for sale included what the editor of *Pro-Rat-a* called "wonderful knitted garments with holes designed in them for rats to snuggle in," but as her review acknowledged: "The 'Is your rat an artist?' competition was the chief focus of interest" (Figure 2.4).[19]

Figure 2.3. "Rat Beauty Parlour" at Lucy Kimbell's *Rat Fair,* Camden Arts Centre, 2005. Photograph courtesy of the artist.

Figure 2.4. "Is Your Rat an Artist?" Drawing competition at Lucy Kimbell's
Rat Fair, Camden Arts Centre, 2005. Photograph courtesy of the artist.

. . . and Nineteen Rat Drawings

The "Is your rat an artist?" competition invited participant ratters at the
Rat Fair playfully to explore the extent to which their own rats might have
unrecognized artistic potential. A webcam was suspended over what the
review in *Pro-Rat-a* called "a large pen . . . filled with wood chip, Perspex
tubes and wooden objects which rats liked to stand upright on to try to
peer over the sides."[20] This "drawing area," as Kimbell calls it, allowed each
rat to operate "as a kind of computer mouse" producing a drawing that was
"literally a trace of where the rat moved." These drawings were then judged
by Jenni Lomax, director of Camden Arts Centre (Figure 2.5), to decide
which one should win "the world's first Rat Art Award."[21]

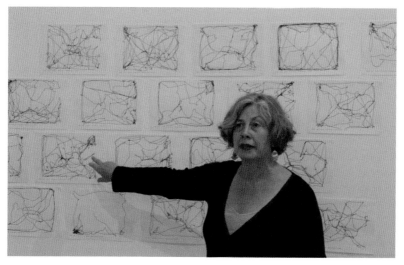

Figure 2.5. Jenni Lomax judges drawings at Lucy Kimbell's *Rat Fair*, Camden Arts Centre, 2005. Photograph courtesy of the artist.

For Kimbell, this is not just an exercise in absurdist aesthetics: she doesn't actually regard the rats as artists, as such, but each rat's agency is of some significance. Unlike a computer mouse, the rat "makes the decisions herself. She chooses her own path." In that sense, Kimbell interestingly remarks in the lecture, the drawings "are perhaps best thought of as portraits of curiosity. . . . Openings, tunnels, corridors and holes are all of interest to the artist-rat."[22]

Kimbell's subsequent thoughts on the drawings and the "system" that enabled their production illustrate the complexity of her engagement with the whole project and of the place of living rats in that project. Of the nineteen drawings made at the *Rat Fair* over four or five hours (each rat being given around ten minutes to move at will around the pen), she says:

> I can't really see the drawings on their own, as objects, without seeing the enclosure, the webcam above it, the fact that that's attached to some specially written software, and remembering the way that I worked with a particular young designer group, called Something, and a rat owner, Sheila Sowter, and her rats, to prototype and test it. The drawings are the output of that, but I think of that whole system as a piece. It was led by me, but involved collaboration: I couldn't make it on my own.

The *status* of the drawings themselves is certainly wide open to conflicting interpretations. The animal historian Jonathan Burt, who was close to completing his monograph *Rat* at the time of the *Rat Fair*,[23] was invited by Kimbell to be a respondent at the Camden version of her performance lecture, and in conversation the following year he reflected on the relation of the "Is your rat an artist?" drawing system to other rat-related art that he discusses in his book. He praised the project as a whole as "a piece that worked very well with rats . . . being built around the particularity of the creature," not least because "the rat is a route-finder that spends its whole time moving through networks"—a point that he acknowledged had much in common with Kimbell's own mode of operation in this project.[24] But in drawing an analogy with the *MEART* (Multi Electrode Array aRT) project developed in the early 2000s, he expressed certain reservations concerning the nature of the art being produced in both cases.

"MEART—the Semi Living Artist," as described on the website of the SymbioticA Research Group that developed and hosted it, "is a geographically detached, bio-cybernetic research and development project exploring aspects of creativity and artistry in the age of new biological technologies."[25] Summarizing the project in *Rat*, Burt explains that it involved "radical hybridization of rat and machine." Neurons from an embryonic rat cortex in Atlanta, Georgia, were stimulated by a webcam filming the movement of gallery visitors, and a signal was sent by computer from the stimulated neurons to a robotic arm that then "draws pictures" in Perth, Western Australia, which the rat neurons back in the United States could "see" through further input they received. As Burt notes, however, the animal body is here so "completely disarticulated" that "it probably makes little sense to talk of the rat in this instance."[26]

The link between *MEART* and Kimbell's "drawing system" is simply that rats figure in both and that "drawings" are produced by both. Like Kimbell, the SymbioticA group seems fascinated by possible scenarios "in which science and art are integrated," as Burt puts it. Although he insists that he intends no criticism of Kimbell's wider project, Burt's observation is that in both of these unusual examples of drawing-production "the art is really quite simple, because it's just a response to movement."[27] But Kimbell's rat-generated drawings are *not* in any very useful sense "the art" in *One Night with Rats in the Service of Art*. And in contrast to what Burt

sees as the rat's effective absence from the *MEART* project, the presence of rats—or rather art's making-present of rats—will turn out to be central to Kimbell's project.

On the question of the conceptual shift from the original idea for the enclosed *Rat Evaluated Artwork* to the *Rat Fair*'s "open" drawing system, Kimbell responded as follows to the challenge that the latter seemed little more than a physical manifestation of the former, but *without the confining tubes*:

> Yes, except it's less stupid. The point about the REA is that it's ridiculous, whereas the "Is your rat an artist?" drawing system is not ridiculous, and also it inherits directly from science. Of course, all evaluations inherit from attempts by institutions to capture and define and constrain activity of different kinds, so the REA *is* a kind of scientific mechanism, but the "Is your rat an artist?" drawing system came directly from seeing the Morris water maze being used with an overhead camera and some specific scientific software for watching and tracking how an animal moved, what segment it spent most time in, and so on.

The Morris water maze, designed by the neuroscientist Richard G. Morris, is still widely used as a behavioral procedure to test rats' spatial memory. In the experiment, a rat that has been given drugs such as receptor blockers is repeatedly lowered into a small circular pool of water that has no local cues such as scent traces, and its attempts to escape by finding a submerged platform are tracked on camera prior to analysis of the progress of its spatial learning.[28] Kimbell makes the point that her own nonwatery enclosure is thus "a direct appropriation from a scientific technology which is well tested and has been used extensively within experimental psychology," and that this is one of the means by which the worlds of the scientists and the ratters are juxtaposed in her project.

Thinking further about the relation of her two rat "art" environments—the REA and the "Is your rat an artist?" drawing system—she acknowledges certain points of connection, ranging from stupidity to the entanglements of agency. Of the drawing system, she concedes "it is a *bit* stupid," and after a pause in which she thinks back to the REA's proposed "diversions and decision points" both for rats and for humans, she resumes:

Yes, no, it *is* similar, because also definitely built into "Is your rat an artist?" is the idea that software *and* human *and* rat agency are all involved and intertwined and you can't separate them, because the owner is trying to entice the rat to move in a particular way, maybe, or some of them sat there trying to hover by the edge to reassure their animal that it was OK, and then the rat was maybe a bit nervous and lurked in that area, you can see that clearly in some of the pictures, the rat is just hanging out in one area, that's because their owner or human companion was there. And in the REA, it's the same, the human audience would have some impact on the rats, even though it's enclosed.

The difference between the pieces, in the end, comes down to the shift in Kimbell's thinking about rats themselves. Still on the subject of the REA, she continues: "But actually, now I know more about rats, they wouldn't like being in there, so it is impossible, given my current sort of 'ethical' position if I had to define it." The difference, in other words, is that for her as an artist in 2005 the "Is your rat an artist?" drawing system was *makeable*, whereas much as she still hankered to find a way to make it, the *Rat Evaluated Artwork* was not.

Aesthetics, Beauty, and Ethics

One of the decision points—the "ridiculous" decision points—in the proposed *Rat Evaluated Artwork*'s tubular maze is a junction where one route suggests that the rat has decided that this artwork entails "ethical dilemmas" and the alternative suggests that it entails "no ethical dilemmas" (Figure 2.6). And near the end of the performance lecture, Kimbell asks of the REA (though with little sense of them being remotely answerable questions): "Could it work aesthetically but not ethically? Could it work ethically but not aesthetically?"[29]

In conversation, similarly, she uses the terms *ethics* and *aesthetics* with caution. This is partly because the *One Night with Rats in the Service of Art* project doesn't have an explicit ethical agenda, and partly because the kind of artist she considers herself to be is not, first and foremost, a visual artist—a point that also has relevance to her ideas about beauty. Asked about what kind of aesthetic dimension there might be to the rat drawings

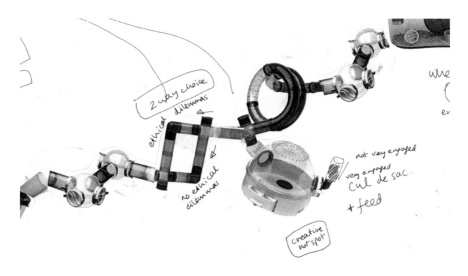

Figure 2.6. Lucy Kimbell, *Rat Evaluated Artwork* (detail), 2005.

and to the REA, she responded: "I never really have a clear idea what aesthetics means." Nevertheless, she acknowledged that in "adding these layers of reflexivity, and criticality, and messiness" within many of her projects— qualities that in her view "actually don't find a lot of success within the art world, but social scientists completely love them"—her work certainly does "have an aesthetic."

This became clearer in her response to a supplementary question about whether ideas of beauty had any place in her work. Unlike other contemporary artists whose work on animal themes, though often far from conventionally beautiful, is strongly motivated by a conviction about the beauty of the animals themselves, Kimbell is clear that in this project she "wasn't interested in asserting some beauty in the rat." As she explained:

> I have a strong interest in beauty but I see it as made manifest in sets of relations. . . . I doubt that I used the word beauty when I talked to the ratters or the scientists. I presented them with my ambiguities, my uncertainties, my anxieties, and I used this word *experimental* which I referred to in the talk, so, "aesthetic experiments," that was my little loose label, but not beauty, because that would be, I imagined, a step too far for them, to see beauty in these relations that I was imagining and building.

Here, interestingly, beauty is understood as something that can indeed be *made* by the artist, but made from not-knowing, from vulnerability, from precariousness. The idea is not dissimilar to Isabelle Stengers's comment on an audience's "wonder" at "the skill of a dancer, understanding how close her gracious moves take her to the risk of falling down, seeing in the dance how close together the double possibility of harmony and failure come." And for Stengers, the individual's figuring out (and acting out) of how to proceed in such circumstances—which "is always . . . a selective and demanding creation"—is as close as she wants to get to a "definition" of ethics.[30] In the question period after the Goldsmiths lecture, Kimbell herself commented, "I tried to show how perplexed I was *in the doing*," and when asked directly about ethics and aesthetics her response was "I don't know what I mean by these terms" and, more than that, "I don't want to have an answer to what they are." If any single remark epitomizes both the confidence and the integrity of her project, it's probably that one.

Cold Language, Warm Language

Meeting Kimbell for the first time in 2004, while she was still in "Stalinist super-project mode," there were no clues that an attentiveness to the emotional power of language would come to lie at the heart of her performance lecture. Her "charnelhouse" metaphor has already been remarked on, but it's preceded in the lecture by several comments about science's linguistic distancing of the animal body. She comments on a PowerPoint slide showing "a small creature, alive, but alive for science. Ordered from a catalogue, No Name animal, an instrumentalized animal." She notes the Charles River company describing itself as a "'provider of animal models.' Not animals. Animal models," and she remarks more generally on language that allows scientists to "maintain a distance from the live flesh they work with. In lectures some scientists refer to an animal prepared for a demonstration as a 'surgical preparation' instead of a rat."[31]

The form of Kimbell's lecture gives her an opportunity directly to counter this scientific usage with what might best be described as *warm language*. There are numerous examples, most effective when they're least expected. The list of facilities she had visited ends with the comment:

"Gated communities of scientists and live and dead bits of science, hearts still warm in their hands." And flicking through pages from the Charles River catalog, she observes: "Rats, it seems, don't really exist in science, although there are millions of hot breathing bodies boxed in laboratories all over the world."[32]

What Kimbell is doing here is nothing as straightforward as deliberately aligning herself with an animal rights position, or indeed of adopting a simplistic antiscience position. It is a matter, rather, of attending to the distinctive modes of operation that her status as "a practice-based researcher" made available to her. This can perhaps be shown most clearly through contrast with an academic approach to similar material. In his book *Rat*, for example, Burt observes:

> there is a parallel between the rat fancy and the development of rat breeds for laboratory science; not only are they two sides of an interconnected practice, but at present fancy rats derive mainly from laboratory stock. Thus scientists manipulate the rat's body for purposes of experimentation, while devotees and admirers of the rat do so for purposes of exhibition and personal satisfaction. In both instances, the aim is to create an "ideal" rat, whatever the purpose.[33]

Kimbell may find little with which to disagree in this passage, but her own commentary on her direct experience of individual scientists and individual judges at rat shows finds more complex and (for want of a better word) humane common ground between them, and works to deny her audience any easy opportunity to demonize them. Of the very first rat show she visited, she reports: "The judge's comments punctuated the day. Good tail. Good head and ears. Let's have a look at you then. Cooing, hello sweetheart. Good tail. Good type. Ooh I do like you as well. Ooh you are a messy boy, poo all over you." Elsewhere in the lecture she speaks of being in one laboratory with a rat, "sweet in its box, enjoying being handled by the professor, enjoying being caressed and stroked and cuddled, here, did I want a go, did I want to hold it? I held science in my hands."[34]

This use of an embodied or embodying language, which has the general effect of making present (even in their physical absence) the rats'

aliveness, is, Kimbell acknowledged, "quite deliberate." In response to a comment about its further effect of making human responsibility to the rats evident, she agreed: "Yes, absolutely, I was conscious of that when I was writing those things." Sometimes the strategy is as simple as asking the same question of herself as of the rat. The sentence in the lecture that follows "I held science in my hands" reads: "Actually it looked pretty small and I wondered how would it cope if I was able, if I was allowed to make the REA and get rats to crawl through it. How *I* would cope."[35]

To borrow the words of the human geographer Nigel Thrift, from his essay on the practice rather than the abstract principles of ethics, this is a matter of the artist "allowing affects themselves to communicate, as well as ideas." Thrift acknowledges the practice of research to be "a profoundly emotional business" that is frequently experienced as "a curious mixture of humiliations and intimidations mixed with moments of insight and even enjoyment," especially when it involves encounters or interactions with others.[36] In exploring "what a 'good' encounter might consist of," he is fiercely critical of the "tapestry of ethical regulation" that leads university ethics committees—contrary to every creative impulse of research practice—to assume "that there is only one way of proceeding" and that their proper role is "to render the ethical outcomes of research encounters predictable."[37] In praising, instead, forms of improvisatory research practice that "perform a space of thoughtfulness and imagination,"[38] his words again come remarkably close to describing the encounter staged in Kimbell's performance lecture.

The Work of Loss

The artist notes that "rats do not live long in human years" and that discussion of illness and death "is part of the way ratters talk to each other," but her own introduction of the notion of "loss" relates to the work that she sees *One Night with Rats in the Service of Art* setting out to do. And she's quite clear that "it is doing some work":

> It's trying to expose the audience not just to the thinking process, but to the lack-of-thinking process that's involved in a project like this. . . . so it's

aiming to take an audience through a story of the cycles of knowing and not knowing that are involved in making something, and the reflexivity is important to show the sense of looking at it at the same time as doing it. It requires work from them to go through that narrative with me when I'm telling the story but also to do the work of coping with the ambiguity, because I don't answer various things. . . . It maintains this ambiguity, which is I think very much part of art and design practice. . . . And it is a kind of work, I offer them a loss: I'm saying, I can't do this project, here's a project I'd like to do, I can't do it, and I'm not going to do it, here's lots of reasons, and you can't have it either.

She is talking here most directly about the *Rat Evaluated Artwork*, of which she says toward the end of the performance lecture: "It's a piece of work I want to make but am not able to make. I can't make it because I can't put live animals into a gallery piece, to make them into this kind of spectacle . . . and anyway they would sleep, or sit in the corner instead of wandering round. It wouldn't work."[39]

Immediately before showing images of the *Rat Fair* in the lecture, she posed the question of whether she could show "rat as rat" rather than as pet or as scientific model, and whether it would be possible to bring together the "knowledges" of these very different rat worlds. The answer, in her view, was itself an enacting of loss: "Because the *Rat Fair* is the answer, the event was the answer, and if you didn't go, then, you get something from the images but it's not the same as being in that room in that moment, in its *liveness*." Much the same was true of the delivery of the performance lecture: "The liveness of that *is* the answer, that *there is no answer*, and that you can't really separate them"—the answer and the impossibility of delivering it more fully—"they're entwined, like we're entwined with the animals, and the science is entwined with the ratting world even though they might not have a direct dialogue."

A Place of Ambiguity

Once the decision had been taken that the *Rat Evaluated Artwork* could not responsibly be made—because any living rat it used "would still be

an instrumentalized animal. Rat for art's sake"—why did the project as a whole continue to be called *One Night with Rats in the Service of Art*?[40] Kimbell says of the title:

> I like it because it suggests there might actually be rats *there*. It brings that fear, so it is provocative. I think "in the service of art" is useful because I'm ultimately claiming this as an art project and therefore there is a home for it. I'm not saying it's philosophy—it has a home, so I name that home. It seemed right . . . and it makes me laugh.

One Night with Rats in the Service of Art might be said to be the sum of its entanglements. It is purposeful, curious, and comfortable enough with the limitations of its grip on things. "I wonder what knowledge, if any, was produced here?" the artist muses toward the end of the lecture. "What came out of these aesthetic experiments?"[41]

Reflecting on Kimbell's project, Burt has said: "It's not confused, that's not the right word, it's crossover, it's mixed, its directions in the end are uncertain, but the reason isn't the project, it's because of the animal that she's chosen":

> The rat as a figure, in terms of the history of its representation in the West, is something that cats through things, and collapses a lot of boundaries, and also *unpicks* language and thought. . . . What she's doing, in the end, is reproducing something that's quintessentially what the history of the rat has always been about, which is erosion, and in a sense this creature is determining much more the project than even she is perhaps appreciating.[42]

His nagging discomfort with the project's open-endedness is something that Kimbell might appreciate, but would not necessarily share. In its aims, at least, *One Night with Rats in the Service of Art* is modest, and exploratory: it is not, to borrow Thrift's words again, "some grandiose reformulation of the whole basis of western moral thinking." But it may indeed have some relation to the "new ethical spaces" that Thrift envisages arising from attempts, "often for a very short span of time, to produce a different sense of how things might be, using the resources to hand."[43]

For Kimbell, accepting and embracing the space of her own not-knowing about rats served as just such a resource. There is a moment in the performance lecture when she says something very telling about one particular encounter with a scientist. Taken out of that specific context, her comment effectively encapsulates how her practice-based approach might engage—and allow others to engage—with the experience of the more-than-human world: "What I had to do at that point was hold open a place of ambiguity and be there in it."[44]

On "Ethics"

"ETHICS DOES NOT EXIST," writes Alain Badiou. "There is only the *ethic-of* (of politics, of love, of science, of art)."[1] Recent French philosophy has been much concerned with the problem of "ethics." In an essay first published in 2003, as part of the focus in his late work on the unhappy history of the animal in philosophy, Jacques Derrida stated directly that it "takes more" than an ethics "to break with the Cartesian tradition of the animal-machine" that has so thoroughly permeated cultural and philosophical attitudes.[2] Years earlier he had already acknowledged the problem that even the most "provisional" morality may serve only "to give oneself a good conscience."[3] Ethics, he suggested, is all about selfishly calculating the extent, and thus the limit, of one's obligation to the (human or animal) other.

Similar arguments are developed in Badiou's book *Ethics*, which argues that ethics has become "merely the province of conservatism with a good conscience."[4] As such, Badiou contends that although the word "has today taken centre stage" in politics and popular thought, it in fact amounts to "a threatening denial of thought as such," compatible with "the self-satisfied egoism of the affluent West" and whose "final imperative" to others is: "Become like me and I will respect your difference."[5] Like Derrida's contempt for the easy "good conscience" of ethics, Badiou writes of it promoting a "cowardly self-satisfaction" and—in a comment whose

implications for animal life could hardly be clearer—he notes that "at the core of the mastery internal to ethics is always the power to decide who dies and who does not."[6]

The problem is that ethics (at least as it's conceived by these two leading philosophers) is about regulation, control, holding back, *not*-doing: the avoidance of irresponsible action. The alternative (as both of them acknowledge in passing, without elaborating on the idea) is to be found in some kind of poetic invention, creative action, and imaginative recognition of unregulated possibilities.[7] And this, of course, is very close to Jean-François Lyotard's conception of the role of the postmodern artist, whom he enigmatically describes as someone "working without rules in order to formulate the rules of what *will have been done*."[8]

This is why the focus of the present book is principally on the diversity of artists' practices and on the particular forms of their responsible and imaginative engagement with these questions, which will often be reconsidered and reshaped in each new encounter or interaction with animal lives. It is grounded less in the paraphernalia of academic debate than in detailed descriptions of how artists think and work—a topic overlooked in much theoretical writing on art and aesthetics, and one whose relevance to questions of ethics has hardly begun to be recognized.

3

Vivid New Ecologies
Catherine Chalmers and Eduardo Kac

> I have seen these humans in their disarray. . . . Disorder stalks
> them day and night. They stalk it back.
> —Verlyn Klinkenborg, *Timothy; or, Notes of an Abject Reptile*

IN "REGARDING NEW ANIMALS," an essay on the animals in the artist
Allison Hunter's photographic series *New Animals*, Branka Arsić specu-
lates that "in order to see new animals, photography itself had to change."
The "radical gesture" of Hunter's large-scale color chromogenic photo-
graphs, Arsić suggests, is "the way she turns the moment of 'taking' a pho-
tograph into an act of freeing" by taking "an already photographed animal
out of its photographed context" (usually an outdoor zoo) and relocating
it "on the surface of a non-identifiable space" (Figure 3.1). Whether that
space is a vast field of ambiguously nuanced light or of dense darkness,
Arsić proposes that it "marks a collapse of the anthropocentric symbolic,
pointing to a space in which a human finds itself at a loss to read it." These
swathes of colored ground do not, for Arsić, represent environments that
humans already "share" with animals, but instead present or constitute "a
new intensity humans will have to learn how to inhabit."[1]

 Part of the interest of these observations lies in the assertion that it's
the medium of photography—or at least its innovative deployment—that
is able to bring to light these "new animals." In this chapter, the attitudes
and working methods of two artists whose work includes photographic ex-
amples of what Arsić calls worlds "utterly new and unknown" to humans
are discussed and juxtaposed.[2]

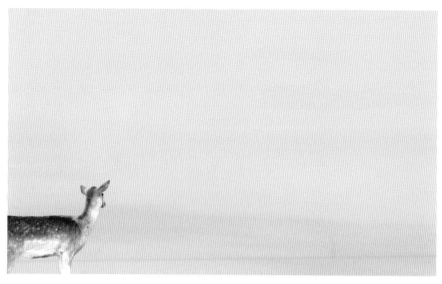

Figure 3.1. Allison Hunter, *Untitled #3*, 2005. Digital chromogenic print from the *New Animals* series.

One of those artists is the Chicago-based Eduardo Kac, whose *GFP Bunny* project, involving the creation of a fluorescent transgenic rabbit named Alba, achieved considerable notoriety in the 2000s. Along with other aspects of his work, something further is said here about Kac's thinking around that project, but without simply rehearsing the familiar debates on the ethics of his actions. The other artist is the New York–based Catherine Chalmers, and her *American Cockroach* project is one focus of discussion here. Like Kac, her work has an engagement of sorts with the world of science and is directly concerned with imagining alternatives to the ways in which humans habitually think about their relation to other animals, not least cockroaches. The chapter includes an exploration of the conceptual and photographic spaces for "new" animals and new animal thinking in their work—spaces that, in the case of both artists, come to be inhabited by actual living animals.

In the two preceding chapters, Olly and Suzi were seen to be concerned with being in close proximity to wild animals in those animals' own environments and to embody that immediacy of experience in their image making, while Lucy Kimbell strove to embody through her narrative and her voice the experience of different groups of people's engagement with

one particular species. In both cases, albeit in unconventional forms, there was a documentary dimension to these artists' work: a reporting (and reflecting) on phenomena that deserve attention. In the work of Chalmers and of Kac, that dimension—that engagement and attentiveness—leads them toward a more direct reshaping of animal worlds and of the look of animals.

In the Difficult Middle of Things

I spoke to Chalmers in her large loft studio in SoHo, which at the time of my visit sustained an ad hoc ecosystem for all the animals with which she had been working—cockroaches, mice, snakes, rhinoceros beetles, a praying mantis, spiders, lizards, salamanders, an African claw frog, and a panther chameleon of which she was particularly fond. She was still exhibiting work from her major *American Cockroach* project, the book of which had already been published,[3] and was in the process of filming the fictionalized narrative of her *Safari* video, which she envisaged to be the final project that would involve cockroaches before she could finally take them out of her studio once and for all.

In *Safari*, which was being filmed on a specially constructed set in her studio (Figure 3.2), a cockroach is "returned" to a wholly imaginary "wild" where it encounters other species that would never meet in any single natural environment: flies, the rhinoceros beetles, "hopefully a spider," reptiles, amphibians, caterpillars, and more. Chalmers explained: "I was interested in taking this animal that has become 'the villain'—in our scenario of domesticity we see it as being the worst of the animals that live with us—and I was interested in putting it back out into the wild and seeing how we feel about it then." In this sense the project has something of the exploratory nature of Kimbell's work with and about rats—trying things out to see what happens and to see how they may or may not affect human preconceptions of the species.

Chalmers continued: "And so *Safari* essentially follows the roach as it comes out of the primordial sea on to land for the first time. And once in the 'wild' it discovers an ecosystem where the scale becomes ambiguous. It's roach scale but it's also large" (Figure 3.3). Here there's an indirect echo of Robert Adams's thoughts on the "reconciliations with geography" in

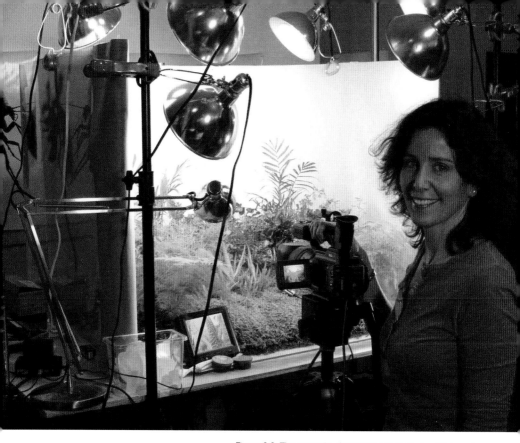

Figure 3.2. The set of the *Safari* video in Catherine Chalmers's New York studio, 2006. Photograph courtesy of the artist.

those photographs by Minor White that "deny the viewer clues to size"— not only Adams's comment that the sea "offers a final liberation from human scale" but also his observation: "If the whole of creation can be found in its smallest fragment, why not try to suggest this by withholding indications of scale?"[4] Chalmers's interest in questions of scale, however, is rather different: "The way I'm shooting it, everything has a grander presence than we would normally associate with wild animals that are only, say, two inches long. And once it's in this fictitious ecosystem that I've created for it, it discovers some of the high dramas that we associate with the megafauna on the African plain"—animals toward which Western viewers are typically far more sympathetic. The effort involved in exploring that shift in sensibility was, however, immense. Chalmers had at that point already

Figure 3.3. Catherine Chalmers, *Safari,* video still, 2007.

recorded over forty hours of footage for what would eventually become a seven-minute video.

Some months later I spoke to Kac in his studio in Chicago. He had moved into it so recently that on our journey there from the city center we took a couple of wrong connections on the "L." Given the nontraditional nature of Kac's art practice, this was, he said, the first proper "studio" that he'd had. Apart from a huge metal-topped table running down the center of the room, the space was almost entirely empty. He was working (though not in that space) on a new transgenic art project at that time, which was due to be exhibited at the Weisman Art Museum about six months later, but he was wary of saying anything at all about it: "I'm focused on the work, like right now, I don't know what's going to happen afterwards, I cannot even tell you exactly what's going to happen *in it,* at this point, and we're so close to it. . . . Things can still change." The piece already had its title—*Natural History of the Enigma*—but it would in fact be another two and a half years before the museum's official announcement of its premiere in April 2009.

Both artists, therefore, were speaking at a point where they were engaged with new projects that were still in the difficult process of taking shape, and of finding their form. Both conversations, unsurprisingly, therefore reflected on the nature of the artists' creative practice and its relation to the wider world, as well as touching on previous projects. Both of them have in the past explained the seriousness of their engagement with social or scientific agendas, as well as making plain their concern with the welfare of the living animals that are sometimes corralled in their work. Speaking specifically about the *American Cockroach* project, for example, Chalmers has emphasized that she takes pains "not to hurt anything" in staging her far-from-natural dramas.[5]

Kac has in the past described his art as "philosophy in the wild,"[6] and is probably best known for pursuing this art-as-philosophy through transgenic art: "a new art form based on the use of genetic engineering to transfer natural or synthetic genes to an organism, to create unique living beings."[7] In the case of *GFP Bunny* this involved the creation in a French laboratory of an albino rabbit whose entire body glowed green under a blue light of a particular nanofrequency. As is well known, Kac subsequently pursued a determined but fruitless campaign to get the lab to release the rabbit, Alba, so that she could live out the rest of her life with the artist and his family in Chicago, as he had intended (see Figure 3.4). Kac's comments about the attitudes that inform that work are clear. In contrast to the one-way relationship of power that's evident in what he calls "corporate genetic engineering," he argues that the artist's responsibility is "to conceptualize and experience other, more dignified relationships with our transgenic other."[8] Of Alba herself he wrote: "I will never forget the moment when I first held her in my arms. . . . She immediately awoke in me a strong and urgent sense of responsibility for her well-being."[9]

Assertions of seriousness and responsibility are of course important in relation to art that makes use—sometimes highly controversial use—of living animals. But no matter how counterintuitively, it is also important to acknowledge that such art may be serious without necessarily being exactly *purposeful*: in other words, it may only have one eye, at most, on a different or better future for humans or for other animals. More needs to be said about this.

Figure 3.4. Eduardo Kac putting up one of seven posters from the *GFP Bunny: Paris Intervention* that were pasted widely around the city in December 2000.

Wavering around the Animal

Contemporary art's approach to the animal need not always be ruthlessly practical or even particularly clear about its purposes. Artists, like any kind of creative thinkers, need the space not to know what they're doing, and to trust that not-knowing as they negotiate its necessary confusions. To borrow a phrase from Wendy Wheeler's writings on biosemiotics and creativity, it involves "the non-instrumental and passionately interested following of hints and hunches."[10]

An example of this frame of mind is found in a fine detective story called *Seeking Whom He May Devour* by the French writer Fred Vargas. The author describes the working method of her central character, the shambolic *Commissaire* Adamsberg: "Adamsberg never thought actively," she writes:

he found it quite sufficient to day-dream and then to sort his catch, like a fisherman scrabbling about clumsily in the bottom of a net and finally picking the prawn out of the mess of sand, seaweed, pebbles and shells. Adamsberg's thoughts contained plenty of seaweed and sand, and he didn't always know how to avoid getting caught in the mess.

He used his brain, Vargas suggests, "like an ocean that you trust entirely to feed you well, but which you've long ago given up trying to tame":

> "Dunno" was among the most frequent of Adamsberg's utterances. He fell back on it neither from laziness nor from lack of wits, but because he really did not know the right answer and was ready to admit it. . . . Wavering was Adamsberg's most natural element, . . . and his most productive by far.[11]

It is entirely possible to take an investigative approach without its being consciously purposeful, and in certain respects it might be said that Kac and Chalmers share such an approach with the fictional Adamsberg. More generally, an important part of what the present book is edging toward describing, in terms of how artists engage with ideas of the nonhuman animal, is precisely a wavering: art as a means of *wavering around the animal.*

Art is not in any necessary or simple sense an issues-focused or future-focused activity. To put this another way, if contemporary art is approached with the expectation that it *is* unerringly purposeful and future-focused, there's every chance of missing what it actually has to offer, both for the present and for the future.

The question with which I usually start an interview with an artist is this: "How would you describe yourself?" Chalmers answered as follows: "Human, female, interested in art and ice-skating . . . sports and arts, science too I guess." Science gets into the answer, but almost as an afterthought. Nor is her work about adopting future-oriented environmental or political stances. "The earth is something that we need to pay attention to," she acknowledges. "I can have that as an underlying fabric for all that I do, but the work is an exploration into the nonhuman, it's not to make political stances . . . the work for me, art for me, is a way to explore the world." It's a way to get beyond the experience of her California childhood,

where "there was really no wider connection to nature than the front lawn, and my dog." Her sense, however, is that the adoption of an overt environmental stance would limit her work: "The work really is about going places I've never been."

Reviewing her video *Safari,* Steven Stern noted in *Time Out (New York)* that the film "doesn't have a message—certainly not one that could be reduced to a position paper or an Al Gore–style 'truth.' Nor is it a call to action." It was first shown in the group exhibition *Ecotopia* at the International Center of Photography, and as Stern observed: "The video is oblique, depicting the natural world as utterly alien, yet strangely alluring. Successful art responds to social issues by complicating rather than simplifying them; the value of such projects lies precisely in this ambivalence."[12] Chalmers acknowledges that the land scenes in *Safari* "have been put together like an abstract painting; it's just line, form, color, movement— there's no natural history logic." She describes her animal work as explicitly operating "in the art category, as opposed to the nature category," and confirms: "I never really think about work to convey issues. So, what they convey always comes out afterward. What it *means,* I see after the work comes out."

When Kac was asked, at the start of our conversation in his studio, how he would describe himself, his answer was this: "An artist. That's it, really." Despite the fact that his various bio-art projects—which are of course only one strand of his art practice—often adopt and to some degree subvert recent medical or scientific procedures and technologies, such as the use of a jellyfish gene to track the development of cancers introduced into the bodies of laboratory rodents and rabbits, Kac is not operating as a scientist. Eugene Thacker has argued, with some justification, that Kac's work has little to do with biological life or the life sciences, but is more about the practice of art as an "emerging" medium.[13]

This is evident in Kac's own account of his efforts to keep the *GFP Bunny* project "indeterminate enough." It doesn't have a fixed aim, or end point, or intention. And for all it is regarded as indefensible by many (but not all) advocates of animal rights, its sheer *being-there* is arguably its real strength as an artwork.[14] As Kac remarked about this project as a whole and about the rabbit at its center: "It's not there to cause cancer, it's not

there to cure cancer, and this is why it's so hard for people to reconcile, she simply *is*. And it's so simple. . . . It's so clear as to be opaque to a lot of people." The fuller context of this striking remark will become apparent later.

Curiosity and the New

Some potentially interesting correspondences have begun to emerge in contemporary writings on the notion of the "future" and its relation to ideas about creativity. At the end of Neil Shubin's 2008 book on human evolutionary history, *Your Inner Fish*, the author writes: "Looking back through billions of years of change, everything innovative or apparently unique in the history of life is really just old stuff that has been recycled, recombined, repurposed, or otherwise modified for new uses. This is the story of every part of us."[15] Glossing this in terms of its relevance for history, culture, and education, Wheeler writes: "Nothing comes from nothing. The past, and its recursive creative reworking in the present, is all that we have for making the future."[16] Fran Bartkowski's *Kissing Cousins: A New Kinship Bestiary* rather similarly welcomes "the rebirth of curiosity— a motivating force that comes from the sense that we do not have all the answers and that, in fact, what moves us along into the future are the questions we pose."[17]

That idea of curiosity was also picked up a few years ago in the British psychoanalyst Adam Phillips's essay, "A Stab at Hinting." He wrote: "If curiosity . . . is always in the service of the new, of the old renewed, then it is always revisionary, making futures out of the past. It is turning orders into hints, and following them up."[18] And this, of course, is close to Wheeler's delight in "the non-instrumental and passionately interested following of hints and hunches," mentioned earlier. This emerging picture of art, curiosity, and innovation as hunch-driven combination and recombination evokes nothing so much as the spirit of Jim Dine's remark from the 1960s, already noted in the introduction: "I trust objects so much. I trust disparate elements going together."

"Everything innovative . . . is really just old stuff . . . recombined, re-purposed," **says Shubin**. Along with those other quotations, this seems to have a direct **bearing on** how it might be possible productively to think

about animal futures, and indeed about art's animal futures. Those futures may indeed be about "disparate elements going together," and trusting in that. In *Kissing Cousins,* which considers human, and animal, and human-animal interrelatings, Bartkowski writes:

> We are, I think, misguided to engage discourses of purity in an age of chimeric realities. . . . Cross-species medical technologies, transgenic identities, and other chimeric beings force us to rework, rethink, rewrite our epistemological categories. . . . These "hot zones" of contact, connection, and conflict between humans and our closest animal kin reward contemplation and speculation for the ethical and intimate issues they raise.[19]

Donna Haraway has of course long called for her readers to attend to such interactions. Identifying those caught up in these interactions as "figures," she explains: "Figures are not representations or didactic illustrations, but material-semiotic nodes or knots in which diverse bodies and meanings coshape one another." She goes on: "For me, figures have always been where the biological and literary or artistic come together with all the force of lived reality. . . . In every case, the figures are at the same time creatures of imagined possibility and creatures of fierce and ordinary reality: the dimensions tangle."[20]

Creatures of Imagined Possibility

Can an object, such as a work of art, be a "figure" in Haraway's sense? Can Dine's picture of the artist *trusting in objects* extend to artworks that comprise, or incorporate, or manipulate "unique living beings," to use Kac's phrase? There's every reason to think so. A potentially useful art historical approach to this question is offered in Stephen Bann's 2007 book *Ways around Modernism.*

Thinking back to the debates in the 1960s about the "literalism" of freestanding artworks ranging from minimalist sculptures to Robert Rauschenberg's goat-centered *Monogram,* Bann writes: "The problematic status of the liberated 'object' has proved to be one of the recurrent issues—perhaps even a defining issue—that marked the shift from modern to postmodern." Although the space in which this confrontational

object is encountered is one that also includes the "beholder," as Michael Fried famously put it, Bann makes the important point that this distinct and privileged "art" space "was in no significant sense 'real.' It was a symbolic space that had been secured by the efforts of the nineteenth-century avant-garde."[21]

The word that Bann introduces to address the specificity of this apparently literal object in a less than literal space is *curiosity*. But unlike the earlier remarks in this chapter about curiosity—and unlike, say, John Cage railing against worthless value judgments as a distraction from what he saw as the artist's "proper business, which is curiosity and awareness"[22]—Bann is thinking primarily of *the* curiosity, of curiosities in the sense of the traditional cabinets of curiosities put together by collectors in past centuries. Tracking what he calls "the heritage of curiosity . . . in order to clarify its applicability to some of the most individual art of the present period," he notes the archbishop of Florence's complaint in 1450 about the painting of "curiosities . . . which do not serve to excite devotion, but laughter and vanity, such as monkeys and dogs, and the like." In the period following the Renaissance these "monsters on the margins," as he puts it, acquired a space of their own in the collector's cabinet.[23]

The significance of this newly-attended-to class of objects, Bann implies, lay less in *what* they were than in *how* they did or did not convey meaning. Distracting the collector from "ascertaining general laws about the properties of the natural world," Bann says this of the curiosity, or "the 'unique' object," as he calls it: "It encourages the tendency to abstruse and even perverse forms of knowledge, rather than favouring the progress of science." Unlike scientific knowledge, or "useful knowledge," he suggests that "the dynamic of curiosity veers in the direction of art. In other words, curiosity alerts us to the interface between art and science, with the 'object' being suspended somewhere between the two."[24]

Alert to the contemporary resonances of this hard-to-fix-ness, he proposes that "it is the edgy relationship of curiosity to science (as indeed to art) that makes it significant as a harbinger of postmodernism," and, in a phrase that perhaps inadvertently echoes Kac's definition of art as "philosophy in the wild," he goes so far as to suggest that the postmodern "'return to curiosity' . . . emphasizes the role of the artist as a wild custodian of realms of knowledge previously relinquished to the scientist."[25]

Kac himself offers an example that links Haraway on the entanglements of the "figure," and Bann on the curious, unique, suspended object. It's an example where the emphasis is less on the appearance, the look, of the individual animal, the future animal, than on the rendering-imaginable (if not exactly visible) of its interrelatings with its human kin. It concerns a photograph that does not exist.

Recalling his original ideas for the development of the *GFP Bunny* project, Kac told the following story, occasionally interrupting himself to explain its context:

> One thing I wanted to do, though—this was a project that was not realized—I had this idea of going with Alba and Ruth and Miriam to the photo studio—of course, it's my work, I'm controlling the shot, I'm directing the shot, but I would be in the photo. We would be doing a pretty standard traditional family photograph, with Alba though, under the proper blue lights with the yellow filter mounted on the lens of the camera, so we would be seen in whatever light would allow itself to be seen, but she [Alba] would glow, so we would be this really unusual family photograph of four mammals, one of which happens . . .

Here he breaks off to explain: "We're all transgenic as you probably know at this point—humans have always been transgenic, not made in the lab, but nevertheless we have absorbed genetic material from bacteria and viruses, in our genome, so we do have genetic material that comes from nonhumans, in our genome." And then he's back to his account of the photograph: "So basically this would be a family of four transgenic mammals, except that one of them happens to glow in the visible length of the spectrum, because you probably know that we glow as well." There then follows an explanation about the infrared warmth given off by the human body:

> There are reptiles that can see that, so we don't really know what it's like for them to see, but they can see the infrared which means that for them we don't have this really clear contour. We have more of an aura-like contour, or fusion with the surroundings; they detect that. So, it would be a photograph of four transgenic glowing mammals except that one would glow

in the visible spectrum and the other three would glow in the nonvisible spectrum—nonvisible for humans, that is.

What seems most interesting here, in this example of a photograph that can't actually be seen (as it doesn't exist) but can certainly be envisaged, is the artist's determination to figure out *how to make visible* new and non-hierarchical ways to envisage humans alongside animals, juxtaposed, re-combined, repurposed.

There's a phrase that Haraway uses in *When Species Meet* to describe Barbara Smuts's initial difficulties in studying baboons in Kenya in the 1970s. The baboons were apparently baffled by the then inexperienced scientist's behavior, and Haraway speculates that they may have seen Smuts as somewhat like themselves, but not quite matching their expectations. She sums it up in the neat phrase: "I imagine the baboons as seeing somebody off-category."[26] And the thing that seems so engaging about Kac's extraordinary anecdote about the photograph he could never take is that it presents an example of an image in which *everybody in it*—rabbit and humans—is seen off-category. This doesn't necessarily have to be theorized in terms of posthumanism. As Haraway says of herself: "I am not a posthumanist; I am who I become with companion species."[27]

It's at this directly personal level that Chalmers describes sharing her working space with the animals she uses: "Art is built around fiction. But in terms of our wider relation to nature at this point, it's *all* a fiction, because without us . . ." She trails off, then offers examples of what she sees as the randomness of human choices in terms of what humans try to re-create or reintroduce in nature. "So it's all a fiction now . . . what's natural now anyway?" She comments that her panther chameleon will tell her what's natural to *it*. "I go by them, what they seem to need. I will build a habitat for them . . . making them as comfortable and as healthy as possible."

Noting that she could, if she chose, resell the twenty-odd animals that she had bought from reptile and amphibian breeders to use in making the *Safari* video, for example, she says:

> But I don't, I keep them, and they live out the rest of their life, like the snake over there was one I used for a shoot—probably four years ago. I did the shoot in probably four days, but it comes down to the fact that I enjoy

living in a more diverse ecosystem on a daily basis, creating a more rich environment in the studio, here where I am, where I'm working.

The pleasures of living alongside animals and the pleasures of making art in this unlikely ecosystem are linked: "Being around them, living around them, is part of where your ideas come from. I enjoy working on drawings and looking up and having my snake looking at me—in downtown New York City."

The exceptions to this Edenic picture are the cockroaches. "Older than the dinosaurs," as she notes, they continue to disturb her. She had only a few left for use in the *Safari* video, the majority from the *American Cockroach* project having been fed to the frogs as part of the ongoing life of her studio ecosystem. But, she says, "there's something about the 'aura' of roaches that still gets to me." She tries to explain it by comparison to the effect of particular colors:

> You have these unconscious emotions that come off from the experience of being surrounded by red, or whatever the colors are. And I think I feel differently, walking in here, being surrounded by animals that I look at and go, "oh, look at that, that is so cool," as opposed to walking in with the roaches there. I hate to say it but they're a bit of a downer, even removed from the context of being scavengers off of us. There's something about them in particular that on some weird sort of level I think is a *dark* presence.

Responsibility, improvised kinship, and fear seem inextricably entangled here. The seriousness and honesty of Chalmers's remarks call to mind a comment by Smuts that Haraway quotes with approval in *When Species Meet*: "'Closely interacting bodies tend to tell the truth.'"[28]

All You Need to Justify the Photograph

There is a significant issue here for art because, as Kac notes, images of animal futures sometimes don't tell *any* kind of truth. Asked whether he would agree that the "meanings" of the iconic chimeric animals of contemporary

science—such as the mouse with an ear on its back—are perhaps generated principally by the people most offended by their creation, rather than by the scientists responsible for their creation, he responded with an impassioned explanation of what he saw as the considerable cynicism that can inform the use of such images. Noting that scientific research is now "very much market-driven" and that much of it is funded by particular companies, he commented:

> Part of the point of a lab, a university lab or otherwise, divulging this kind of imagery *is* indeed for it to circulate in the media, to drive up the stocks of the investor. It doesn't really matter to what extent the piece is successful, and we know that we're always going to get that meta-narrative: "oh this is going to cure, maybe, this may one day possibly lead to a path towards the beginning of a cure for cancer," you know we're always going to get that line. And that's all you need to justify the photograph, and to skyrocket or at least spike the stocks of the investor.

Whether the research led to any scientifically successful outcome was "secondary," because the rise of the stocks was "what it's really all about." In this regard, "the reaction of the public, feeling repugnance, does not affect the stock of the company." And here he gave the example of ANDi.

ANDi was the first genetically modified primate, born (in a research center in Oregon) a matter of months after Alba, his genetic material having been modified in exactly the same way as hers. This rhesus macaque was the final result of over two hundred attempts to modify the genes of unfertilized macaque eggs that also produced forty embryos and five pregnancies. Even then, the experiment was not wholly successful: his hair roots and toenails should have glowed green under fluorescent light, but didn't. His birth was nevertheless blithely described by one of the scientists involved as "an extraordinary moment in the history of humans."[29]

Kac spoke with some contempt of the cynical use made of the image of a genetically modified primate "that *did not even glow*"—not least because he had monitored for himself the state of the company's stock immediately before and after "the announcement of ANDi." As he pertinently observed:

And will a GFP chimpanzee that does not glow *really* lead to the possibility of the beginning of a cure for cancer? No, it won't. In a very general way, the more you understand about genetics, everything helps everything else, but the line just doesn't stick in such a straight way.

In contrast, the point of Kac *as an artist* working with this same technology on the creation of Alba, a rabbit whose whole body had been engineered to glow green, was that Alba was thus rendered useless to science, irrecuperable by science (Figure 3.5). As he explained:

> This is one of the things I find interesting about *GFP Bunny*: it's not there to cause cancer, it's not there to cure cancer, and this is why it's so hard for people to reconcile, she simply *is*. And it's so simple. But because none of these meta-narratives are there, and by not being there they also expose the mechanisms of what these polar meta-narratives do, then it's difficult. It's so clear as to be opaque to a lot of people.

Figure 3.5. The classic image of the glowing Alba from Eduardo Kac's *GFP Bunny* project, 2000.

ANDi, on the other hand, had in Kac's view failed *as science* but could still be hailed as the future because the relevant and reassuring "meta-narratives" of scientific progress and medical promise were securely in place.

Crossings of Speed and Slowness

Turning back to Chalmers and to *American Cockroach*, of the book's three photographic series it is *Impostors* that is in certain respects the darkest and most difficult. It's the series in which the artist seems most directly to address her own fear of these creatures. The imagery is hallucinatory, visceral. It's an imagery of unfathomable dread, of terror tinged with beauty, and not—as it might first appear—of a beauty that's merely tinged with terror. The flora and fauna of this strange blue world recall the complaint of a character in a Tom Robbins novel about his hateful experience of the "sticky, buggy, rainy" environment of the Amazon jungle: it's just "too damn vivid."[30]

"What are the aesthetics of our sympathies?" Chalmers asks. In setting out to explore this largely neglected question, she imagines a world shorn of human sympathy and certainty and morality (despite her determination, in the staging of these dramas, "not to hurt anything").[31] It is a world, an ecosystem, where nothing is familiar, where the scale of things is again hard to figure, and where plant and insect—aloe and aloesaurus—are in cahoots, in alliance, bound up in the same deception, whose purpose and whose ends remain unclear (Figure 3.6).

The preposterous fuzzy-backed thing in *Sweet Veronica (Portrait)* is perceived as doing precisely what humans often cannot bear animals to do: it is waiting, looking—*looking at the viewer* (Figure 3.7). The gaze is inescapable; its effrontery intolerable. Here insect and artist are at one: photographing these scenarios with a macro lens from a distance of only inches, Chalmers offers a "roach's-eye view" that momentarily eschews human identity and control. "I like getting into where I can't see myself," she has revealingly remarked.[32]

The artist has spoken of her fascination with those points "where the natural world and the cultural world cross," but there are crossings of speed and slowness at work here too, marking out a precarious equilibrium between artist and animal. As the cockroaches are placed on the flowers and

Figure 3.6. Catherine Chalmers, *Aloesaurus,* 2004.
Photograph from *American Cockroach.*

Figure 3.7. Catherine Chalmers, *Sweet Veronica (Portrait),*
2004. Photograph from *American Cockroach.*

foliage of the studio set, and begin to stir from their artificially chilled sleep, Chalmers has to judge with care the pace of her own movements. Artist and camera moving slowly and deliberately, mindful that any too-sudden movement may cause the creatures to panic, she readies herself for the moment "when they are acting like roaches. That's what you want."[33]

Kac also has to think in terms of speed and slowness, pace and patience, in relation to the development of his work. "I work in slow cycles," he observes. Although the cycles overlap, it generally takes him two to three years to develop a piece. With the transgenic works such as *Natural History of the Enigma*, "because I am inventing a life-form that is literal, that is alive, but doesn't exist prior to the work . . . there's nothing I can do to expedite it—you can't expedite pregnancy, you can't expedite germination, life has its own rhythm, and you have to work with it, so even after everything is set in motion, from that point on you have to wait."

Patience is central to Chalmers's working process. Referring to *Molting (under Motherwell)*, a photograph from the *Residents* series, she explains: "Well, it's according to their biology—that one there in the art collector's living room is when they're molting . . . it's that rite of passage . . . it's a very beautiful process, and it's strangely mysterious" (Figure 3.8). But therein lies the difficulty:

> When I have to capture an event like sex or birth or molting, it's like walking out on the street with a camera expecting to find somebody murdered in front of you—it just doesn't happen, you wait forever. . . . you're actually working with the biological processes of the animals—that is where it really becomes difficult. . . . So these very basic things we take for granted, to actually work with the animal or try to film it or photograph it is where the frustration and the patience come in.

Given the investment that both Chalmers and Kac have made in the exploration of the space and the pace of the nonhuman, it would be easy to bring other rhetorics into play here in order to characterize their immersive creative practices: Gilles Deleuze and Félix Guattari's "You are longitude and latitude, a set of speeds and slownesses between unformed particles, a set of nonsubjectified affects,"[34] for example, or Hélène Cixous's "One must be able to live according to the slow seasons of a thought."[35]

Figure 3.8. Catherine Chalmers, *Molting (under Motherwell)*, 2004. Photograph from *American Cockroach*.

But that would be to romanticize work that is, for much of the time, experienced by these artists quite differently.

Chalmers makes this plain. Asked whether she'd managed to turn her patience, and all this waiting, into something that fed positively into her art practice, she answered: "No, it's just exhausting, it's sheerly, mind-numbingly exhausting to be working with an animal that's nocturnal, where you're trying to capture *a moment.*" She gives the example of trying to photograph the cockroaches mating: "I had a month, I got *one* mating. One. And that's staying up all night, under *their* conditions, with no light on, because they don't see red light, so I had just red modelling lights, which means I could barely even focus, and no, they didn't mate, nothing . . . I got one."

The focus of the present chapter, through the example of Chalmers and Kac, has been less on what art's imagining of future animals or animal futures might look like than on what being an artist with an eye on both the past and the future might feel like. Working in strange light and at slow speeds, caught up in biological cycles whose pace can impose limits on creative intervention, thinking through the relation of visibility and invisibility, they offer less a glimpse of the future than a sharper picture of the present, and of how the available view of the present can all too easily be narrower than it appears.

After interviewing Chalmers in New York, we caught a train together back up the Hudson Valley. From time to time she dipped into the novel she was reading, Verlyn Klinkenborg's *Timothy; or, Notes of an Abject Reptile.* The novel imagines the life and thoughts of Timothy, the real eighty-one-year-old female tortoise living in the eighteenth-century cottage garden that belonged to the English curate Gilbert White, author of *The Natural History of Selbourne.* Klinkenborg's fictionalized narrative is very much concerned, as Chalmers recognized, with the nature and the narrowness of human vision. At one point Timothy asks herself this of the humans around her:

> How do I escape from that nimble-tongued, fleet-footed race? . . . The true secret? Walk through the holes in their attention. . . . Quickness draws their eye. Entangles their attention. What they notice, they call reality. But

reality is a fence with many holes, a net with many tears. I walk through them slowly.[36]

Chalmers already had in mind at that point a film she wanted to make in the future about leafcutter ants in their natural habitat in Central America. By February 2011 she was in Costa Rica working on the film.[37] As she wrote on her Facebook wall: "Surrounded by fast moving ants and slow moving sloths. Paradise."

On Artists and Intentions

WRITING IN THE FIRST ISSUE of the online humanities journal *nonsite.org*, Walter Benn Michaels makes the case that for the past fifty years the demand that artists be "unconcerned with producing an effect on the beholder" of the artwork has been "at the heart of aesthetic theory and a great deal of the most advanced aesthetic production."[1] Whether or not that particular claim is justified, it certainly doesn't apply to the work of the principal artists discussed in this book. These artists, working with varied motivations and often unaware of each other's work, cannot be said to adhere to what Michaels calls this "new theoretical anti-intentionalism." They would probably share Roland Barthes's view that artworks should not be "blustering,"[2] but they would also go along with something close to Félix Guattari's uncompromising assertion of art's purposefulness, when he wrote in *Chaosmosis*: "The work of art, for those who use it, is an activity of unframing, of rupturing sense."[3]

So, if these are artists who do have a clear sense of purpose, how is that actually manifested in the work that they make? Without getting mired in the familiar debates about the relevance of artists' intentions, it's worth noting Victor Burgin's comments, in his 1983 essay "Seeing Sense," on a photographer's "recognition that there is something 'there' to

photograph." He writes: "*It is neither theoretically necessary nor desirable to make psychologistic assumptions concerning the intentions of the photographer*; it is the pre-constituted field of discourse which is the substantial 'author' here: photograph and photographer alike are its products and, in the act of seeing, so is the viewer."[4] This is a fairly familiar poststructuralist stance, but it's significant that Burgin chooses to articulate it specifically in relation to what he identifies as sexist and racist elements in some of Garry Winogrand's photographs (including one featuring a human–chimpanzee juxtaposition). "Such 'isms,'" Burgin notes, "*in the sphere of representation*, are a complex of texts, rhetorics, codes, woven into the fabric of the popular preconscious."[5] The argument against individual intention works well enough here, but in large part because the example in question is that of an artist trading in stereotypes, which could hardly be further from Guattari's conception of art as "an activity of unframing, of rupturing sense."

A particularly fruitful and attentive account of intention is found in the chapter on Picasso in *Patterns of Intention,* where Michael Baxandall explicitly states that "'intention' is a word I shall use as little as possible."[6] He does, however, think of artworks themselves as "purposeful objects," so his use of the word *intention* refers "to pictures rather more than to painters." "Intention is the forward-leaning look of things," he announces.[7] This is not a piece of abstract thinking but the result of observation: "In painting a picture the total problem of the picture is liable to be a continually developing and self-revising one. The medium, physical and perceptual, modifies the problem as the game proceeds. Indeed some parts of the problem will emerge only as the games proceeds." This, Baxandall notes, "is intuitively obvious to anyone who has made anything at all," and he continues: "A static notion of intention, supposing just a preliminary stance to which the final product either more or less conforms, would deny a great deal of what makes pictures worth bothering about. . . . It would deny the encounter with the medium and reduce the work to a sort of conceptual or ideal art imperfectly realized."[8]

Several points are worth drawing out from this. Baxandall's idea of intention as a forward momentum sits comfortably alongside Wendy Wheeler's sense that any kind of creative inquiry is characterized by "a general confidence."[9] It also represents a shift in attention: attending to the

integrity of practice, and attending to the *object*. It's the object, and not the artist's "intention," that is both the site of the work's getting-done and the thing that shapes the work's getting-done.

I learned this myself, most directly, working collaboratively with the London-based artist Edwina Ashton on the development of a large installation for the *Animal Nature* group exhibition in Pittsburgh in 2005.[10] As the project falteringly took shape, Ashton occasionally grew frustrated by my relentlessly ideas-oriented approach. Ideas, she suggested, could all too easily pose what she called "the wrong questions—certainly for making things." There's a photograph, somewhere, of me trying to write while wearing some particularly ungainly gloves that she'd made as part of an animal costume. Preoccupied by the material impediment that they posed, the focus of my attention had to shift: "You're guided by an object rather than by any kind of intention," she observed.[11]

4

Of the Unspoken
Mircea Cantor and Mary Britton Clouse

> Moral thought gets no grip here.
> —Cora Diamond, "The Difficulty of Reality and the Difficulty of Philosophy"

> There is no moral vision. There is only the ordinary world which is seen with ordinary vision.
> —Iris Murdoch, *The Sovereignty of Good*

IT WILL BE CLEAR by now that one major hypothesis of this book is that careful attention to artists and their objects may in itself suggest ways around some of the more entrenched attitudes found in discussions about art, animals, curiosity, and creativity, and that Jim Dine's notion of trusting "disparate elements going together" is one way to approach this.[1] The present chapter again concerns trust and its absence, and moves toward an account of the work of the artist Mary Britton Clouse and the Justice for Animals Arts Guild by means of a description of some objects, some elements, that perhaps do not go together so readily. It is a story, of sorts, about awkward spaces, hapless birds, and mismatched discourses.

Three Objects That Don't Fit

In March 2009 I spent an hour and a half one early afternoon in gallery 3 of Camden Arts Centre in London—the same building that staged Lucy Kimbell's *Rat Fair* a few years earlier. Gallery 3 is a well-lit rectangular space on the upper floor, with large windows along two of its four walls. On that particular afternoon, sunlight flooded across the floor. At the end of the gallery farthest from the entrance a concentric arrangement of three circular, gold-painted, bell-shaped cages made up the structural frame of

the Romanian artist Mircea Cantor's installation *The Need for Uncertainty* (Figure 4.1). The installation was part of a more extensive exhibition of his work, under the same title. It had been shown in a slightly larger gallery space at Modern Art Oxford the previous year. At Camden, however, the diameter of the largest cage, at about thirty feet, was greater than the width of gallery 3. It had therefore been necessary to slice a segment off that cage; the severed bars intersected rather awkwardly with the flat surface of the gallery's windowless long wall.

This artificial environment was the habitat for one peahen and one peacock for the exhibition's eight-week run, as it had been for a similar period in Oxford the previous year. The whole caged circular floor space was covered in thick clear polythene sheeting, which was itself covered in

Figure 4.1. Mircea Cantor, *The Need for Uncertainty,* 2009. Installation view at Camden Arts Centre. Courtesy Yvon Lambert, Paris and New York. Copyright Mircea Cantor.

a thin layer of wood chips. Two large and gold-painted wooden branches had been installed as perches between the bars of the cages. One, near the window bay at the far end, ran between the outer and middle cages, and the other, just inside the middle cage on the slightly darker window-less side, was close to the bowls of food and water provided for the birds. Nearby, in the narrow space between the gallery wall and the middle cage, was some fairly dense cover, about two feet high, provided by what looked like discarded Christmas trees. This was clearly added during the exhibition's run: Camden Arts Centre's own installation shot, seen in Figure 4.1, shows the birds to have been there before the cover was.

For the first forty-five minutes or so that I stood quietly in the gallery, occasionally talking to the attendant, the birds were completely hidden from public view by this small area of cover. The attendant observed that the birds looked "very regal" when they used the perch at the back of the space. I asked whether they made a lot of noise. "They haven't started calling," was the reply. "They just do a bit of scurrying." Within minutes, some quiet whistling sounds were followed by the appearance of the peahen, scurrying, flapping her feathers and moving fast across the middle space, briefly launching herself a foot or so above the ground before foraging in the wood chips. Moving between the middle and outer cages, and very occasionally poking her head though the bars of the outer cage, her head twisting around, she seemed curiously attentive not to the humans in the space but to the light coming through the windows, or the view of the sky through them. The peacock later appeared, his train of feathers extending a good four feet or more beyond the length of his body. The attendant had "never seen him display" his feathers. In the two fairly narrow circular corridors between the three cages, it looked unlikely that there would have been space for him to do so.

Conscious of the controversy, or at least the questions, that may be raised by the inclusion of living birds in an art exhibition, Camden Arts Centre had prepared two information sheets to assist viewers of this particular installation. One began: "The peacocks in this exhibition are receiving the best possible care," and went on to reassure visitors about the nature of the welfare arrangements that had been put in place, referencing the RSPCA, London Veterinary College, and other specialists who had been consulted. There was a certain defensiveness to its tone: the gallery was

"taking all responsible steps" to ensure the birds' welfare; the birds were in any case "not wild birds, they were bred on the farm and are accustomed to being in a pen"; and, viewers were assured, "the size of the largest cage is in excess of the minimum required."[2]

It was only in the other information sheet that the issue of whether it's justifiable to incorporate and incarcerate even the most "well cared for" living animals as part of an art installation was addressed, and even then, only in terms of citing precedents from the 1960s, which had been restaged in major London galleries in recent years, such as Jannis Kounellis's tethered horses.[3] The unstated implication was that with that sort of aesthetic pedigree, the ethical credentials of Cantor's installation were more or less beyond reasonable question. Mary Britton Clouse—the artist and animal advocate whose own work is discussed later in this chapter and who was one of many who opposed Cantor's exhibition—certainly read the gallery's use of such precedents in that way, pointedly remarking: "I guess Kounellis continues to be the gold standard—it's easier than thinking."[4]

What were Cantor's own views? An essay in the exhibition catalog opens with a statement from the artist, which includes this observation: "There's a lack of trust about everything. We want to prove, to know, to be certain. There is an inflation of the value of certainty; we need the opposite. This is where artists can play a role."[5] In Cantor's view this role is sometimes best fulfilled by saying nothing about the work. In a 2006 interview in *Flash Art* he stated: "I think that today, to write something about one's work is easy. It's more difficult to refuse or to keep the silence. And it is much more difficult to understand, talk and communicate about one's work. Nowadays the term communication is one of the most abused."[6]

Given his reluctance to direct viewers toward any particular reading of his work, it's somewhat baffling that the gallery's literature disregarded the trust and the silence spoken of by the artist, and instead confidently instructed readers that the two live peafowl "represent the idea of migration and displacement," and that the "configuration of cages refer to worlds within worlds, and the limits we all set ourselves—both visible and invisible."[7] The basis for these readings is not explained (and possibly not even explicable, since, as Britton Clouse observed, Indian Blue peafowl are not in fact migratory birds).[8]

A different kind of directive reading or "lack of trust" was to be found in some of the opposition to the use of living animals in this installation. A formal letter of complaint from Jan Creamer, chief executive of the organization Animal Defenders International, stated:

> I am appalled by the use of live animals in this "art" exhibit to demonstrate the limitations on freedom. These peacocks are in a barren, sterile environment, deprived of any interest or enrichment. . . . Camden Arts Centre should be ashamed of itself for using living animals in this trivial and crass way.[9]

I became aware of Cantor's London exhibition halfway into its run, having been copied into e-mail correspondence between animal advocates in the United States who sought to gather support for the closure of the exhibition, or at least for an open debate in London about its ethical shortcomings. My visit was prompted by the fact that I was not prepared to be drawn into that correspondence without having seen the exhibition. These e-mails (from advocates who had not seen it) expressed outrage and distress in a forthright manner. The comments—"This is appalling!"; "I do hope that real artists and art critics will protest to these scumbags!"; and "How utterly conventional these 'art' people are"—give a sense of their tone. And as these comments suggest, disapproval of the use of living animals in art was sometimes complexly entangled with a deep skepticism about contemporary art and a widespread mistrust of artists.

Words and art do not sit comfortably together here, either for the representatives of the art or for the advocates. Their perspectives and their vocabularies seldom correspond, or intersect, or meet, and both too often overlook the artist's nonverbal engagement with his "materials," which in this case include living animals. On the question of those materials, there is no readily available evidence to suggest that Cantor's installation is in his own view *about* peafowl (in the way that, for example, Eduardo Kac's *GFP Bunny* project was undoubtedly intended by the artist to be about rabbits and what's done to them in the name of science). But this is not necessarily to say that Cantor's birds must therefore be there as symbols of something else. They're part of the artist's available range of materials, as Cantor seems to acknowledge in this observation about his attitude to

shaping the exhibition as a whole: "It's a question of how to translate ideas that have nothing necessarily to do with the material."[10]

The scenario, in short, is one of voices talking *past each other* rather than to each other. On the one hand, the gallery is saying "it's art," but in case you're worried, "it's been approved by the RSPCA." On the other, the animal advocates are saying "it's just wrong." And somewhere in the middle, or the background, this particular artist is saying "I'm saying nothing" or, if pushed, "it's about materials." This is "not so much a case of disagreement as disconnection," as Cary Wolfe has concisely remarked of a related example of philosophical noncommunication.[11] The pressing question that remains in relation to the responses generated by works such as Cantor's installation is how to turn, or to reframe, these mismatched voices into something that more closely resembles a conversation. It's a question about *how* to write about contemporary animal art in these circumstances. The present book addresses that question, but may not necessarily answer it.

Tim Stilwell (co-organizer of the 2008 London symposium and exhibition *The Animal Gaze*, where the exhibition included an earlier work by Cantor) has said of *The Need for Uncertainty*: "What's at stake is the banal zoo relationship between human animal and other animal—the usual disagreeable arrangement."[12] But having spent some time with the installation, my impression was that the experience lacked the gaunt misery of many zoos. There was no noise, no smell, just the rule of the visual that's so familiar in the white cube of the contemporary gallery, which seemed all the more melancholy given that the loud vocal crowing that might ordinarily be expected of peacocks in the spring months had failed to materialize, failed to disrupt the polite calm of the gallery.

A few days after my visit, a Sunday newspaper published a feature titled "Why It Pays to Be Alone with the Truly Great Works of Art."[13] *The Need for Uncertainty* isn't one of those (Stilwell's assessment of it as "unexceptional" is closer to the mark), but it was worth spending time with it. While I was there, only one other visitor came in, who left within a matter of seconds. What I experienced for that hour and a half, as the only visitor in the gallery, was certainly an artwork, but was also the habitat and some of the behavior of two particular birds. Had I traveled to London to see the birds, or to see the art? Both. Was it possible to distinguish my looking at the art from my looking at the birds? Yes. Did the two experiences jar?

No, not particularly, but neither did they enhance each other. Do I now have a view of its merit as an artwork? That will probably be evident from what's written in these pages, but it seems more relevant to point again to John Cage's words about aesthetic value judgments: that they are distractions from and destructive to "our proper business, which is curiosity and awareness."[14]

The sawn-off cage in the Camden installation calls for one last comment. Writing about *wonder* as "the moment of illumination . . . between the subject and the world," Luce Irigaray explains that wonder "goes beyond that which is or is not suitable for us," and beyond what can be made straightforwardly meaningful in human terms: "an *excess* resists," as she puts it.[15] That little phrase "an *excess* resists" calls to mind Camden Art Centre's defensive assurance that in *The Need for Uncertainty* "the size of the largest cage is in excess of the minimum required." But that's a non-Irigarayan excess if ever there was one: an excess that precisely *doesn't resist*.

At stake, here, are questions of calculability, in relation to the "three objects that don't fit": the outer cage and the two birds. The size of the outer cage and its relation to the size of the birds have been calculated to within inches of the legal minimum, but the size of that same cage seems not to have been calculated in relation to the size of the gallery it occupies, which it doesn't fit. Yet this is nothing so simple as an ethical fit and an aesthetic lack of fit. Creamer's reading of the cage—"a barren, sterile environment, deprived of any interest or enrichment"—suggests that for her and for many others it is wildly miscalculated as an ethical fit. The improvised slicing and splicing of that same cage with the gallery wall, however, shows an artist with the ability to shrug off the concerns of the calculable. It's the sense that this improvisational generosity has not been extended to the birds themselves that suggests that the whole piece (and not just the size of the cage) is not as expansive, not as trusting, and not as productively unfitting as it might have been.

Two Perspectives on Art's Distinctive Work

When it comes to thinking about human attitudes to other animals, why should the evidence of contemporary art be of interest? One answer would be that it's of interest because of what art does, or at least what it *can do*: as

Félix Guattari uncompromisingly wrote in *Chaosmosis*, "The work of art, for those who use it, is an activity of unframing, of rupturing sense."[16] But if this makes the work of art sound like a form of philosophical intervention or argument, then wariness is called for. It may be that art has its own distinctive work to do.

This point is acknowledged by some philosophers, though usually in relation to poetry rather than the visual arts. Jacques Derrida, of course, in "The Animal That Therefore I Am," notes tantalizingly briefly: "For thinking concerning the animal, if there is such a thing, derives from poetry. There you have a hypothesis: it is what philosophy has, essentially, had to deprive itself of. That is the difference between philosophical knowledge and poetic thinking."[17] The point is expanded, though without direct reference to Derrida, in Cora Diamond's later essay "The Difficulty of Reality and the Difficulty of Philosophy." Writing of the fictional character Elizabeth Costello in J. M. Coetzee's novel *The Lives of Animals*, Diamond notes that "she sees our reliance on argumentation as a way we make unavailable to ourselves our own sense of what it is to be a living animal. And she sees poetry, rather than philosophy, as having the capacity to return us to such a sense of what animal life is." This is the work of form, and of the materiality of form, which is perhaps more evident in poetry than in philosophy. And just as the fictional Costello points to the distinctive work of poetry, Diamond insists that Coetzee's novel should not be read (as it has been by commentators including Peter Singer) as though it were a philosophical text, "pulling out ideas and arguments as if they had been simply clothed in fictional form as a way of putting them before us."[18]

Diamond directly challenges the view that Costello's lectures are "centrally concerned with the presenting of a position on the issue of how we should treat animals" and insists: "She does not engage with others in argument, in the sense in which philosophers do." She specifically notes "Costello's rejection of the form of argument that Singer thinks is appropriate, argument which responds to the *therefore*-arguments of those who justify treating animals as we do by their own different *therefore*-arguments."[19]

For Diamond, it seems, these *therefore*-arguments represent philosophy operating within its comfort zone. Of "the discussion of a moral issue: how we should treat animals," she notes, "philosophy knows how to do this." But in doing so it conveniently sidesteps a more immediate and

embodied and *difficult* reality: "Philosophy characteristically misrepresents both our own reality and that of others, in particular those 'others' who are animals." The issue "becomes deflected, as the philosopher thinks it or re-thinks it in the language of philosophical skepticism." It is for this reason that she finds serious fault with "the common and taken-for-granted mode of thought that 'how we should treat animals' is an 'ethical issue.'"[20]

In place of this, Diamond writes, "Coetzee gives us a view of a profound disturbance of soul, and puts that view into a complex context. What is done by doing so he cannot tell us, he does not know." It is this, crucially, that distinguishes him (and the fictional Costello) from philosophers. Philosophical argumentation, Diamond suggests—at least in certain styles of philosophy—is "meant to settle" things, to use her own phrase.[21] Novels and poems are not meant to settle things.

The broad argument of the present book is a similar one. Artworks are not meant to settle things. They are *objects,* things in themselves: not (just) the persuasive illustration of an idea. Adam Phillips, in "Talking Nonsense and Knowing When to Stop," quotes the poet John Ashbery's remark that "the worse your art is the easier it is to talk about," and Phillips goes on to speculate "that making sense, the wish to make sense, can be a species of conformism."[22]

This remark is pertinent to some of the issues raised in the second example to be discussed here. In a very different context to that of Diamond's essay, clear recognition of the distinct character of the work frequently undertaken by contemporary art was expressed in a 2009 anticensorship amicus curiae brief relating to the Supreme Court case of *United States v. Stevens.* Signed by both the National Coalition Against Censorship and the College Art Association, it concerned a section of a federal statute (18 U.S.C. § 48) that makes it a crime to own or display depictions of animal cruelty in a state where the acts portrayed are themselves illegal. Stevens was initially convicted for owning a video documentary about dog fighting, but the conviction was reversed on appeal on the grounds that prohibition of the depiction alone was a violation of the First Amendment. The purpose of the amicus curiae brief was to "discuss the implications for free expression" with direct reference to depictions of animal cruelty in contemporary art, and to urge the Supreme Court to uphold the appeal court's decision "in striking down Section 48 as unconstitutional."[23]

In a notable section of the brief that discusses the "real risk that prosecutors and jurors will fail to recognize the 'serious value' of conceptual and avant-garde art," doubt is cast on the effectiveness of the U.S. government's assurance that works (including artworks) that have "redeeming societal value"—that serve "the social interest in order and morality" and that do not "'offend the sensibilities' of most citizens"—will be exempted from prosecution under section 48. Quite apart from the fact that the value of contemporary art may be found in qualities other than "order and morality," the brief acknowledges the fact that "artists often may refuse to explicate the intended meaning of their art, leaving it up to viewers to take from the work whatever meaning they wish."[24]

Importantly, the brief notes: "Although likely to obscure their work's meaning, the artists' refusal to articulate an explicit message is a hallmark of modern art" from Marcel Duchamp on. It continues:

> By declining to publicly ascribe any message to their creations, contemporary conceptual artists leave viewers free to ponder and debate the meaning and purpose of their work and of art generally, thereby generating ideas without explicitly stating any message themselves. That fact does not deprive their work of First Amendment protection.[25]

Further, it acknowledges that this principle extends to work with "potentially off-putting subject matter" such as Adel Abdessemed's video installation *Don't Trust Me*, which depicts various large mammals "being slaughtered using a sledgehammer." The work's potential to cause controversy or misunderstanding stems from the fact that "Abdessemed does not take a position on the method of slaughter": "He simply provides a visual experience, the import and impact of which will vary according to each viewer's perspective." The brief also notes the opinion of the director of special exhibitions at the New Museum in New York that Abdessemed's "explicit program is to offer no program and no answers."[26]

Abdessemed's reluctance to comment or to explain sounds very much like Cantor's, even if the animal cruelty depicted in *Don't Trust Me* is more explicit and more extreme than that enacted in *The Need for Uncertainty*. But the particular relevance of the amicus curiae brief discussed

here lies in its very public assertion of the importance of the nonverbal (and, by implication, the nonjudgmental) dimension of contemporary art, including contemporary art that addresses questions of animal life. And it's a further demonstration that such art typically takes a form quite distinct from that of the "*therefore*-argument."

Mary Britton Clouse and the JAAG

The issues raised by Cantor, by Diamond, and by the amicus brief, about *what either is or is not articulated,* are brought into sharp focus in the various dimensions of Britton Clouse's work. Her photographic series *Portraits/Self-Portraits* (see Figure 4.2) is at the center of this discussion, but is not its sole focus.

Britton Clouse's art practice is difficult to consider in isolation from other aspects of her working life. Focusing in particular on chickens rescued from illegal cockfights and from other forms of "neglect, abuse and abandonment," Britton Clouse and her husband, Bert Clouse, run an animal shelter from a modest house in an inner-city neighborhood of Minneapolis that also serves as their home and their studio. Founded in 2001, their nonprofit organization Chicken Run Rescue is currently the only urban chicken rescue of its kind. In its first ten years it provided temporary shelter and veterinary care for almost eight hundred birds, prior to finding suitable adoptive homes for them in the Twin Cities area.

Shortly before launching that initiative, Britton Clouse had also become a founding member and the principal spokesperson for a small group of local artists with animal rights sympathies. This was the Justice for Animals Arts Guild (JAAG). Formed in the autumn of 2000, the group's specific aim was to campaign against the use of living animals in contemporary art. The JAAG not only opposes art that involves the killing or cruel treatment of animals but also regards even the seemingly benign use of living animals in the making of an artwork as unnecessary and unwarranted.

From the outset, there were two distinct emphases to the work that this group of artists aimed to undertake. Writing in November 2000, Britton Clouse acknowledged a concern both "to advance the ethic of animal rights through our creative works" and "to negotiate with state arts

Figure 4.2. Mary Britton Clouse, *Nemo: Portrait/Self-Portrait,*
2005. Sepia photograph.

organizations and funding agencies for the institution of policies that would prohibit the inclusion of live animals based on the premise that they are 'beings,' not 'ideas.'"[27]

The fact that the JAAG's members were all artists marked them out from other animal advocates in the very important sense that their campaigning could not easily be dismissed as another mundane instance of the widespread misunderstanding of contemporary art and mistrust of contemporary artists. An early statement of their goals recorded their concern "to sensitize the arts community to the idea that animals are sentient beings, not ideas or inanimate materials with which to create a performance or exhibit," "to prevent the cruel or degrading use of animals in contemporary art work by influencing institutional policy," and "to develop criteria for constructing standards or guidelines to censor *acts* causing direct harm or potential direct harm, but never *ideas.*" It added that their intention was to "challenge the institution sponsoring the offending event rather than the individual artist."

This clear statement that "the individual artist" was not to be the target of the their campaigning was important, but so too, at this early stage, was the JAAG's recognition of the value of "mischief" as one of art's strategies, and the need critically to examine art's claims to "truth."[28] Both views recall Donna Haraway's "argument for *pleasure* in the confusion of boundaries and for *responsibility* in their construction."[29]

One example gives a flavor of the JAAG's engagement with art institutions over the harming of animals in contemporary exhibitions. In 2005 Huang Yong Ping's retrospective exhibition *House of Oracles* was staged at the Walker Art Center in Minneapolis, prior to its showing at MASS MoCA the following year.[30] It included the installation *Theater of the World*, first made in the 1990s, of which the artist wrote in the catalog:

> Is *Theater of the World* an insect zoo? A test site where various species of the natural world devour one another? A space for observing the activity of "insects"? An architectural form as a closed system? A cross between a panopticon and the shamanistic practice of keeping insects? A metaphor for the conflicts among different peoples and cultures? Or, rather, a modern representation of the ancient Chinese character *gu*?[31]

Evidently anticipating public disquiet at the sight of spiders, scorpions, crickets, cockroaches, millipedes, lizards, toads, and snakes devouring each other in the museum, the Walker posted a long text on censorship on its website, seemingly intended both to head off *and to taint* criticism of the exhibit. Part of it read:

> To suggest that Huang's experience of censorship was specifically limited to his years in Communist China would make the case too facile. Since he settled in France in 1989, the artist has been subjected to new forms of censorship, which may be characterized as liberal humanist and (if veiled) racistculturalist. In 1994 Huang's work *Theater of the World* (1993), which features live insects and reptiles, was to be included in the exhibition *Hors-limites* ... at the Centre Georges Pompidou, Paris, but was pulled at the last minute under pressure from the museum staff and animal rights activists.[32]

As Britton Clouse wrote at the time: "How arrogant of the Walker to preordain objections to actually putting animals in peril as censorship and racist culturalism. It precludes any discussion about the ethical considerations that should have been part of the curatorial discussion and subsequent public debate." She also noted how convenient it was for the museum that "only creatures who are excluded from federal care and use standards have been included in the exhibit."[33]

There was in fact substantial public opposition to the use of animals in the *House of Oracles* exhibition, much of it appearing on the Walker's own blog. In contrast to the depressing personal abuse employed by some contributors to that blog, Britton Clouse's contribution stuck to the facts. Challenging the Walker's own claim that the installation had been deemed by the relevant authorities "humane and respectful of the animals involved," she wrote: "I spoke with the animal control officer who inspected the 'Theater' exhibit and she never 'deemed that it was humane and respectful of the animals involved,' she only inspected it for code compliance. Further, had she been aware that the species might prey upon each other she would not have issued the permit."[34]

The extent of public opposition to the display apparently created a change in policy on the part of the Walker Art Center very soon after this. Britton Clouse reported that two performance artists who were planning

to include their dog in a performance at the Walker were advised that this would not be permitted, as the museum would no longer condone the use of living animals in art exhibits or performances "because of the negative reactions to the current exhibit."[35]

Reflecting on this case in conversation in 2006, Britton Clouse acknowledged that the JAAG's early determination to put "standards . . . in place" and to demarcate "lines that should not be crossed" might need to be amended in the light of what the group had learned from the encouraging but "quite shocking" extent of the public reaction to the *House of Oracles* exhibition. In place of the JAAG having its own "hard and fast policy," it looked increasingly necessary "to take into account how the culture needs to play a part in that, because you can't legislate morality, it's true." And "the role of public perception is probably going to be more effective in the long run." The question was therefore how to tap into that—how to frame "the right questions to ask, instead of the answers, you know what I mean?"[36]

Britton Clouse's own clear priority for the JAAG was to maintain public awareness that artists should not do to animals what they wouldn't choose (or be allowed) to do to humans:

> The one thing that I keep coming back to with the whole issue of using animals in a harmful way in creating art is that I really, I *reject* the idea that there should be any opportunity for negotiation about the morality of it because it would never be accepted if they were to do it to humans. So there's already a moral precedent there. We can be there to say that, and to simply restate it until we're blue in the face—maybe that's enough.

Harking back to one of the JAAG's initial aims—"to advance the ethic of animal rights through our creative works"—she also observed, in a more downbeat moment, that "maybe the only *manageable* way is just to seek out like-minded artists and support each others' work."

Britton Clouse's own art practice had, until the mid-2000s, focused primarily on painting, collage, and sculptural pieces including a series of methyl-cellulose cast-paper portraits, one of which takes the form of a self-portrait in which a carefully modeled spent hen's comb runs the length of the artist's forehead (Figure 4.3). It exemplifies her interest in "the

Figure 4.3. Mary Britton Clouse, *Spent Hen: Self-Portrait for Nellie,* 2005. Mixed media.

sculptural aspects of bringing together disparate parts, and incorporating human and animal forms into a three-dimensional reality."

The meticulous use of paper in works such as this draws at least indirectly on skills that she and Bert Clouse employ in a small specialist book and paper conservation business that they also run from their home. (At the time of my visit in 2006 they were working on a commission for the British Library.) Her background in bookbinding and box-making skills is more directly evident, however, in a powerful and very beautiful piece from the 1990s called *What a Surprise* (Figure 4.4).

Britton Clouse has long insisted that her political activism informs her art, and vice versa. More than this, she has directly compared the two

Figure 4.4. Mary Britton Clouse, *What a Surprise,* 1994. Mixed media.

activities: "I think activism, if it's well done, oftentimes is almost like a performance piece, because you need the same creativity, you need the same kind of open-ended approach to be able to roll with the way things unfold. A lot of the same things that make for good art can make for good activism."

What a Surprise shows one way that the two activities might come together. It concerns a court case in which two brothers were unsuccessfully prosecuted for appallingly callous cruelty to cattle, and an ultimately unsuccessful piece of animal welfare legislation that followed from the case. The physical form of the artwork is "a series of nesting boxes" covered with archival material from the case: "I incorporate a lot of real archival evidence

into my work," she notes. In this instance, although the perpetrators of the cruelty were never convicted, the judge banned the publication of the photographic evidence of their actions on the basis of its being "clearly offensive to public sensibilities." This further cruel irony is addressed by the inclusion of that photographic evidence in *What a Surprise*.

The work was exhibited at a state fair, where it won an award, and where people were able to have what Britton Clouse calls "a hold-in-the-hand relationship with the piece." Despite its subject matter, but because of its physical beauty and delicacy, it served as an example of "how to present things in a way where you don't send people off running." The form becomes part of what the work is able to mean. As she noted: "just from a technical standpoint there's a lot of care that *is* conveyed in that piece. And if you take that one step further, that communicates a reverence for *what the thing is about.*"

The question of handling takes a different but equally significant turn in work that Britton Clouse moved toward making in the mid-2000s. As she later explained, "The *Portraits/Self-Portraits* started as a practical task—when I was devising a way to get nice close-up portraits of the birds for our adoption website—to show them as I see them as warm, noble, unique individuals one would want to be close to—not generic specimens." She regarded the chicken photographs, of which there were hundreds, as something quite separate from her art practice. They were made very simply, by her standing in her backyard holding a bird in one hand and her camera in the other. But by chance, and by mistake, she failed in one instance to keep her own face out of the photograph, and found herself confronted by the overlapping faces of chicken and artist. She wrote: "My heart raced the first time I saw the image because I was shocked by it, as if someone else had taken it."[37]

Even then, it was only slowly that she came to realize that the first accidental image—and others like it that were made following her hunch that something interesting might be going on there—might come to find a place as a new element in her art practice. Eventually deciding to use sepia as "a perfect way . . . to show that the bird and I are 'made of the same stuff,'" as she puts it, she commented: "Judging from the reaction people have to the ongoing *Portraits/Self-Portraits* series of photographs, I know they get a glimpse of how I see the birds and it affects them. Their guard is down

because they were looking at art and the truth got in."[38] By this point, as that last statement shows, the images had unambiguously become part of her art practice, and as a result the work that those images could undertake had also changed (Figure 4.5). In Guattari's terms, they unframe things, they rupture sense; in Britton Clouse's terms, they let the truth in. It may amount to much the same thing.

The thing that particularly excited her about the photographs was that they seemed to address the "unjustified apprehension" that many people have "about being physically close to a bird": "They're such an alien species to people, and there's that 'oh, they're dirty and they're scary and they'll peck your eyes out'—and having that physical proximity to my face is an intimacy that I want. There's a level of trust there as well."[39] The title of the whole photographic series was initially *Self-Portrait with Human,* a more resonant and provocative title, but as the artist explained, she quickly decided that "it crosses a line I try very hard to avoid—putting my words in the animals' mouths. I decided that *Portraits/Self-Portraits* works better because it is ambiguous about who is the 'self.'"[40]

In one respect the series might be thought to sit rather awkwardly alongside the JAAG's view that even the benign use of living animals in the making of an artwork is unwarranted and should be avoided. The series is, after all, wholly dependent on the photographic presence of a chicken alongside the artist, in temporary alliance with the artist, huddled together with the artist, and being handled by the artist. And the power of that juxtaposition—of those "disparate elements going together," as Dine has it—is itself wholly dependent on the recognition that these are unfaked photographs, rupturing the sense of human–animal distinctions and hierarchies in a manner that a painting couldn't begin to achieve.

Does the apparent mismatch between the principles of the JAAG and the art practice of its spokesperson make her into some kind of hypocrite? Not at all, not for a moment. Artworks are objects, material things, with their own internal necessity and integrity, their own resonances, and their own work to do. They are not illustrations of moral philosophy. As Diamond has it: "Moral thought gets no grip here."[41] Formal and ethical vocabularies simply turn out not to equate in a context such as this. But for the artist, this need not be experienced as an insoluble contradiction. Britton Clouse offers her own synthesis of her concerns, writing:

Figure 4.5. Mary Britton Clouse, *Daphne*,
2006. Sepia photograph.

I see my rehabilitation work with animals and my activism as being as much a part of my art as pushing paint around on a canvas. Both demand science, discipline, creativity, stamina, a willingness to be emotionally vulnerable and to risk public ridicule and failure for an ideal, *and* freedom to make stuff up.[42]

These partly accidental but *trusted* images do indeed involve a degree of risk—not least the risk of their tipping over into full-blown sentimentality—but they are nevertheless evidence of how Britton Clouse trusts her art to wander into territory that seems more nuanced and exploratory than the certainties of her campaigning words (such as "I *reject* the idea that there should be any opportunity for negotiation about the morality of it"). Thinking about this, I kept coming back to a line about Cy Twombly's mark making in the early pages of Stephen Bann's book *The True Vine*, where Bann writes of "the straying, often excessive character of the representation."[43] Britton Clouse's, too, are images prepared to stray, in a way that the artist's verbal campaigning for animals cannot do so easily. Might it be that the appeal of images—and the *work* of art—often lies, and precisely lies, in this ability to stray?

The Not-Chosen Images

Only after writing what I took to be this chapter's closing sentence, above, did I remember some images I'd been shown on Britton Clouse's computer in 2006. These were the photographs in which she was tentatively assessing what might be made of that initially accidental juxtaposition of chicken head and human face. They would lead to the sepia images in the *Portraits/Self-Portraits* series, but these were images that were not eventually selected for inclusion in the series. And some of these *not-chosen* images—the clumsiness of the phrase seems wholly appropriate to their character—were rather extraordinary (Figure 4.6).

The "fusion" of human and chicken in the *Portraits/Self-Portraits* may be striking—even startling at first glance—but they lack the raw dark fierceness and vivid colors of some of these not-chosen images. These were on the edge of constituting part of Britton Clouse's work, up for

Figure 4.6. Mary Britton Clouse, *Naomi*, 2006.
Photograph.

consideration, but weren't there yet. It's rare to get the opportunity to see work in this state of *almost tipping over into being something else,* and some of those wilder images do work that's distinctly different from the "finished" sepia pieces.

What is it that they do, these images that didn't quite come to be recognized and resituated as part of Britton Clouse's art practice? It's something defiant and uncompromising, fiercely majestic. These are images in an unrationalized state. Britton Clouse's use of sepia is in a sense a rationalization. So is the title *Portraits/Self-Portraits,* rather than *Self-Portrait with Human*—the wittier and more spontaneous title, which (like these not-chosen images) did some uncontrolled work. These are images out of order, out of control, and sometimes out of focus, with an unsettling edge of visual violence that the artist may not have wholly intended.

In *Art beyond Representation* Barbara Bolt discusses the kind of *practice of assemblage* envisaged by Gilles Deleuze and Guattari that "only works when it is not functioning properly," and goes on to observe that "art thrives where things don't work properly." Art is precisely about the production of awkward unwieldy objects or images, whose very "unreadiness-to-hand produces possibility."[44] Britton Clouse's not-chosen images are the point where that possibility can be glimpsed—the possibility of articulating something on "the other side of the words," as W. S. Graham puts it in his poem "The Beast in the Space."[45] This sense of possibility is still visible in some of the finished pieces in the *Portraits/Self-Portraits* series, but in others things have been honed, fixed, and are once again ready-to-hand, available for instrumental use. In 2011 Britton Clouse reported, for example, that the animal advocate and author Carol J. Adams had started using one of these works in her campaigning talks.[46] The images were gradually being reclaimed by language.

It may seem misguided to question the fact that the resonance of the work in the *Portraits/Self-Portraits* series is being recognized as useful to the work of animal advocacy (a recognition that the artist herself undoubtedly values), but there's something different going on in the not-chosen images that *needs not to be lost.* The not-chosen images are not about a finely judged balance, an unexpected congruity, an envisioning of the nonhierarchical. They are images of being almost-overwhelmed, or of conspiring

together, or of the knowing proximity of beak and eye, of power shifting from the human, of the artist's undoing. It is something of this sort that Deleuze calls "the power of affirming chaos," which is part of art's work.[47] For all their lack of focus or composition, these not-chosen images speak of an alliance and an awe that's not remotely "caught" by the language and the well-judged arguments of animal advocacy.

These are images that do difficult work. They don't complete it, but they make a start, they point to its necessity. At the time of writing, these images don't even constitute a recognized part of Britton Clouse's body of artwork, but they have an untapped potential. In response to Annie Potts's question, "What do you ultimately want your art to convey about chickens?" the artist's simple answer was: "How alike we are."[48] But the not-chosen images cast this as an altogether edgier likeness-in-strangeness rather than in recognizability. They depict a nonanthropocentric exchange whose character and extent cannot be readily and reassuringly mapped— a mapping that the official series perhaps tries too hard to do. This is the properly posthuman territory into which these unused and unusual images quietly stray, and productively stay, on "the other side of the words."

On Maddening the Fly

"TABOO-BREAKING ART is not philosophy. . . . Philosophy wants to let the fly out of the bottle; art wants to keep it there, but to madden it." This is Anthony Julius's assessment, in his book *Transgressions: The Offences of Art*, of the fundamental philosophical shortcomings of much contemporary art. This is art that "can violate our sensibilities. It can force us into the presence of the ugly, the bestial, the vicious, the menacing. These are all kinds of cruelty."[1] Since this is art that has the temerity to question or to challenge "what might be termed the ordinary integrity of things" through its exploration of unfamiliar and hybrid bodily forms,[2] Julius's criticisms would presumably extend to much of the work discussed in the present book.

In a fascinating essay called "On the Duty of Not Taking Offence"—which has nothing directly to do with contemporary art or even with visual imagery of any kind—Robin Barrow makes the case that "causing offence . . . is sometimes necessary, and sometimes even morally desirable." Barrow is particularly critical of cases where "the term 'offensive' . . . is simply the emotivist shriek of distaste." In his view this "involves a judgment on the propriety" of the thing to which offense has been taken, and, as he observes, "one can choose not to make such judgment."[3] But notions of "integrity" and "propriety" are evidently held dear, in order (as Richard Sennett puts it) "to preserve intact a clear and articulated image of

oneself."[4] This emphasis on the defensive and the inward-looking is very much to the point. In one of Barrow's most thought-provoking passages, he writes: "One reason that taking offence seems morally questionable is that it is necessarily a very self-regarding stance to take. . . . Being offended is one of the supreme self-serving acts—far more unattractive and objectionable than causing offence in most instances."[5] (The cartoonist Martin Rowson concurs, irked by special interest groups' "totalitarian imperative to be freed from the threat of being offended.")[6]

When accusations of offensiveness lump together aesthetic distaste and moral outrage, as they often do in public responses to contemporary animal art, Barrow's comments on self-regard seem broadly consistent with Jacques Derrida's insistence that even the most "provisional" morality may serve only "to give oneself a good conscience."[7] Applied to the present circumstances of thinking about some of art's more challenging representations of animal life, it might be said that taking offense—tainted as it is with something uncomfortably close to the self-regard of anthropocentrism—is a response that's perhaps best avoided.

5

Almost Posthuman
Catherine Bell's Handling of Squid

> He returns his attention to the screen, where
> everything is so intensely what it is.
> —Don DeLillo, *Point Omega*

THIS IS WHAT HAPPENS: the date is July 15, 2006, and a single, fixed camera faces a stage, painted black, onto which an arc of light illuminates a small area where the artist is sitting, close to the bowed front of the stage. The artist has bleached hair and is wearing a man's suit that has been completely and meticulously covered in pale pink felt. She is sitting on the floor, facing forward, her back upright, her legs flat on the floor in a diamondlike shape reminiscent of a yoga pose, the soles of her bare feet touching each other. Inside this diamond-shaped enclosure formed by her legs is a pile of forty large, dead, freshly caught squid. To the outside of each leg, a slowly spreading pool of squid ink is already visible, and a narrow rivulet of the ink also edges its way toward the front of the stage.

The camera records the artist's actions as she lifts the first of the squid, tilts her head back, and squeezes its black ink into her mouth, then leans forward and down to spit the ink out over her bare feet. The squid is then set down in front of her feet, outside the enclosed diamond shape, and the next one is lifted. The actions look assured from the start. Each squid is lifted, either with one hand or with both, its ink sucked out and then spat back out in a gradual process of coating the artist's feet and then suit-clad legs with the ink. Increasingly, in addition to the sucking process, further ink is squeezed directly from the squid's body, which is

119

sometimes laid over her legs, her hand stroking along its tentacles, and along her legs, before the "used" creature is laid aside with some care: placed, arranged.

The symmetry of the artist's sucking body is striking, particularly in some early instances where both hands are used and the head is tipped right back so that the squid is held directly above the mouth. On the vertical axis of the artist's torso, the image of the diamond shape of the legs below that "line" is directly echoed above it by the diamond shape of the bent arms lifted above her head, the dangling line of the squid's tentacles continuing the line of the artist's torso (Figure 5.1). At the same time, of course, the spitting and spilling and squeezing and spreading of the ink is slowly creating a blacker, messier body.

After the eleventh squid is set aside, the artist shifts the position of her legs, opening them into a wide V-shape reminiscent of a childlike pose. From that point on, the "used" squid are placed between her splayed legs as well as to either side of them. After thirteen, the spat-out ink has reached the lower edges of the suit jacket, and the trouser legs are almost entirely ink-soaked. By the eighteenth, the upper half of the artist's face is still surprisingly ink-free. She is having to reach farther out to position the used squid, which are gracefully flung, tentacles flaying, creating (whether by chance or by design) an impression of bodies swimming in toward the artist, their tentacles fanning out away from her.

With the twenty-third squid, the process of spitting ink over the sleeves begins. After twenty-five, the hand spreads ink over the body of the jacket, too, pulling it out of shape; this is registered and the material pulled back into approximate alignment. By the twenty-eighth, the upper arms are getting covered. Nothing (to this viewer, at least) seems ugly or repellent about this performance: it's caring, attentive, beautiful. On the thirty-third, the torso as well as the neck has to twist so that she can spit ink on the shoulders of the suit. On the thirty-fifth and thirty-sixth, ink is squeezed not only into her mouth but over her forehead, dripping down into her eyes. The next one is squeezed over the top of her head.

Part of the remaining action involves the hands "grooming" the body with the ink, under the arms and elsewhere, doing bits she's missed. Everything is now slippery with the ink: she picks up, drops, and again picks up the thirty-ninth squid. After the fortieth, the last of them—coincidentally

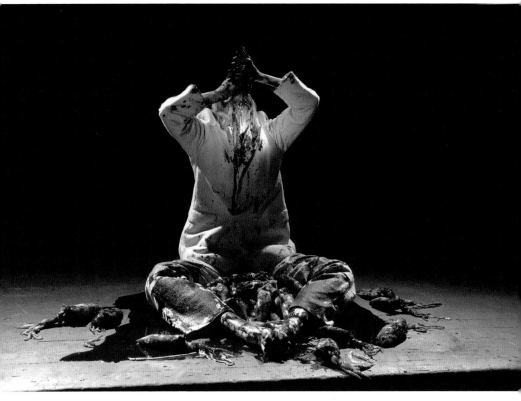

Figure 5.1. Catherine Bell, *Felt Is the Past Tense of Feel,* 2006. Performance still. Photograph by Christian Capurro. Courtesy of the artist and Sutton Gallery, Melbourne.

about forty minutes into the performance—she spreads more of the ink from the floor over her groin, down her legs, over her feet, as if giving them a good wash.

Free from the encumbrance of the discarded squid, the legs and torso now move more, the body reasserting itself, moving into a kneeling position. Then, from the front, and the right side of the body, and then the left, the squid are swept back in with extended arms, gathered back, until the body has reconfigured something very close to its original relation to the squid, except farther back on the stage, almost in darkness. And in the dark, something is happening: the squid are being put inside the still-fastened jacket, between the lapels, down between the breasts. As this is happening,

the body is shuffling itself backward into the darkness, the legs alternately gathering stray squid as they go—the jacket and the cradling arms can't hold them all. Darker now, there's only the glint of the inky feet, and the inky squid, indistinguishable. Then, at the end, very nearly an hour into the performance, just the glint of the ink on the stage.

The Artist's Perspective

What kind of object, what kind of *thing* is it that's been described here? It's one element in the Melbourne-based artist Catherine Bell's striking 2006 artwork *Felt Is the Past Tense of Feel*. The whole piece takes the form of an installation, the other elements of which are described in due course. The installation, however, is perhaps best thought of as an extended documentation of the performance. Early in 2007 Bell described the piece (which she had already exhibited) as "my latest performance work . . . where I suck the ink out of forty squid and spit it on myself as an act of erasure; at the end of the performance I have disappeared. The work investigates how we process grief in Western society."[1]

Much hangs on the manner in which that last sentence moves from description to explanation. It was intended to offer a context in which to view the work, but was open to being read as something closer to an instruction: *this is how the work is to be understood*. And if it *is* read that way, it seems to block other views of the work, and other productive consequences that flow from its collision of bodies and materials.

Presenting this work at a conference in Hobart a year after filming the performance, Bell contextualized *Felt Is the Past Tense of Feel* in relation to ideas drawn from Mary Douglas, Gilles Deleuze and Félix Guattari, and Jacques Derrida, and also noted that several of her performance works "investigate the way humankind responds to loss." She again directed her audience toward a rather specific reading of the squid performance:

> The squid work is about the public recognition of death as more than funerary ritual controlled by religious and social protocol but as an opportunity to publicly grieve and display emotion. . . . The performance is analogous to shamanistic curing ceremonies to overcome a fear of death or the guilt of inflicting death. In these works the animals are symbolic

and the ritual carries a meta-social commentary or aids the selection of personal experiences for concentrated attention. In the squid performance the ritual externalizes experience and puts feelings that have not been expressed into cathartic action. The compulsive repetition of sucking and spitting becomes . . . a way of distracting my memory, by erasing the thoughts of witnessing my father die.[2]

This revealing passage says much about the complexity of Bell's ambitions for the piece. From her perspective, it's at one and the same time a reenactment of a particular death, a way to distract herself from her own grief at that death, a wider investigation of Western attitudes to grief, an attempt to reposition public recognition of death, and a symbolic use of both living and dead bodies that bears comparison to shamanistic ceremonies that address both fear and guilt in relation to death.

It may not be immediately obvious why this chapter is devoted to a performance that seems to be regarded by the artist as addressing wholly human concerns and that employs dead animal bodies only for symbolic and ritual purposes. There are indirect echoes here, perhaps, of the kind of thinking that informed Kim Jones's *Rat Piece* performance in the 1970s, but those issues have already been explored. Why then choose to consider *Felt Is the Past Tense of Feel* in detail?

There are three main reasons. One is that the work may be judged to have a significantly different impact—and to say more about artists' engagement with animals—if the narrow terms of Bell's own explanation are set aside. Another is that this cannot really be done: awareness of the artist's views cannot be pretended-away, and to insist on a different reading would be to impose a form of critical intervention that this book has generally tried to avoid—even though the closing pages of the previous chapter began to move in that direction. A third reason is precisely to find out what happens when that kind of interpretive intervention is, nevertheless, attempted here—as it now will be.

Does this mean that the artist's words are no longer to be listened to and taken seriously? It does not. They will be listened to attentively, not least for clues as to how the making of the work may itself establish a "visibility" for it—an independence of form, or a forward momentum—that makes it *more than* an expression of the intentions that still attach to it.

Spaces and Bodies: Contested Readings

Questions about the immediate physical circumstances of the work's making, and about Bell's experience of its making, were to be the focus of an interview conducted with the artist the day after she gave the Hobart conference paper. Several of those questions concerned the organization of the spaces (of the performance itself and of its subsequent exhibition) and the disposition and distribution of the bodies (both human and nonhuman).

The space eventually used for the performance, almost a year after the death of Bell's father, was a bow-fronted stage in a theater in south Melbourne. Finding a suitable venue had been difficult, not least because she needed "to find a theatre that would allow me to paint it black." She stated: "It was really important that I created this sort of *abyss*, like staging this retreat into the shadows."[3] As she describes it, the setting that she was creating was laden with symbolic references. For example, in relation to the spotlight on the bow-fronted stage, she said: "The way I'd set it up I wanted to have that semi-circle of light because it represented the family around the death-bed."

Bell had herself set up the main camera on a tripod in front of the stage, but two other people were in the space during the performance—one with a handheld camera taking close-up footage (of which more will be said later), and another taking photographs because Bell "wanted to have lots of still images of the performance." Much depended on advance planning, not only because of the expense of hiring the venue, the lights, and the cameras, but also because this was to be "a totally one-off, I would never re-enact it."

Felt Is the Past Tense of Feel has been exhibited on several occasions, usually in a relatively small and confined space (Figure 5.2). Echoing both the work's title and the material in which the suit is covered, the large screen on which the complete filmed performance is projected, "like a movie," had been made by the artist from gray felt. In another corner of the room, close to where viewers might stand to see the main screen, is a hospital monitor mounted fairly high on the wall, and on this the handheld footage of the performance is screened. The films are silent. And close

Figure 5.2. Catherine Bell, *Felt Is the Past Tense of Feel,* 2006.
Gallery installation view. Photograph by Christian Capurro.
Courtesy of the artist and Sutton Gallery, Melbourne.

to the monitor, freestanding in the viewer's space, hangs the felt-covered
and ink-stained suit:

> You actually are standing next to the suit when you're watching. The suit
> is watching the video, and it immediately stands in the presence of the fa-
> ther, like it's his height, it's his body, but it's deflated. The only place you
> can stand is next to it, and you can't escape because you've got the footage
> on the monitor that's up higher.

The suit, of course, was her father's, and "is an integral part of the presen-
tation of the work." Of the crafting of this suit, and of her own actual and
symbolic mourning of his death, she said:

> I wanted the suit to become a repository for that grief, which was the ink,
> and it was an absorbent fabric, and also I was very aware of the Joseph
> Beuys felt suit and what felt represented to him in terms of protection and
> nurturing. And I chose the pink because for me that was the closest to the

> flesh, human flesh, that color. . . . And everything was covered—the buttons,
> the inside of the suit, the pockets, everything was covered in the felt, and
> it was a very absorbent material, so I knew that it wouldn't repel the ink.

Above all, however, the suit makes its claustrophobic presence felt in the installation space through the lingering and overwhelming smell of the squid ink: "I always warn the gallery before they show it that it reeks. . . . Cancer has that rotten stench, it smells like death and I think it is important to be shown alongside the work."

Bell was confident that the installation would invariably be understood by its viewers in much the way that she intended, regardless of their familiarity with the conventions of performance art. She gave the example of one particular visitor to the gallery in Melbourne where the work was first shown:

> He looked at it for about five minutes, and he said "my wife has just died
> of cancer, and when I look at that, that's what I think of." So I thought,
> he gets it, he got the message, so I know people recognize it. . . . Even the
> technicians, when they were setting up the work and they saw it, they im-
> mediately said this is about *death,* this looks deathly.

Her own view was that "these archetypal images are already implanted in the work—I don't have to do much explanation."

It's certainly possible to read the work very differently, as *a thing in itself,* a compelling and absorbing encounter entirely free of deliberate symbolic weight—even for a viewer who knows (as I did) of Bell's intention to stage an investigation of "how we process grief in Western society." The remainder of this chapter is an attempt to articulate how such different perceptions of what was happening in those spaces might sit alongside each other.

Artist as Shaman?

This is where Bell's account of the bodies in these spaces—and in particular the account she gives of the spatial, intellectual, and emotional

disposition of her own body—comes to the fore. Responding to the interview's opening question, "How would you describe yourself?" her unhesitating answer was "I would describe myself as an artist, a shaman—a modern-day shaman, a social commentator." As noted earlier, the analogy with shamanistic ceremonies had been mentioned in her conference paper the previous day, where she had also said more about the shamanic role of animals in some of her performances:

> In my performance practice I work with dead and living animals to create primordial rituals that enact the catharsis of suppressed human drives and emotions. . . . As the performance continues the human–animal encounter is somatically shared. What I experience is a shift from the subjectivity of human to animal. . . . Performing with the animal makes it possible for me to critique . . . social taboos.

The paper described animals being assigned the role of "substitute" for an absent human, or of "an accomplice in self critique."[4]

As comments such as those make clear, Bell's characterization of herself as an artist–shaman seems unquestionably to entail the adoption of an anthropocentric attitude to animals. Some of the artist delegates at the Hobart conference who aligned themselves with the cause of animal advocacy certainly read her work in that way, and responded negatively to it. But the dynamics of this work—its material coherence—probably cannot be fully grasped unless Bell's investment in her shamanic identity is acknowledged and taken seriously.

Prior to the performance, she had commissioned local fishermen to line-catch the squid she planned to use, because she knew that trawled squid frequently ended up with their ink sacs perforated and their eyes and tentacles "ripped off," and she wanted to avoid that damage to the dead bodies: "I was very definite that I wanted the animals to be intact." They also had to be as fresh as possible, to minimize their smell and to maintain the luminosity of their eyes. The fact that "they had just died" was important to her for another reason: "It fitted the concept of, you know, the death had recently left the body—I guess for shamanistic purposes, as a way of resurrecting the life of the animal, that they had to be recently deceased."

The reference to resurrection is no mere metaphor. It crops up again when she refers to sucking the ink from the squid "while it was dead, but with the hope that it would come back to life, like I was going to resurrect it."

From a mainstream contemporary Western perspective (and certainly from an animal advocacy perspective), the idea that her role as artist–shaman is to breathe life back into animals whose death she had herself commissioned is problematic at quite a number of levels. Seen as one of the shamanic aspects of her practice, however, it may look less absurd or preposterous. In a valuable essay on occurrences of shamanic thought and practice in recent Western art, Michael Tucker refers not only to the familiar example of the "shamanic element" in Joseph Beuys's "cryptic use of such materials as honey, fat and felt," but also to the Catalan artist Antoni Tàpies "wanting to make his inert materials come alive, or speak." "Breathing life back into the humble but essential things of the world," Tucker writes, "Tàpies functions like a shaman . . . redirecting attention . . . to an animistic integration of self and world."[5] Although Bell was not familiar with Tucker's essay in 2007, it seems likely that she would recognize this sentiment.

A further important dimension of the improvised ritual that is *Felt Is the Past Tense of Feel*—though one only evident in Bell's own account of it—is the unexpected recycling of the discarded squid as foodstuff. Shortly after the filmed performance, as she notes, "I turned up at this communal barbecue with the squid in their state of being dirty with the floor of this theatre and all covered in black, and I was waiting for people just not to want to consume it." The barbecue was to celebrate the birthday of a friend's neighbor, and the young men attending already knew something of the artist's activities with the animals: "They knew what I'd done with them, but it didn't make any difference. . . . I showed them these corpses that were covered in ink and dirt and they'd been rolled around and all of this, and it didn't matter to them one bit, that they were going to eat those."

Showing them the film, however, was a different matter: "I said if you partake in eating these animals you have to partake in the viewing of the work, that's a proviso, and when they came and saw it they were revolted by what they were seeing, that made them feel disgusted." As in subsequent

gallery installations, the suit was hanging there too, pink on one side and black on the other, like a bad piece of barbecuing: "They could smell the fishiness of it, you know, two weeks, three weeks afterward, it was just so repellent you could smell it down the street, and then when they saw the visual it's like they put everything together."

On this point, it has to be said, Bell's thinking about the project seems inconsistent. Noting that some people's response was to say that they could no longer eat squid after seeing the filmed performance, she reflected with interest: "I'm doing something here, I'm actually turning people off it, because of the way I'm presenting it in an abject context." This could indeed be regarded as a welcome side effect of the piece, but it sits awkwardly with the artist's view that recycling the postperformance squid as foodstuff would mitigate their having been killed at her behest to make an artwork in the first place.

Intensifying the Human

Tucker quotes with approval the Scottish poet Kenneth White's call for the contemporary artist–shaman to "expand and intensify" everyday experience through their work[6]—a call that also brings to mind Deleuze and Guattari's view that creative experience is likely to involve "opening the body . . . to distributions of intensity," and the quest "to find a world of pure intensities where all forms come undone."[7] The word *intensity* may not itself have cropped up much in the interview with Bell, but her vivid memory of the intensity of her own embodied experience of the performance ran through the conversation and shaped her explanation-laden answers.

For example, in response to a question about whether the squid ink had seeped through and stained the suit underneath the felt covering, Bell said:

> It did, it did, it went right through, and that was important, because that suit was what my mother wanted to bury my father in, and I was imagining that being on his body and how his bodily fluid would seep out, and the last thing he said to me when he was conscious was that he could feel a salty liquid seeping out of his legs, and it was really important to put myself in that position. . . . I wanted to feel that pain.

Interestingly, her conscious identification with (or better, embodiment of) her father's situation and his pain is described principally in terms of an attentiveness to materials—fabric, ink, skin—and their permeability:

> I also had some squid ink in a bucket and I poured it behind myself so that during the performance . . . you can see it moving to the front and that gets sucked up into the fabric of the suit. I'm actually sitting in squid ink, and it was corrosive, it actually stung the skin, it was like acid biting into the skin, it stained me for months.

The pain itself is described in terms of finding appropriate comparisons to the effects of other materials. Answering a question about whether the ink got into her eyes later in the performance, she said: "It did, it did, it's like salt water, it's like when you get dumped in the surf, and it's gritty, it's like sand, and it really stung, it was like acid, it was really really like acid."

She also described the painfully "cathartic" effect of "six hours of bleach on my hair" the day before the performance:

> My scalp was burned, and I guess blistered as well, so when I put the ink on my hair it was excruciating. But it was important that that was white, so that it looked like I'd either had chemo or it had been bleached out. I wanted it to look like I'd had a shock. . . . Also the make-up, I'd gone to a mortuary, and got the pancake, the make-up that they put on dead bodies to make them look alive, that's why it has that orange hue. It's so thick.

As she noted with a laugh, "Every element was considered." This included her sense of the symbolic resonances of her materials and her actions and their relation to her father's condition, their connections described in something like a stream of consciousness:

> He was bringing up black bile, coughing that up, and for me that was like the squid, as soon as you squeeze it the black will come out, so I started to see . . . the ink being sort of like a cancer that should be sucked out. And that's also a sort of euphemism, people say you've got to suck up your

emotion, and not let it out, and so the action seemed to relate to that re-
pression of emotion.

Despite this account of an accumulation of materials and effects centered
on her own body in the performance space, Bell's principal attraction to
the idea of "embodiment" is "that Freudian model of melancholia, that you
incorporate the other, and that for me is like the clinging on to the father,
and wanting to make that lost love object part of your body." In the tension
that was beginning to emerge in her words between materials and mean-
ings, there was just as much evidence of the tenacity with which she was
"clinging on" to her intended meanings.

Slipping Out of Control

Some of Bell's most interesting comments related to questions about how
things worked in the performance space. An important balance between
the controlled and the unplanned became apparent. Like her earlier remark
that "every element was considered," she said of the photographer who was
hired to take still images of the performance: "He was instructed on what
I wanted, and where I wanted them, and how I wanted them. There's a lot
of direction from me in all of the work. I like to have full control."

 This, of course, was in advance of the performance itself, where even
Bell's basic plan of action—sucking the ink from forty squid before shuf-
fling her blackened body back into the darkness at the back of the stage—
had elements of uncertainty about it:

> I never rehearsed the performance. And I didn't plan that after two or three
> of the sucking of the squid that it was so salty that my mouth couldn't actu-
> ally purse and suck any more, which is why it gets quite violent at the end
> because I have to manually push out the ink and squeeze it on me, because
> I can't suck it any more. My mouth was all blistered inside, my lips were
> all cracked, it was so painful, and I hadn't planned that.

The desire, in advance, to "feel" her father's pain was there, but other as-
pects of the interaction of bodies and bodily materials on the performance

stage seemed to come as something of a surprise. The squid were "very slippery, to hold, and they were actually a lot bigger than I could manage":

> I thought the bigger they were, the more pronounced the body would be for the visual, but it was actually really hard to get my hand over the whole bodily form, so a lot of the time I had to use two hands, because if I squeezed too hard it would sort of push out. And I was really conscious of how precarious the head section of the squid was to the body, because the body was quite tough, and it's only connected by quite a small sort of hinge. . . . I didn't want it to come off in my hand, that would have been a disaster.

She also couldn't guarantee in advance that the retreat into darkness would be completed before the hour-long tape in the fixed camera ran out. And some of the decision making within the performance was itself unexpected:

> I don't know how it's going to end up, and even with the squid I had no idea that I was going to gather those, and put them in my suit, that's just what evolved. It's like when I was about to retreat, I thought I can't leave them there, and I don't know if this is me thinking about it now, but at the point in time you don't really understand what happens.

She went on to describe in some detail how the *process* of the performance was characterized by an awareness of the evolving interaction of her emotions, her bodily reactions, her materials, and her sense of responsibility to the film's eventual viewers. Her intention as an artist–shaman was to create and enact a "ritual" that "is going to resonate with the community when they see it," and that sense of responsibility still needed somehow to figure in the not-really-understanding-what-happens. Initially thinking of the performance as an opportunity to mourn her father's death and to purge her grief, she reported that "I actually thought that it was going to be way more emotive. . . . But once I started, I was, it just became so methodical, the whole process and the sucking and concentrating and focusing on that." That in itself was difficult:

Because the first time I did it I sucked too much in and it actually took my breath away because it went right down my throat, and I thought, I'm going to vomit, and it's going to ruin the performance. So, I was very aware of my own body and how it was reacting to what was going on. A lot of the time I had to try and put that aside, I had to put the hurt, the ego aside, I guess, and realize that if I think about any of that it's going to come across in my face, it's going to distract what the viewer sees. I felt I had to be totally deadpan, so that it wasn't about me, and me performing something, it was about just a process, it's like I couldn't be in my body, because I thought I'd be thinking about my father and all of that, but it was totally me and the material, me and the animal, and me and the process of doing that, and being totally caught up in that exchange.

As she recalled, "At the end it was like there was no differentiation, I felt like I had become the animal. I know that sounds really corny, but I didn't have to see the footage to know that."

Reflecting further on the aftermath of that exchange, or rather on the brief surviving visual evidence of it, Bell said: "I love that sort of skirmish that's left on the stage, because that's the way my legs went, actually the patterning of the movement, that was the greatest joy for me when I saw that" (Figure 5.3). She recognized too that this was a direct result of the unplanned decision to scoop up the discarded squid and to draw them back with her into the darkness:

It impaired my movement because I put as many as I could in my suit but they're also slipping through, and so I had to keep gathering them and holding them and cradling them. And in moving back I couldn't really get any suction . . . because it was really wet, but in doing that the way that the body moves became really animalistic somehow. What it left behind, that trace, for me that was the human–animal collaboration, that trace on the ground, because we both left that pattern on the surface.

Caught up in the exchange of "me and the material, me and the animal, and me and the process," she describes a state that will of course be familiar to many artists—a state where informed decision-making and not quite

Figure 5.3. Catherine Bell, *Felt Is the Past Tense of Feel*, 2006.
Performance still. Photograph by Christian Capurro. Courtesy
of the artist and Sutton Gallery, Melbourne.

understanding what's happening go hand in hand. "There's things I could
have done differently," Bell reflected, "but it's good to have that necessary
blindness, that you don't know how it's going to unfold."

In that unfolding, it might be said that Bell's sense of "shamanic"
responsibility to her audience is acted out through a mixture of deliber-
ate and improvised attentiveness to and care for her animal materials: the
concern that the squid bodies should be "intact," her sense that it would
have been a "disaster" if heads and bodies had come apart through her

ham-fisted handling of them during the performance, and her bringing them back to her own body as a result of her last-minute realization that "I can't leave them there."

The Black Hole Has Become a Home

What does Bell's view of herself as a shaman contribute to the process described above? In the interview, she said: "When I talk about myself as being a conduit for social crisis, I see that as my role as an artist." It seems that the work itself is intended to serve as a kind of conduit, "creating a ritual that's going to have some sort of community benefit." In the case of *Felt Is the Past Tense of Feel*, she connected this to her memory of watching her father "gasping for air, his eyes were wide open. . . . And I just thought why can't they put him out of his misery? Why are they making us be exposed to this horrible death?" So in the performance "I wanted the viewer to be exposed to that prolonged death, for an hour they have to watch this performance happen before they see an end to it."

Similarly, she said of her father's suit: "Covering that suit was shrouding it, it was about shrouding the suit, and I wanted that to be a symbol of grief, and that's what it's become." And of the viewers of the filmed performance: "I want them to empathize with the plight of the artist who performs it, and actually to take that melancholia on when they leave."

Bell later clarified her understanding of her relation to shamanism in the following terms: "My performances identify with anthropological models of rites of passage because they aim to facilitate catharsis and motivate a similar pattern of experience in the participant and viewer."[8] And this is the difficulty with using shamanism (or at least that particular understanding of shamanism) as a way to account adequately for the considerable interest of Bell's work. If it's necessary to "motivate a similar pattern of experience in the participant and viewer"—the artist and viewer—then the performance, the ritual, must presumably be said to have failed to some degree for those viewers who read it in a significantly different way to the performer.

This is no mere abstract quibbling. In my experience of *Felt Is the Past Tense of Feel*, the suit did not become a symbol of grief, and I did not

take on the performer's melancholia, and I watched the full hour of the main camera's continuous footage in fascinated admiration of its calm and extraordinary beauty, with no sense whatsoever of being exposed to a "prolonged death." The video's almost stately development, combined with the artist's reference to the dark rear of the stage as a "sort of *abyss*" that she had created, brought to mind an observation in Deleuze and Guattari's *Thousand Plateaus*: "Sometimes chaos is an immense black hole in which one endeavors to fix a fragile point as a centre. Sometimes one organizes around that point a calm and stable 'pace' (rather than a form): the black hole has become a home."[9]

Finding or making a home in chaos might be a different way to describe the process of mourning. It might equally serve to describe the process of art making. Here is one example, which perhaps begins to suggest a route through and beyond this difficulty. In Tucker's discussion of shamanism in modern and contemporary art, he complains about the "literalism" with which some critics and artists tend to view the idea of the artist as shaman. In place of this, he advocates the adoption of White's call for the "anarchic use" of shamanism's "archaic tradition."[10] This is what Bell might already be said to be doing, and doing successfully. In the middle of her comments about her role as an artist, a shaman, and "a conduit for social crisis," she said: "But there's always an underlying sort of deviant side of that which for me is like how the social drama will play out as an artistic drama."

That playing out, that acknowledgment of the work of form and of process, seems to be most evident in the structuring of the gallery installation spaces. Quite apart from the stench of the inky suit, two films of the same performance—more or less facing each other—play out a stark and surprising confrontation that's every bit as compelling and contradictory as Bell's own account of her experience on the black-painted stage.

One, of course, is the hour-long film described in some detail at the start of this chapter, projected on the large-scale, felt-covered screen on the gallery wall. The other is the twenty minutes or so of edited footage from the handheld camera, shown on the hospital monitor mounted in an opposite corner. Their effect is startlingly different. Bell had spoken about not wanting the performance "to be something where I stood up, and I moved around; I wanted it to be something really stationary," and this gives

the fixed camera's footage much of its sense of calm. But in the handheld footage, which she calls the "in your face sort of footage," the movement is nonstop. The camera is closer in, and the eye registers details (Figure 5.4). Spat and spilled ink is splattered over the suit's lapels, and drips down the artist's uncovered neck and wrists, right from the start. The ink's thickness, its density, is more evident, as is the fuzziness of the felt, and the meticulousness of the stitching. The cutting between shots makes what's happening on the stage look more alarming, more "violent." Ink squeezes not only into the mouth but between the fingers, down the arms inside the sleeves.

Figure 5.4. Catherine Bell, *Felt Is the Past Tense of Feel,* 2006. Performance still. Photograph by Christian Capurro. Courtesy of the artist and Sutton Gallery, Melbourne.

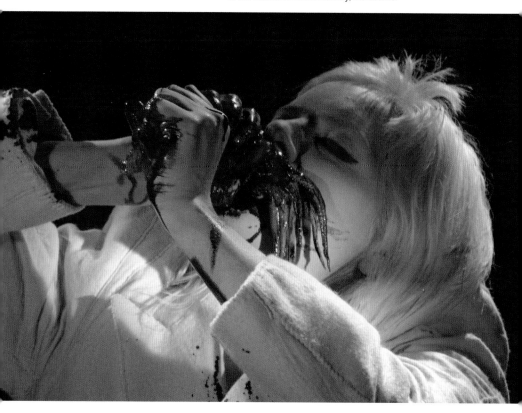

A shot of the squid piled between the legs, tracking up over the splattered suit, looks like carnage. Everything seems starkly blacker (the squid, the stains, the eye makeup) and "whiter" (the face, the bleached hair, the pink suit). The body's moves look, perplexingly, both more calculated and more random. Squid in mouth, the artist's eyes twice engage directly with the camera's gaze. Occasional shots of the bare feet, indistinguishable from the squid, are among the most alarming—certainly more so than the gaze of the squid-sucking face. And again, all this happens in silence and, unlike the fixed camera's footage, out of time. Jumpy, jerky, the flow of the long shot's recorded movements is entirely missing. But even here, the pain and discomfort that the artist describes is not apparent. Toward the end, in the gathering-up-again of the squid, the jewel-like quality of their bodies is more evident. The arms can't hold them all.

It's not at all clear what is to be made of this. But the gallery installation is certainly a space in which all the artist's emotive subjectivity is rendered material. Bell's striking remark, "the suit is watching the video," is one way to describe part of what happens. Stripping back the pathos and the symbolism, *felt faces felt* might be another. The singular thingness of the work is what persists. Stench overwhelms symbolism. Calm and chaos, carefulness and violence, vie for attention—and refuse resolution. This is an experience of an extraordinary place, an artist-made place, in the present, in the moment. The piece may have its origins in the specific circumstances of the artist's family history, but in the process of its making, those have been left behind, "mourned," moved on from, in what it may not be wholly inappropriate to call the shamanic shaping of this thing.

And in all the rich contrariness of the thing's insistent material presence, it really doesn't matter that its title, *Felt Is the Past Tense of Feel*, seems to take it in quite the opposite direction, with the material (felt) punningly reduced to the emotional (feel). The dynamic of the work itself, however, is (as Bell seems to recognize) more rigorously Deleuzian. Sentiments, emotions, and pain—all the weighty trappings of human subjectivity— are transformed, with both determination and a lightness of touch, into unfamiliar "materials, affects, and assemblages."[11] Tucker opens his essay on art's shamanic transformations with a statement by Georges Braque that seems apt here too: "Art is a wound become light."[12]

A wound becomes light. A subjectivity becomes an intensity. This is the process of *Felt Is the Past Tense of Feel*. Pushed aside (though still clinging on) are both the sincere but mundane human grief that motivated the work, and the less than wholly convincing explanations of its shamanic social purpose. Unaware, in 2006, of the detail of Deleuze and Guattari's elaboration of the idea of becoming-animal, Bell acknowledged that when she subsequently "read that statement about the line of flight, I knew I had done that."[13]

What is it that happened in the performance, and in particular in that moment of separation marked by the artist's realization that "I had to put the hurt aside, the ego aside," because otherwise "it's going to come across in my face," and that this would "distract what the viewer sees"? One way to think about this might be to see it as a shift from a humanist to a posthumanist register. More generally, I'm inclined to view *Felt Is the Past Tense of Feel* as a posthumanist work made by an artist in a humanist frame of mind—until, that is, she was swept up in the process of the performance itself. As Bell herself acknowledges, "By the end there was a remarkable shift in my understanding of the animal."[14]

Cary Wolfe, in his detailed categorization of the degrees of posthumanism to be found in various philosophical positions, lists Deleuze and Guattari among those he regards as posthumanist posthumanists.[15] Something of their steeliness, their refusal of sentiment, their mixture of sobriety and excess, and their fascination with things *spilling over* can certainly be glimpsed in Bell's work. And the compromised nature of her work suggests something that might be said of all the artists discussed in the present book. The assigning of fixed positions may be neither realistic nor helpful. If art can productively be discussed in terms of a distinction between humanism and posthumanism, then artists' words and work will almost inevitably shift, at times, between those registers. To be almost posthuman, or sometimes posthuman, is good enough.

On Cramping Creativity

Can't do this, can't do that, always on
at you about something.
—Fred Vargas, *This Night's Foul Work*

IN HIS INVALUABLE ESSAY, "Practising Ethics," Nigel Thrift offers a worka-
day definition of ethics as "the effort to formulate principles of right and
wrong behaviour" before launching into a quiet but devastating critique
of "the rise of the dictates of the ethics committee," which, "in its despera-
tion to avoid mistakes, closes down some of the main means by which we
learn about others." His concern is that research in fields such as the social
sciences and the humanities is now "subject to a new tapestry of ethical
regulation which ... assumes that there is only one way of proceeding."[1]

He attributes the growth of these committees principally to vari-
ous scandals in American biomedical research in the 1960s and 1970s,
which caused a "whole new industry of bio-ethics" to emerge, "at whose
centre was the increasingly ubiquitous ethics committee."[2] Here it's worth
pausing to note Donna Haraway's trenchantly expressed view that bioeth-
ics is "perhaps one of the most boring discourses to cross one's path in
technoculture":

> Why is bioethics boring? Because too often it acts as a regulatory discourse
> after all the really interesting, generative action is over. Bioethics seems
> usually to be about *not* doing something, about some need to prohibit,
> limit, police. . . . Meanwhile, reshaping worlds is accomplished elsewhere.[3]

140

With specific reference to the emergence of British university ethics committees, Thrift observes that "the problems begin when this bio-ethical apparatus is transferred wholesale into the realm of the social sciences . . . and the humanities," not least because "such committees attempt to render the ethical outcomes of research encounters predictable."[4]

His understandable dissatisfaction with this situation stems from his conviction that the value of research free from such regulation comes from "not knowing what exactly will turn up and therefore not knowing exactly what ethical stance to take. Indeed, in certain cases that value may lie . . . in having one's own ethical certainties shaken up." In contrast to the ethics committee's "normative regime that takes responsibility away from the researcher," Thrift calls for the development of imaginative strategies that "can open out the ethical possibilities of an encounter" and that allow researchers "to trust their judgement and so be carried along by it"—strategies, in other words, that evince "a vulnerable optimism towards the world."[5]

The university ethics committee, as characterized by Thrift, looks very much like an example of what Iain McGilchrist—in his book on the divided brain—would call left-hemisphere thinking. Fearful of the growing dominance of this perspective in contemporary Western culture, McGilchrist offers an imaginary picture of what the human world might look like if right-hemisphere thinking was further suppressed:

> There would be a remarkable difficulty in understanding non-explicit meaning, and a down-grading of non-verbal . . . communication. . . . There would be a loss of tolerance for, and appreciation of the value of, ambiguity. We would tend to be over-explicit in the language we used to approach art and religion, accompanied by a loss of their vital, implicit and metaphorical power.

Here, it seems, there would be no clear place for the values of contemporary art. And as McGilchrist goes on to acknowledge, it's "hard to resist the conclusion" that such a world is already "within sight."[6]

Evidence of its imminence can be found in unexpected quarters. In March 2011 the College Art Association, which has a record of opposing censorship in the arts (as the example discussed in chapter 4 demonstrates),

sent out a survey to its members. The covering letter explained that the CAA board of directors had approved a task force to consider "the rationale for, purpose of, and possible content of potential Standards and Guidelines for the Use of Human and Animal Subjects in Art," and was seeking members' "input on this important advocacy issue."[7]

Explaining what had prompted this initiative, Paul Jaskot, its chair, wrote as follows: "The task force originated when several members and PETA contacted me about their concern with examples of cruelty to animals in art. . . . The Board, realizing that we do not have standards for the use of animals or humans equivalent to the sciences and social sciences, decided to form the task force." After evaluating the survey responses, the recommendations of the task force would be sent to the board, which could either accept or reject the report.[8]

The notion that the CAA might usefully develop "standards . . . equivalent to the sciences" was evidently in place from the outset. The questions chosen demonstrated the difficulties both of shaping and of evaluating such a survey. Members were asked both about whether they supported "banning cruelty to animals in the production of an artwork" and about whether "a set of proper and respectful use guidelines" should be established "for artists using animals in art." Those bald adjectives—"proper and respectful"—seemed already to hint that, as Haraway warned of bioethics, "the really interesting, generative action" would be "accomplished elsewhere."

Certain questions seemed at least to hint at the futility of the exercise. Members were asked whether they would support regulations governing both the "use of" and the "genetic modification of" different types of animals in art. In both instances they were invited to register the extent of their concern for each of the following: "wild animals," "domesticated animals," "mammals," "birds," "reptiles," "fish," "amphibians," "insects and spiders," "invertebrates (worms, snails, mollusks, crustaceans)," "one-celled life forms (protozoa, bacteria)," and "genetically created cells and tissue cultures." This skewed species hierarchy gives a sense of the randomness of any ethical "standard" that might be drawn from responses to it. It also represents exactly the kind of thinking that an artwork such as Mark Dion's *Scala naturae* quietly but effectively lampoons.

Over a decade before this survey, Dion had of course written his own tentative manifesto on the subject, "Some Notes towards a Manifesto for Artists Working with or about the Living World," which includes the uncompromising assertion that "Artists working with living organisms . . . must take responsibility for the plants' and animals' welfare."[9] This document presents rather clearly the difference between an artist's engagement with these issues and a committee-led approach to them. How? It's handwritten. It's "notes towards." It's put out there, like an artwork. It's *not* put out for consultation. It's *not* a set of "standards." Importantly, it insists that artists "must take responsibility for" what they do, and *not* that they must not do it. In this sense it resembles Thrift's, and Derrida's, and Eduardo Kac's various calls for taking-responsibility-for. Like other manifestos, it proclaims rather than prohibits. And it's an instructively reflective piece of writing which notes that in making work that "reveals complex contradictions," artists may be just as interested in "highlighting" them as in dissolving them, and that the artist has a responsibility to be inventive because "nature does not always know what is best." The penultimate paragraph reads: "The objective of the best art and science is not to strip nature of wonder but to enhance it. Knowledge and poetry are not in conflict."[10]

One further thought on these matters. In his foreword to Deleuze and Guattari's *Thousand Plateaus,* Brian Massumi notes that the "nomad thought" which the authors advocate "goes by many names. Spinoza called it 'ethics,' Nietzsche called it the 'gay science.'"[11] The references to Spinoza and Nietzsche are pertinent here for two reasons. First, Thrift's reservations about the work of contemporary ethics committees are expressed in an essay in which they're immediately preceded by an appreciation of the contemporary relevance of Spinoza's understanding of ethics as an imaginative, creative practice. And second, as Nietzsche noted in *The Gay Science*: "We should be *able* also to stand *above* morality—and not only to *stand* with the anxious stiffness of a man who is afraid of slipping and falling at any moment, but also to *float* above it and *play*. How then could we possibly dispense with art—and with the fool?"[12] This seems a fitting rebuke, ahead of its time, to the "anxious stiffness" of ethics committees to come.

6

Art and Animal Rights

Sue Coe, Britta Jaschinski, and Angela Singer

> The function of art . . . is to make the world
> appear within the world.
> —Niklas Luhmann, *Art as a Social System*

IN A CHAPTER OF HIS BOOK *What Is Posthumanism?* that includes discussion of the artist Sue Coe's book *Dead Meat*, Cary Wolfe asks that given what Coe sees as the ethical function of her own art (a furthering of the cause of animal rights), "Why not just show people photographs of stockyards, slaughterhouses, and the killing floor to achieve this end? To put it another way, what does art *add*?"[1] What does art add? Wolfe does not go on to answer this question directly, but it is a highly pertinent question that sets the broad agenda for the present chapter.

Rather few contemporary artists working with animal imagery see their work as being directly shaped by their own commitment to the cause of animal rights. This chapter considers some of the recent work and concerns of three such artists: the U.S.-based Sue Coe, who is primarily associated with graphic work for the printed page; U.K.-based Britta Jaschinski, whose medium is photography; and New Zealand–based Angela Singer, who recycles taxidermy and other animal materials. Where previous chapters have given some sense of the variety of practices and purposes found in contemporary artists' engagement with questions of animal life, the emphasis in this chapter is on illustrating diversity of practice within singleness of purpose. The intention is to present a preliminary comparison

of how and why these particular artists see their diverse presentational strategies as a necessary means of taking the viewer beyond Wolfe's "photographs of . . . the killing floor." Along the way, it becomes clear that their recognition of their own status as artists is in no sense subservient to their commitment to animal rights. Their aesthetic strategies and their political commitments are complexly entangled.

The Unstable Killing Floor

First, however, it's worth identifying some of the ways in which slaughterhouse imagery (and other documentary imagery in support of animal rights) has recently been read, in order to have a clearer sense of how it may be distinguished from the practices of these and other contemporary artists. The positions taken on such matters can be surprising, and it's certainly not a case of finding the purposeful immediacy of the "documentary" image contrasted with the wayward or indulgent creativity of the "art" image. Two examples are considered: Kathie Jenni's essay "The Power of the Visual" and Jonathan Burt's review of the PETA video *A Day in the Life of a Massachusetts Slaughterhouse*.[2] In both cases, the interpretive issues raised by photographic and filmic documentation of the use and abuse of animals are acknowledged to be uncomfortably complex, no matter how apparently immediate and direct the purpose of this kind of campaigning imagery.

Jenni and Burt arrive at this view by different means. Writing as a philosopher, Jenni opens her essay with the assertion that "humans are visual creatures, and this is reflected in our patterns of moral motivation and response." Noting that "the power of the visual is frequently observed," her specific aim is to explore "the moral implications of this truth." Using examples that are sometimes hypothetical and insufficiently specific (such as: "Presented with detailed images of factory farms, the student who dismissed horror stories as activists' exaggerations is forced to acknowledge the neglect and brutality that she had heard of as real"), she arrives at the rather uncritical proposal that "visual presentations elicit a necessary condition of moral response: belief that a problem exists. In this way, the visual enhances moral perception."[3]

The language of her essay repeatedly displays a desire for certainties, and she quotes with approval Jamie Mayerfeld's references to "accurate moral understanding" and to "the true moral state of the world," for example.[4] The visual, however, can all too easily muddy the waters of any such certainties, and this presents Jenni with some difficulties. In trying to tie the power of the visual to an explicitly ethical agenda, she finds herself having to acknowledge that "the power of the visual is frightening, too, because images can be *abused* to arouse misinformed and dangerous passions, as well as morally admirable and constructive ones." Having framed the issue in this way, she is left with a desire to draw lines that will never be easily drawn: "We need to be able to distinguish helpful and legitimate uses of images from morally pernicious ones."[5]

Burt, writing as both an animal historian and a film historian, handles such concerns rather differently. His brief overview of "pro-animal and animal rights films" is less judgmental than Jenni's analysis and more accepting of ethical uncertainties that he encounters in dealing with this material. Given "the barbarity" of the "human exploitation of animals" documented in these films, he notes that "it can be—and has been—argued that there should be no limits to excess, no codes of decorum, or consideration for the viewers' sensibilities." However, noting what he regards as these films' *stylistic* affinity with low-budget "manipulative horror films," he expresses this concern: "Given the possibilities of voyeuristic and sadistic pleasure this imagery also can entail, it could be argued that extreme imagery is much less controllable or predictable in its effects than something more low key. . . . transgressive imagery, by definition, perpetually transgresses its own effects."[6]

The danger, in his view, is that "animal rights videos are at the extreme end of an identifiable, cinematic language which—although highly manipulative of the audience's sensibilities—has very uncertain effects." And one of his worrying conclusions is that if sadism is indeed a feature of this cinematic format, that sadism could (entirely unintentionally on the part of animal rights filmmakers) potentially be "inflicted in all directions."[7]

The difficulties to which Burt alludes are addressed more generally by James Elkins in a short meditation on images of extreme violence, including a sequence of four blurry photographs taken in China in the 1930s

documenting a deliberately cruel and gruesome form of prolonged human execution. Most images of death, Elkins contends—even when they get beyond what he calls art's preference for death's "costume jewelry of signs and symbols"—show death as "something that happens just after or moments before the image" rather than showing the death itself. In the first of these four execution photographs, however, the victim is still alive; by the last she is not. The particular terrible power of these images, he suggests, comes from the way they "hold the idea of death," which happens somewhere "in the sequence, trapped between the frames." He writes: "I know it happens before my eyes and that it happens over and over again as I look at the sequence." His assessment is that "there is also a nearly unbearable immorality to these images."[8]

From there he observes that images this powerful "are also extremely rare. Especially in the art world, where artists continuously struggle to be noticed and there are few boundaries to what is possible, it is odd that most images are not this powerful." The reason is in his view to do with "the nature of the power itself":

> It is too strong for most image making, and if an artist attempts to put one of these images in a larger composition, it will poison whatever is around it. The sheer visceral power of images like these is too much for any modulated, well-considered composition, no matter what its subject might be. So I like to think of this as a problem of relative energy rather than as a question of revulsion against some specific subject matter.[9]

This is useful because (despite its aesthetically conservative wording) it focuses on the formal work undertaken by artists and recognizes the necessity of that work regardless of "specific subject matter." In art, Elkins rightly notes, "the image must be able to speak in several registers." The problem with images as strong as the execution sequence is that they "shout all other images down: they are harsh and importunate, so that they are not only hard to see; they also make everything else hard to see."[10]

In the context of animal rights, as much as in any other, the artist's responsibility is to look and to make looking possible: to "make the world appear within the world."[11] It is driven by the curiosity of Jacques Derrida's

cat: the determination "just *to see*."[12] This is to *shape* seeing but not to "moralize" it. Iris Murdoch is clear about this: "There is no moral vision. There is only the ordinary world which is seen with ordinary vision."[13] This seeing is the framing of its own unframing. It's something *made* in the image, and not (as Wolfe seems to imply) something simply or transparently recorded in the image. And frequently, even in the apparently purposeful context of animal rights imagery, it will turn out to be something surprisingly tentative and open-ended.

Sue Coe: Work That Works

Sue Coe's 2005 book *Sheep of Fools,* produced collaboratively with the writer Judith Brody, was named "nonfiction book of the year" in the 2005 PETA Progress Awards.[14] It traces aspects of the historical development of the present-day phenomenon of the live export of sheep (see Figure 6.1) and is Coe's third book-format work to deal directly with animal rights issues. Like the earlier books *Dead Meat* and *Pit's Letter,* it incorporates drawings, paintings, and works in other media by Coe that were seldom made specifically as illustrations for those publications and weaves them into a narrative in conjunction with the accompanying text. But while *Dead Meat* was in effect an extended diary based on Coe's travels around North American factory farms and slaughterhouses, and *Pit's Letter* was the story of one fictional dog's experience of (and reflections on) various forms of incarceration, experimentation, and abuse,[15] *Sheep of Fools* presents an ambitious and expansive (albeit highly unconventional) historical narrative packed into little more than thirty pages. Subtitled *A Song Cycle for Five Voices,* it takes the reader through the "Song of the Medieval Shepherd," "Song of the Venture Capitalist," "Song of the Modern Shepherd" (Figure 6.2), "Song of the Trucks and the Ships," and finally "Song of the Butcher."
 The book's double-page spreads have been ably described by Jane Kallir as "masterful compositions that combine compassionate observation with dramatic narrative sweep."[16] In many cases they incorporate Brody's rhyming couplets: "A wooly tale of avarice and one that's seldom told: / how merchants spun their fortunes as they turned our fleece to gold." Coe describes Brody as "someone who's not replicating the visual imagery, she's adding something else . . . that *I* can't put in the work." Coe's determination

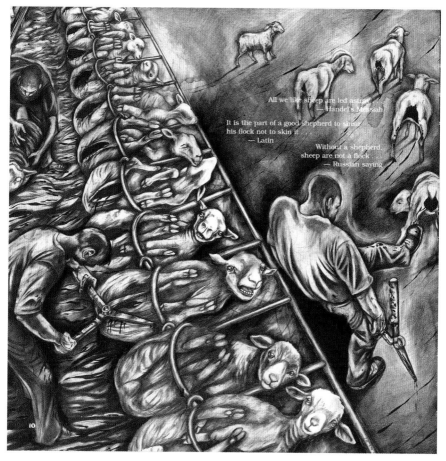

Figure 6.1. Sue Coe, *Sheep of Fools*, page 10. Copyright 2005 Sue Coe. Courtesy Galerie St. Etienne, New York.

was concisely to present the history of how the wool trade "created the British Empire" and to explore its later consequences:

> Just to follow back the trail of wool, and what it meant, because it was never about eating meat, people could never afford to eat flesh, it was about grazing, and about the wolves, keeping the land clear, and getting the wool. Now the wool is worthless . . . there's no money in the wool, there's money in the flesh.

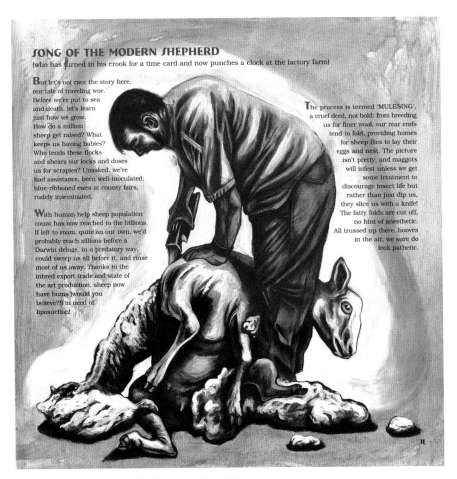

SONG OF THE MODERN SHEPHERD
(who has turned in his crook for a time card and now punches a clock at the factory farm)

But let's not race the story here,
our tale of traveling woe.
Before we're put to sea
and death, let's learn
just how we grow.
How do a million
sheep get raised? What
keeps us having babies?
Who tends these flocks
and shears our locks and doses
us for scrapies? Unasked, we've
had assistance, been well-inoculated;
blue-ribboned ewes at county fairs,
rudely inseminated.

With human help sheep population
count has now reached to the billions.
If left to roam, quite on our own, we'd
probably reach zillions before a
Darwin deluge, in a predatory way,
could sweep us all before it, and rinse
most of us away. Thanks to the
inbred export trade and state of
the art production, sheep now
have bums (would you
believe?!) in need of
liposuction!

The process is termed 'MULESING',
a cruel deed, not bold: from breeding
us for finer wool, our rear ends
tend to fold, providing homes
for sheep flies to lay their
eggs and nest. The picture
isn't pretty, and maggots
will infest unless we get
some treatment to
discourage insect life but
rather than just dip us,
they slice us with a knife!
The fatty folds are cut off,
no hint of anesthetic.
All trussed up there, hooves
in the air, we sure do
look pathetic.

Figure 6.2. Sue Coe, *Sheep of Fools*, page 11. Copyright
2005 Sue Coe. Courtesy Galerie St. Etienne, New York.

This was the context in which Brody's text could provide a "factual con-
crete anchor for the images."[17]

Coe is absolutely clear that the book's audience "will be activists."
She says: "Really this work is directed primarily to activists . . . it gives them
the impetus to increase their desire, *the* desire for social change." She's
equally clear that this is something that art can do, and that *her* art can do.
In an earlier interview for the *Los Angeles Times,* one of her "five tips" for

artists at the start of their careers had been: "Before art can be a tool for change, it has to be art."[18]

In response to the suggestion that that particular "tip" reflected a strong conviction about contemporary art's potential influence and importance, Coe acknowledged: "It's important to me, and it's a voice that worked." The complexity of Coe's distinctive visual "voice" is well caught in Peter Schjeldahl's observation that "her blunt, sooty drawing is ugly and brutal," but that it's done "with such accuracy and economy that a kind of beauty arises. It is the sense of utterly seeing something—anything, never mind if it scalds—once and for all in an unforgettably particular way."[19]

Published by Fantagraphics Books—a name associated principally with alternative comics and graphic novels—*Sheep of Fools* shares the same large, square-page format as the *BLAB!* comics to which Coe contributed several eight-, ten-, or twelve-page illustrated story lines in the mid-2000s. Interviewed shortly before the book's publication, she noted, "I tend to work sequentially, in a mode that I think of as reportage, or visual journalism," and said of other art she admired: "The most exciting work for me today, is sequential art, stories directly observed in cartoon and book form."[20] Publishing in *BLAB!*, where no restrictions were placed on the form or content of her work, she found a freedom that had been unavailable in her work for more mainstream publications. Discussing the process of working on *Sheep of Fools,* she was emphatic that "that's the absolute bottom line of my creative processes—I have to have freedom."

The book's main focus is on the nature and the sheer scale of contemporary live export operations. Coe says of the individual drawings that preceded the book: "What started me on the series was I saw one little newspaper cutting"—about a ship that exploded—"where it said 'one life was lost,' but they didn't count the sixty-five thousand sheep as lives." She soon enough discovered that the ships' crews were nonunionized labor, uninsured and untrained: as she says, "Twenty two men with eighty thousand animals, how does *that* work?"

She spoke of "fascinating bits and pieces that I wanted to put together to make vague sense," and acknowledged that it could easily have become "a bit preachy" if done entirely through language. But the written word is of course not the only alternative to her distinctive drawing style.

Thinking very much of animal rights videos of slaughterhouses and the like, she describes her own chosen medium in the following terms: "The subject matter I address is very difficult to look at in any other form . . . almost impossible to look at." What she's reaching for is that fine line between Schjeldahl's "never mind if it scalds" and Elkins's recognition that without due care such imagery can "also make everything else hard to see."

Some of the images of which Coe is proudest are largely text-free. One double-page spread from the "Song of the Trucks and the Ships" section, for example, shows two ships that are about to pass in the night (Figure 6.3). One, the *Al-Yasrah*, has deck upon deck stacked with sheep, their faces looking out into the night, as two crew members hurl a dead animal overboard. The other, the *Princess Cruise*, has three couples waltzing on the foredeck to the accompaniment of a lone trumpeter. The ships' names are the only text in the whole spread. Coe remarked:

> That's one great drawing. That's the full Sue-Coe-ness. . . . And it's not a great drawing in itself, but it's got exactly the content I want . . . because

Figure 6.3. Sue Coe, *Sheep of Fools*, pages 22–23. Copyright 2005 Sue Coe. Courtesy Galerie St. Etienne, New York.

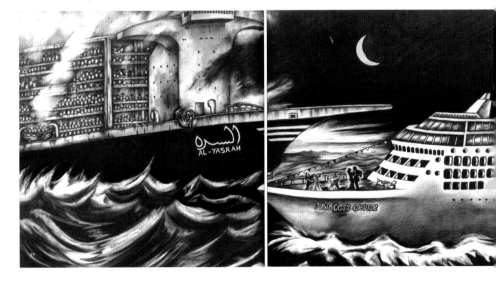

nothing's invented. . . . Just to put those two things together—that makes me happy—because it's not a lie, it's not an artifice, yet it's obviously stylized but it's based in truth. . . . One's a luxury cruise and one's a journey to death.

The key thing is directness, or what she calls "keeping the vision *mobile*." "The urgency of the content has to overcome any art-making process, even though I'm obviously adept at drawing," she says. "I'm always trying to sabotage my instincts. . . . Just to remove any artifice is an art in itself, and that's what I'm always trying to do."

The effort and the uncertainty is evident in a telling distinction that Coe draws, regarding her work as a whole, between *work that sells* and *work that works*—work that sells through the New York gallery that represents her, and work that works in the sense of reinforcing the determination of the animal activists whom she regards as her core audience. The key point that she makes about any single piece of her work is that while she's actually working on it, she can't reliably predict which of those two categories it will fall into: "You can't, you can't," she insists.

Juxtapositions of human and animal circumstances are found throughout *Sheep of Fools*. The page that follows the ships passing in the night shows the fate of the *Farid Fares*, a decrepit ship on which forty thousand sheep burned, as the hapless crew rowed away in lifeboats. It reproduces part of Coe's earlier drawing *Goats before Sheep* (seen in Figure 6.4), which had been made before Coe had any idea that the live export issue would become the basis for a book project. As with other such drawings, sections of Brody's text were subsequently superimposed on "emptier" parts of the image—in this case the sky. Asked whether there was an intentional echo here, in the depiction of the falling sheep, of those indelible images of humans jumping from the Twin Towers on 9/11, Coe replied: "Yes, definitely. . . . the ship is the high-rise building, that's what it is, and they would have been jumping out. It wasn't like I invented it; that would have been true." Other resonances crowd in, too, with Brody's text at the upper right of the page including phrases like "10,000 sheep packed Auschwitz tight."

Coe describes her collaboration with Brody in very positive terms: "Once we started researching, it's endless and it's fascinating and that's the

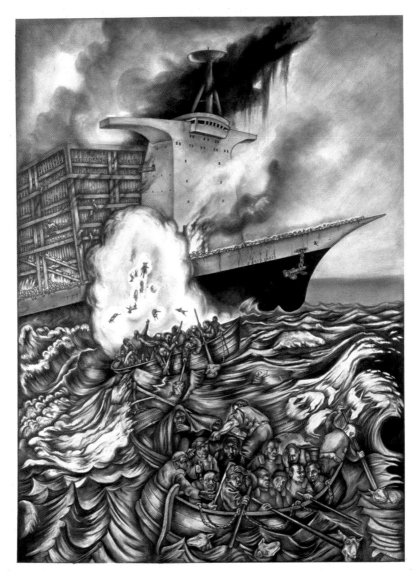

Figure 6.4. Sue Coe, *Goats before Sheep,* 2002. Copyright 2002
Sue Coe. Courtesy Galerie St. Etienne, New York.

joy of it." Brody came up with the idea of the "song cycle," and her "dog-
gerel—she calls it doggerel" is something that Coe very much likes. This
pleasure in the actual making of an artwork that addresses such distressing
events may surprise some readers, but it's an important aspect of Coe's abil-
ity to understand and effectively to handle the skills of her craft, as was her
comment, quoted earlier, about "always trying to sabotage" her instincts,
her facility. It also goes along with recognizing the limits of her skills. She
has never felt entirely satisfied with the balance of image and text in the de-
sign of her books: "It's a failure in every single book I've done," she suggests.
Of one particular artist she admires precisely for the ability to use "the text
and the image as one," she says: "But he's a Buddhist from Japan; I'm a
white working-class woman from Hersham . . . I can't do that same flow."

Flow, and skill, are things that Coe admires wherever she finds them.
Of the sheep-shearer (Figure 6.2), for example, where—as in many of her
images—the folded forms of shearer and sheep echo and cross each other
in a deliberate and sympathetic manner, she says:

> This one, the sheep shearer, I drew hundreds of pictures of him. And
> sheep-shearing is such an art. . . . Their backs go very quickly. The hard
> part is not the shearing, because they do that flawlessly, with no nicks and
> cuts, in thirty-two strokes. But the flipping of the sheep is very hard on the
> back, and they do thousands of those sheep a week, shear them, and it's
> completely painless when they're good. . . . This is an art form that hasn't
> changed in thousands of years, and they're great at it.

It's an image that reflects well enough her working ethos: "quiet observa-
tion without projection." But even when other pages show more gruesome
imagery—such as, on the page to the immediate left of the sheep-shearer,
her fierce depiction of the horrific practice of "mulesing" the sheep (Figure
6.1)—Coe's aim is never simply to condemn those caught up in an indus-
try that creates and permits those practices: "There's a neutrality in how I
depict the human beings, I hope."

The extent to which Coe does achieve a sense of "flow" both within
and across her images should not be underestimated. In the campaigning
poster *Terrorists or Freedom Fighters?* (Figure 6.5)—produced at around

156

TERRORISTS OR FREEDOM FIGHTERS?

Figure 6.5. Sue Coe, *Terrorists or Freedom Fighters?* 2004.
Copyright 2004 Sue Coe. Courtesy Galerie St. Etienne,
New York.

the same time as *Sheep of Fools,* though it harks back to animal rights imagery of the 1980s—the bodily forms of activist and rescued dog echo each other and are folded across each other in a manner close to that seen in the sheep-shearer image. Invited to comment on this comparison, Coe acknowledged it and observed: "They're both done with gentleness." A

different but equally necessary kind of flow runs across the double-page spread of pages 10 and 11 of *Sheep of Fools* (Figures 6.1 and 6.2). The cruelty of the mulesing on the left is balanced by the care of the shearing on the right, and the description of the mulesing is itself placed on the right-hand page rather than the left. It's a clear example of how an artist can handle the "problem of relative energy" that Elkins described, and an acknowledgment of his point that if such imagery is to work *as art*, it "must be able to speak in several registers."

Coe's aim to be true to what she sees, and to address "social justice issues," doesn't always make her work popular, even among the activists she sees as her key audience. But as she says, "they don't have to *like* the work, in fact, many activists would prefer the cute puppy with the halo, you know, because they're regular people, they don't always want the horrible truth of what happens to animals."

Britta Jaschinski: We Will Never Know

Britta Jaschinski's award-winning photographs have been widely reproduced—on the covers, for example, of books such as Randy Malamud's *Reading Zoos* and Linda Kalof and Amy Fitzgerald's *Animals Reader*, to name only two.[21] The principal new photographic series on which Jaschinski worked in the mid- to late 2000s carried the evocative title *Dark* (Figure 6.6). Although, like Coe, Jaschinski makes and exhibits individual images, she has acknowledged that her books are probably the means by which her work initially reached its widest audience. Following *Zoo* in 1996, and *Wild Things* in 2003, she envisaged *Dark* as her third book project.[22] At the time of writing, it has yet to be published, and Jaschinski now seems quite reconciled to the fact that recent changes in the nature of the publishing industry mean that the work may not now appear in book form.[23]

This seems a great shame, because the particular strengths and the distinctive appearance of the photographs from the *Dark* series would have worked particularly well in book form and would have had a quite different impact from their individual or collective display as prints in gallery or museum settings. In the mid-2000s Jaschinski produced several dummy versions of the proposed book, one of which I had the opportunity to see and to discuss with her in detail in 2006. It's that particular version of the

Figure 6.6. Britta Jaschinski, *Tiger,* 2006.
Photograph from the *Dark* series.

project that is the subject of this account—partly to record the complexity of her thinking about the integrity of the series and partly to acknowledge what is lost in the absence of the narrative dimension that the artist had positively embraced at that point.

The *Dark* photographs are all landscape-format, and most of them are indeed dark. That impression was reinforced in the book dummy, where in quite a number of the double-page spreads one of the two pages was a blank, black page—a strategy that had also been used in *Zoo.* Unlike Coe's work, which invariably shows human and nonhuman animals locked together in circumstances that are seldom comfortable, the human is generally absent from or only indirectly present in Jaschinski's work. In *Wild Things,* for example, the principal human "presence" is the text that runs as a single broken line through that book, irregularly interspersed with its many photographs, which takes the form of a letter from the artist herself (printed in the style of lowercase typescript) that begins "dear animals" and ends "your devoted friend." Along the way, it includes the

sentence "human existence is purely accidental," which gives a sense of her perspective on the issues.

Jaschinski describes the *Dark* series as "much more abstract" than the photographs in her earlier books and hopes that there is some degree of progress "in terms of the way I see animals and what I manage to communicate about them." Hers is the difficult process of, as she puts it, "waiting for something to photograph which nobody else has seen before."[24]

Even when she's managed to do so, it may not immediately be clear to her. There's an ongoing process of editing and reediting. One extraordinary photograph of an orangutan is a case in point (Figure 6.7). A lower jaw, an upper lip, a forehead, and part of a left shoulder are just discernible as isolated clusters of fine diagonal lines of light sweeping from left to right across the otherwise black image. The impression is of the animal's forward movement, but it could equally be a retreat, or just as easily the camera's own movement. The orangutan wasn't part of the initial sequence

Figure 6.7. Britta Jaschinski, *Orang-utan,* 2006. Photograph from the *Dark* series.

she had envisaged for the book dummy, but "suddenly I feel like I want this to be part of it," she said.

The rhinoceros, too, "wasn't in at the beginning, in fact it came in, and went out, and then it came back in" (Figure 6.8). Why? "It looks so incredibly lost," she explained—*lost* being a word she constantly used to describe the animals photographed for this project. How, from her point of view, did this particular animal's image differ from that of the rhino in her earlier book *Wild Things*? There, in sharp Dürer-like focus, the sepia image of the animal in profile is seen against what looks like (but is not) a blank photographic studio backdrop (Figure 6.9). Appearing toward the end of the unpaginated book, it was one of a sequence of pictorial interruptions over several pages of a line from the artist's "letter" that has her saying to the depicted animals: "I hope you don't mind me telling you that your strength and craving for an unrestricted existence make you quite anachronistic." Those last four words appear on a right-hand page; the rhinoceros photograph is on the left.

Jaschinski's answer to how the two rhino photographs differed was to say that the one in *Wild Things* "conveys a huge amount of power"; the one in *Dark* is the opposite. In *Dark*, she said, "I'm trying to see it from the angle of the animal rather than the viewer . . . and that's so hard." There's a parallel of sorts here with Derrida's recognition of both the importance and the extreme difficulty of seeing things "from the vantage of the animal," and of imagining philosophy rewritten from that vantage point.[25] For Jaschinski this is grounded in the specifics of the image. "It looks so awkward," she said of the rhinoceros; "what a weird picture. . . . We never *really* look at animals, we look at animals the way we choose to look at animals."

Her priority is to work out "what needs to be said next"—not in terms of her own aesthetic ambitions but in terms of the relation of nonhuman animals to the state of society and the state of the planet. Again, this is no abstract exercise but one that necessarily involves an artist such as Jaschinski in aesthetic decision-making, and she's quite open about being dissatisfied with aspects of her earlier work. Of *Wild Things*, for example, where "you have the color and the black and white, you've got different sizes, you've got animals, you've got nature, and you've got a narrative," she said with a laugh: "It's such a mess, that book, isn't it?" This is why so much care, attention, and revision went into the editing and ordering of

Figure 6.8. Britta Jaschinski, *Rhinoceros*, 2006.
Photograph from the *Dark* series.

Figure 6.9. Britta Jaschinski, *Rhinoceros*.
Photograph from *Wild Things*, 2003.

the dummy versions of the *Dark* book: "in that particular book that's very important for me, the order of it."

Jaschinski also importantly distinguishes her approach from that of certain other photographic traditions: "The more information an image has, the less interesting it is for me. . . . That's why I'm not interested in a lot of wildlife photography." Audiences, she suggested, tend to trust what they've seen before, whereas, she insisted, "I have absolutely no intention of glamourizing wildlife."

Her dissatisfaction with the style and effect of mainstream wildlife photography finds parallels in Matthew Brower's *Developing Animals,* a study of the historical development of the genre that demonstrates how selective and manipulative the rhetoric and vision of wildlife photography has now become. Brower laments the fact that the variety of approaches to "the photographing of animals in nature" in the nineteenth and early twentieth centuries has in contemporary practice "largely been subsumed within the genre of wildlife photography." He proposes that the operation of the photographic blind (itself a development of the hunting blind) was at least partly responsible for the emergence of a visual rhetoric that "transforms animals into spectacle, severing the human–animal connection; real animals, therefore, only exist when humans are absent." This is what he calls "the discursive regime of wildlife photography."[26]

The result is an impoverished iconography that, as Brower puts it, "does not simply soothe a nostalgic desire for direct contact with animals. It structures the understanding of animals." It has lost sight of earlier photographic strategies that worked with the quite reasonable assumption that "the normal condition of animals is invisibility," or that drew attention "to the important difference between seeing and knowing animals," which contemporary wildlife photography "generally obscures."[27] Both of those "lost" outlooks are far closer to Jaschinski's practice and to her ongoing attempts to do something less facile, less soothing: "I think there's nothing worse for a viewer than walking round in a gallery or looking at a book where everything's like, *easy,* you turn the page, you walk around, and it's *easy.* I always want to create a kind of challenge for the viewer. . . . I think I haven't quite done that enough yet."

What exactly are the means, then, by which the *Dark* photographs undo or unsettle or *render uneasy* some of the conventions of contemporary

wildlife photography? First, rather remarkably, by the simple fact that the photographs are black and white, undercutting the "transparency" of a human gaze at the more-than-human world. Second, by the fact that (at least in their proposed book format) there is a considered narrative in which the order of the photographs matters. Third, by the fact that these animals—tiger, orangutan, rhino, sea lion, polar bear, llama, panther, wildebeest, and the rest—manifestly come from a multitude of natural habitats and only come to meet in the book's pages at the direct and purposeful contrivance of the artist. Fourth, by the absence of clues about habitat in most cases, generally as a result of the close framing of these creatures and the darkness of the imagery. A double-page spread of running wildebeest is a rare exception, but still gives next to nothing in the way of visual "information" about the habitat they are crossing. Fifth, the scuzzy haze through which most of the animals seem to be seen might certainly evoke the idea of something seen from the perspective of the animal—if not that of the depicted animal, then certainly that of another nonhuman animal rather than that of a wildlife photographer. And finally, hard though it may be to pin down, there is something in these images of the unrecognized and the unknowable.

In saying of her work, "I don't want to take a picture of anything people know," of course, Jaschinski sets the bar very high for herself. But as much as anything, it's her conviction that her photography is above all "about what we don't know, about the animal" that justifies her hope *not* to be seen as "somebody who preaches." "I think it needs to be said," she adds, "that we will never know."

That openness to not-knowing creates its own difficulties. Jaschinski has in recent years staged exhibitions of her work in museums of natural history more than in art galleries. But the very fact that her photographs are more "difficult to read" than most images seen in those settings, and that, as she put it recently, she is openly "questioning stereotypical wildlife photography"—not least in order to try to address the threat of extinction in her work—seems to trouble curators.[28] In this context, she has given the collective title *Ghosts* to her recent exhibitions of a selection of photographs running from the *Zoo* work of the 1990s to the *Dark* series, and museums have apparently been very uncomfortable with that title.

A specific and rather extraordinary example of this discomfort concerns her 2007 photograph *Ghostly Cheetah* (Figure 6.10). It shows

a cheetah crossing blackened soil in Ndutu, Tanzania, "only days after a huge bush fire had ripped through the area, burning down a vast number of majestic acacia trees" and further depleting the habitat of this already endangered species. When the photograph was shown at the Natural History Museum in London, the museum disregarded Jaschinski's title and chose instead to give it the more comfortingly redemptive title *Out of the Ashes*. The irony of all this is not lost on Jaschinski, not least because her work has started to win wildlife photography awards. In 2010 *Ghostly Cheetah* in fact won the artist the European Wildlife Photographer of the Year award—though only after a change to its rules that had previously excluded black-and-white photographs from consideration.

So the "mission" that Jaschinski sees her work undertaking inches forward, whether or not *Dark* as a book project—which would arguably constitute her most articulate and most "difficult" expression to date of that

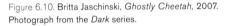

Figure 6.10. Britta Jaschinski, *Ghostly Cheetah*, 2007.
Photograph from the *Dark* series.

mission—ever comes to fruition. But that is the nature of her attentive and exploratory work. As she says, "I always feel like the subtle approach, in the long run, has the greater impact than the in-your-face and pointing your finger approach."

Angela Singer: It Should Be Done Strongly

Angela Singer's uncompromising taxidermic constructions have won her friends in some unexpected places. A 2009 entry on a certain Lady Lavona's *Cabinet of Curiosities* online blog, for example, described her as "Artist, animal activist, goddess!"[29] Singer herself did not particularly care for the accolade, but the growing recognition of her work both within and beyond New Zealand is welcome.

Like Jaschinski, Singer's conviction is that "people need to see animals in a new way" and that "artists can provide the new visual language." The artist's role is to "shock the viewer into a new way of seeing and thinking about the animal." Of an early work, *Portrait of a Naturalized New Zealander* (Figure 6.11)—a work built up from a recycled trophy-kill taxidermy ferret, a rabbit head, a fawn head, pig ears, ferret tails, chicken claws, boar tusks, plastic human mannequin eyes, wax and shellac—she has said that it's "about animal rights":

> It's not ideological, it's about real life and real death. . . . Almost everyone knows something about the reality of animal suffering. It doesn't really matter if the work is understood with anything other than the heart. I would prefer it to be felt, for the viewer to be vulnerable and open up to compassion.[30]

Compassion is perhaps more readily coaxed from her audience in less brutally hybridized pieces. Quite a number of her reworkings of trophy heads or of complete taxidermic animal bodies over the past decade have been encrusted with jewels, sequins, porcelain flowers, and other such materials that may connote beauty and elicit sympathy, but in a complex and often troubling manner (Figure 6.12). Some of these works she describes as her "memorial works": "The animal, having no grave site, no bodily burial,

Figure 6.11. Angela Singer, *Portrait of a Naturalized New Zealander*, 1999–2000. Recycled taxidermy and mixed media.

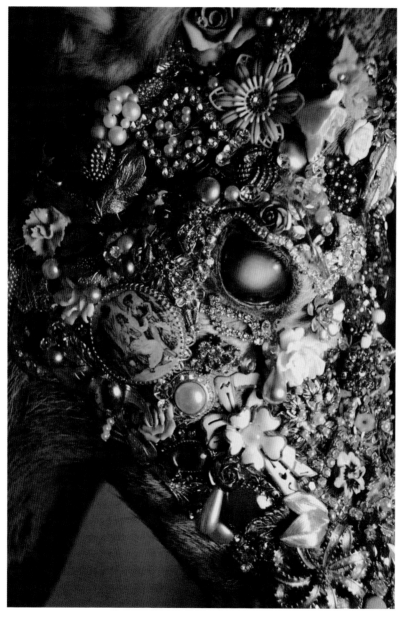

Figure 6.12. Angela Singer, *Unexplained Recovery* (detail), 2010. Vintage recycled taxidermy stag and mixed media. Courtesy of the artist and Weisman Heyman collection, New York.

becomes its own memorial." The artist turns the already dead animal (or animal remains, to be more precise) into an object, a different kind of object, and the object then "works," as it were, on the animal's behalf. Animal advocates unsympathetic to contemporary art sometimes criticize artists for "objectifying" animals—Singer herself reports being accused of turning "gallery walls into open graves"—but her work offers one of the clearest examples of the unsettling power of the animal-as-object.

As she's observed of her working methods, in an interview for the Spanish magazine *Belio*:

> For some artists the material they use isn't important, it's just a way to achieve the object. For me the material, the animal, is everything. Working with the animal body makes me want to investigate what it could have to do with me, with the relationships I have with animals in the world. It confronts me in the safe space of my studio with real everyday brutality.... The animal challenges me to accommodate the frightening.[31]

As that last comment perhaps suggests, Singer herself isn't immune to the effects of her chosen working methods. She notes:

> The brutality of deconstructing taxidermy is unavoidable; it jars the senses, it can be quite unsettling to break apart a fragile, vulnerable body. I don't see any way around the process as I need to make the inconspicuous appear conspicuous. Sometimes I think, "I'll write about this instead" but I don't because my artwork can express this further than I can in words.[32]

This is not necessarily always the case. Describing her early installation *Ghost Sheep*, from 2001, which was made of two hundred and forty discarded sheepskins from a processing plant, she says: "I requested one batch of sheepskins to soak, stretch back into their natural form and dry.... The skins are a gray chalky silver blue and have a glow in the dark quality. I hung them high, using invisible thread, near the gallery ceiling to form a tightly grouped ghost flock. The movement of visitors walking under the work made the flock 'shiver.'" In a letter she sent to me at that time, she wrote of having "been to freezing works . . . and seen the sheep arrive for slaughter":

They sense danger from the scent of blood. The stench on the killing floor is revolting. . . . The sheep and lambs bleat continually, they shake with fear, shitting and pissing *en masse*. . . . The sheep skins are putrid by the time they reach the pelt processors. . . . I was not able to think of the skins as anything other than whole living sheep. . . . Their skins bear the history of their lives and I feel like their witness.

In that instance at least, and even though it's only the photographic documentation rather than the art installation itself that I've had the opportunity to see, her graphic description of its subject matter might just surpass the effect of the shimmering skins in the gallery.

The works from a few years later are often more direct, concise, and accomplished. *Dripsy Dropsy* presents the stark image of a recycled taxidermy rabbit head fused with wax, vintage crystals, and red glass beads, the whole thing encased in a vintage glass dome (Figure 6.13). Singer offers this terse description of it: "A work with two sides—repulsion and attraction, the beauty of the animal and the ugliness behind its death. Death meets decoration in an undoing of the Victorian diorama. *Dripsy* is not lifelike or posed within a 'natural environment', it's in sterile glass, a head on a metal stake." But here it is indeed the object itself, rather than the description, that is unforgettable.

The animal historian Erica Fudge tried to articulate something about the distinctive power of the animal as an object in a marvelous paper called "Renaissance Animal Things," which concerned the use of certain animal products in early modern culture. (Her two key examples were the use of civet as a perfume, and the wearing of one particular pair of dogskin gloves.) She aimed to take seriously "not only the objects themselves, but their active power in the world." To do this she proposed an adaptation of Bill Brown's "thing theory," noting that for Brown, "'We begin to confront the thingness of objects when they stop working for us.'" Fudge's own concern was with both "the *animal-made*-object—the object constructed from an animal, but also the animal-*made-object*: the objectified animal." This object, she proposed, "embodies recalcitrance in a way that makes the animal-made-object an exemplary thing." The "animal that persists" in this recalcitrant object is, she suggested, "a particular kind of animal," and one that can be "a powerful active presence, even in its death."[33]

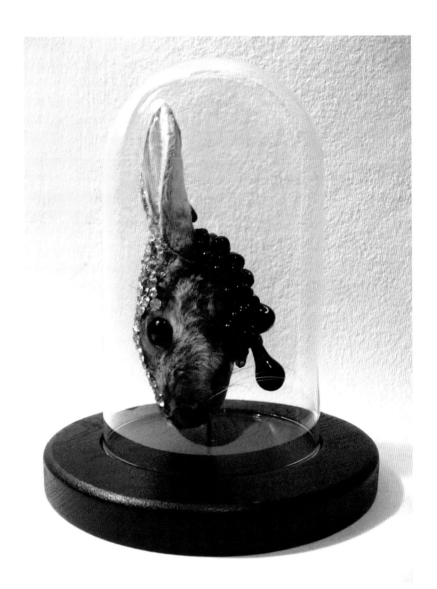

Figure 6.13. Angela Singer, *Dripsy Dropsy*, 2006. Recycled vintage
taxidermy rabbit, wax, glass, crystals, wood.

Fudge gave no examples of what might constitute a contemporary recalcitrant animal thing, or any indication of whether an artwork deliberately intended to overturn the earlier anthropocentric uses of its animal materials might count as such a "thing." But Singer's sculptural *détournement* of hunting trophies and the like seems, at the very least, to operate in a similar realm, to similar effect.

In relation to what she calls the "flawed dead animal" of her recycled and "botched taxidermy," Singer has said: "I don't see an animal separate from myself; there is permeability to the boundaries separating other species from us. . . . it draws me closer because it's not beautiful, not sentimental, not what animal art is meant to be."[34] As she insisted some years ago, art of this kind "should be done strongly, and for me that means using animal bodies that retain the look of a living body because the animal body speaks to the viewer's human body. Lines of body communication are opened up. In our gut we know human and animal are interdependent."

How to make works that address that conviction is an ongoing challenge. Among her recent works, *Spartle* (Figure 6.14) is particularly compelling because its look—somehow arrived at in the coming-together of the recycled taxidermy hawk, modeling clay, and wax of which it is composed—is utterly baffling. There's something terrible in this object's floundering, flailing, foundering, failing-to-be-an-animal. And its power as an object is in that instability, that inserting of an instability into human expectations of the natural world. It's a useful reminder that artworks are objects, not ideas, and they have to work as objects. Whether and how they do so will shape what they can convey or communicate. These things are determined by the *form* of the artwork, by the thickness of its form, and in many cases by its resistance to ready interpretation.

Singer explains that with *Spartle*, "because it's quite an abstract work," she had initially to consider spatial constraints because she knew that she wanted to exhibit it in a glass dome, which influenced how big it could be, and in particular how far the sculpted clay shapes coming out of the bird's head could extend. In the end, she says, "I think that containment was really helpful, because it became a really intimate work, working with it really close up." With works of this kind, she explains, "when I get the taxidermy pieces they're usually damaged," so early work on a piece typically involves some restoration and repair, "just because they've come

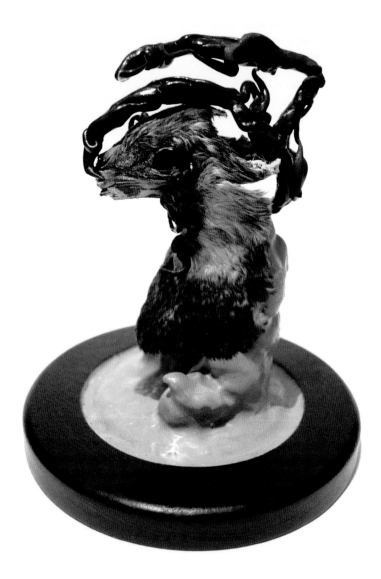

Figure 6.14. Angela Singer, *Spartle,* 2009. Recycled vintage taxidermy hawk, modeling clay, wax, wood.

to me in this terrible condition." A major problem is the fact that "old taxidermy is such an unforgiving material":

> It's incredibly thin, the skin, it has no give whatsoever, it's like dealing with tissue paper, and it requires incredibly delicate handling, but at the same time because when I'm taking them apart there's usually metal inside, or bone, then there's this *wrenching*, so it's a combination of trying to be delicate with the outer while still busting through, getting through the inner workings.

Working with equipment ranging from "quite delicate dental tools all the way up to the saws and hammers," Singer is acutely aware of "the problems in handling an animal's body, handling it with respect but still being able to make the artwork I want to make. Just because there's so much pulling apart and destroying in order to create." Her initial discomfort with working with taxidermy in this manner was something she had to overcome "because I wanted to use that as the medium to express what I wanted to say about animals and how we treat them." She openly acknowledges that "it's bizarre that I'm handling these animals so roughly" in order to comment through her work "on how we treat animals so badly."

Returning to the taxidermy used in *Spartle*, she observed: "This one, the hawk, was beyond repair, it's absolutely gutted and dried out, and the person who'd had it, their cat or dog had ripped all the innards out." Generally the idea for a piece "mainly emerges from working with the materials: even pieces that look like they've been put together *just so*, they just tend to happen, it's kind of like I know what animal or bird I want to work with, and if the person who's given me the work has told me its backstory, that's really what I'm working with, and I just see what happens."

In the case of the hawk, she says, "I really responded to this head and the opening up at the back and wanted to create something to fill that." The resulting modeling clay forms that flail around the bird's head had no clearly predetermined identity or purpose: "When I was making it I wasn't sure whether these were going into the shell to fill it up and to create some kind of new body, or whether it was coming out of it. I just really liked this idea of fluidity." This fluidity or open-endedness extends to the interpretation of the work: "I thought it would be interesting to make this quite

abstract form so that people would bring their own interpretation or their own questions to it, and I'm not really giving them very much."

The elements of abstraction and ambiguity here do not represent a move away from the conscious awareness of animals with particular lives and animal bodies with particular histories. Of the pieces such as *Spartle* that have been placed under glass domes, Singer suggests: "I think it almost says that they're so damaged that they need protection, they are parts, they're no longer part of a whole, they need some form of reverence . . . and they need to be honored."

This is never a matter, however, of telling the audience what to think—even when they ask. In relation to this she recalls an incident concerning *The Inseparables*— "the one with the small goat that's got lovebirds around it" (Figure 6.15):

> I was showing it to a collector who was thinking of purchasing it, and
> whether or not they wanted this work depended on whether the birds

Figure 6.15. Angela Singer, *The Inseparables,*
2009. Recycled taxidermy and mixed media.

were hugging this little baby kid, and protecting it, or whether they were attacking it . . . and I said well we're not going to have a sale then, because it is what *you* decide it is. This wanting to be told what the piece means, so that the viewer knows how to *feel* about it, is to me really disconcerting. And I think it's a problem.

It's a problem precisely because some of Singer's work "does invoke strong emotions" and does so deliberately. As she rightly insists: "I don't think that I should be required to say anything that softens that, or helps people out of feeling whatever they feel." In this regard, the importance of elements of ambiguity is not to be underestimated. In a particularly powerful statement about contemporary animal art in her interview with Giovanni Aloi, Singer says:

> Work that seeks to persuade viewers to take a specific form of action can be quite awful. It can also be sanctimonious and literal. Trying too hard to show the issue you're addressing can lead to dull passionless art of little interest to anyone except those concerned with the same issues. For me the best art is difficult to "read." Returning repeatedly to an artwork that does not give up its meaning easily is a great joy. A great infuriating joy.[35]

What Does Art Add?

So, back to the question that opened this chapter: what does art *add*? What does art bring to the cause of animal rights that cannot be delivered by the terrible and necessary photographs and film footage of animal abuse that are all too familiar to animal advocates?

For Coe, Jaschinski, and Singer, this much can certainly be said: art *doesn't* bring answers, or certainties, or "information" in any straightforward sense, though there's certainly an intention on the part of these three artists to engage with what they see as truth or truths. For each of them, art entails provisional decision-making, a preparedness to make changes, and an acknowledgment of the risk of failure, of the audience not getting it, or getting it "wrong." In relation to viewer reactions to her own work, Singer

asks (and answers): "Do many of them *get* the animal rights message? Some do, some don't."[36] Yet this uncertainty can be seen as something to be welcomed. As Coe notes, "What is intriguing about being an artist, over most other professions, is that there are no right or wrong answers, there is only the search for meaning."[37]

These may not sound like clear positives, so, what else? Art brings questioning, and an avoidance of the *easy*. Jaschinski talks of her attempt to "lure the audience into something." Singer says: "I want the audience to come away with questions, not obvious answers."[38] But she has in mind a purposeful questioning: people "understand what an animal is meant to look like. If it has been altered they know it and they can question why."[39] It unapologetically brings ambiguity—"the most political art is the art of ambiguity," Sue Coe has said—and at all costs it involves the avoidance of "preachiness."[40] Each of them would agree on this. It involves the attempt to turn meanings around (as in Singer's taxidermic transformations) and a belief in the possibility of using art to see animals differently, to see them anew. But here again the discussion is about attempts, and beliefs, which may or may not come to anything.

What else does art add? In the case of all three artists, there's what might rather loosely be called a *warmth* to the work: it's there in Coe's sympathetic rendering of the humans who get caught up in the industries of animal abuse, in each of the artists' care in the handling of their materials, and of course in their concern for the animals that are the subject of their work. In conversation in 2009, expressing surprise that Wolfe should have raised the "What does art *add*?" question at all, the artist Yvette Watt expressed a similar idea in more articulate terms: "The one thing it really adds is somebody making a considered emotional response."

For each of the three artists discussed here, along with that considered emotional response goes a formal rigor, a formal toughness, an understanding of the medium being used, and of the history of that medium, and of the scope for working with *or against* that medium. And for each of them—and this is what separates them (and a few others) from a lot of equally well-intentioned artists with similar convictions—it involves vigilance in never allowing this warmth to slide into a comforting sentimentality. As Coe's work demonstrates (Figure 6.16), this need not preclude the occasional moment of gleeful reveling in the effects of human stupidity

Figure 6.16. Sue Coe, *Lucky Shot!* 2007. Copyright 2007
Sue Coe. Courtesy Galerie St. Etienne, New York.

when that stupidity misses its intended animal target. To borrow Singer's
words, if it's worth doing at all, then "it should be done strongly."

Does that guarantee that the art will "work," that it will indeed "add"
something? No, it does not. But it's a matter of artists being, and working,
in the difficult messy middle of things, and *still* trusting in the processes
and the objects with which they work. This outlook can most readily be

clarified by contrasting it with a particular philosophical perspective or mind-set. At the 2009 Minding Animals conference in Australia, during a panel discussion on the question "Does philosophy have anything new to say about animals?" Dale Jamieson offered the view that philosophy's key contribution to debates about animal rights, and its primary responsibility in that context, was to offer a "consistent" and "coherent" perspective on the issues.[41] This view was not challenged by the other philosophers on the panel, Peter Singer and Bernie Rollin. Whether such a view is a sustainable one in a contemporary context is an open question, but it reflects a confidence about philosophy's ability to engage with the world, and to achieve its intended effects. That same confidence is also acknowledged in Cora Diamond's suggestion (again in relation to questions of animal life) that there is an expectation that philosophy—as distinct from novels and poems, for example—is "meant to settle" things.[42]

And one way to answer the question "What does art *add*?" is by saying that artists generally understand something both of the messiness of the world and of the messiness of their work, especially in terms of the precariousness of trying to get the latter to affect the former in any "consistent" or "coherent" manner. Does this mean that art almost invariably fails? It generally fails "to settle" things, admittedly, but it very seldom sets out to do so in the first place. It would be too easy to say that it more often *unsettles* things, though its effects are often regarded as unsettling, and for all three of the artists considered here there is evidence of their preparedness to embrace the unsettling aspects of their practice, both for themselves and for their audiences.

Certain philosophical traditions have perhaps been slow to recognize that all this messy undoing may be at the heart of the distinctive kinds of formal rigor and ethical engagement that characterize much contemporary art practice. In this context, the statements "this is how it works" and "this is how perilously close it comes to not working" are effectively inextricable. That risk, that precariousness, is a necessary part of what art can bring to the table. It was very much in this context, and with an awareness of artists' distinctive ways of doing things, that the philosopher Rachel Jones, responding to a question from the audience at the symposium On Not Knowing: How Artists Think, stated: "I think that philosophers have more to learn from artists than the other way around."[43]

But it's not a competition, of course. It's about seeing and embracing opportunities. "We are the changes we want to see," Coe has said.[44] Glib as that may sound, it chimes with Francisco Varela's conviction, in *Ethical Know-How*, that a particularly persuasive model of "ethical behaviour"— and one that contrasts markedly with "the dominant Western tradition of rational judgment"—involves what he calls "a journey of *experience* and *learning*, not a mere intellectual puzzle that one solves." And this only happens, he suggests, "when the actor *becomes* the action."[45] If, just at the moment, it's artists rather than philosophers who are more inclined to adopt and to act on that view, Coe may be right to insist: "There is a gigantic maw out there, starving for pictures, an opportunity for artists who can create their own worlds and share them without waiting for permission."[46] As long as it's not forgotten that art's role, and art's strength, does not lie in resolving things, settling things, and then putting them comfortably aside, Coe's may be a positive message both for contemporary art and for animal rights.

If that sounds altogether too comfortable as the conclusion to a chapter about artists whose work is marked by *a refusal to reassure*, there is another way to express it, another way to articulate the answer to Wolfe's question "What does art *add*?" Ironically, it comes from Wolfe himself. Writing very persuasively of the importance of disciplinary specificity within the apparently interdisciplinary field of animal studies, he acknowledges the need to "recognize that it is only in and through our disciplinary specificity that we have something specific and irreplaceable to contribute to this 'question of the animal' that has recently captured the attention of so many different disciplines: not something *accurate* to contribute, but something *specific*."[47] That is precisely what art adds—and, as importantly, it's what the practices of individual artists have the opportunity to add.

On Relevant Questions

ISABELLE STENGERS MAKES the simple but singularly important obser-
vation that "there are no good answers if the question is not the relevant
one."[1] One reason for its importance was noted in the introduction's ac-
count of the debacle around Marco Evaristti's goldfish, where the im-
porting of particular kinds of ethical expectations into the discussion of
contemporary art allowed less-than-relevant questions to flourish. In that
sense it's instructive that Stengers makes her observation in the context of
a short paper that itself addresses questions of ethics.

In "The Challenge of Complexity: Unfolding the Ethics of Science,"
she asserts that ethics, as she understands it, "is first linked with keeping
alive the sense of wonder." And "unfolding" the ethics of science offers op-
portunities for "emphasizing openness, surprise, the demand of relevance,
the creative aspect of the scientific adventure."[2] The word *unfolding* seems
carefully chosen, suggesting something between finding and making, that
will only be made evident with an attentive eye and a light touch—and, it
must be said, with disciplinary rigor.

For all the interdisciplinary potential of a field like complexity the-
ory, she is insistent that the sciences can offer "no universal key" and that
"nothing can take the place of the process of creation of relevant questions
in each field." Neither science nor philosophy in themselves can identify

the relevant questions to be asked in the field of contemporary art, for example. Stengers proposes that new developments in any field should "be first appreciated as . . . precious new tools for thinking." And she notes of them: "Tools modify the ones who use them. To learn how to use a tool is to enter a new relation with reality, both an aesthetic and practical new relation." Apart from anything else, they "may free us from the intellectual habit of relying on the obvious identification of what is to be explained." A sensitivity in their selection is imperative. This is the context in which she writes:

> There are no good answers if the question is not the relevant one. Tools are demanding—they do not confer the power of judging, they ask for the choice of the right tool for the right situation. In other words they oblige us to think and wonder.[3]

In what she calls her "definition of ethics," "the production of relevant questions is always an event, a selective and demanding creation." Above all, she warns against the danger of "transforming precious tools for thinking into a universal source of answers."[4]

Relevance is presented by Stengers as something simultaneously creative and ethical. Its absence is neither. The attraction of these ideas for thinking about contemporary art seems clear. Art consists in the shaping of just such "precious tools for thinking." The kind of ethics that seems to see itself as "a universal source of answers" may be keen to barge in with ready-made rulings, but the relevance of many of its answers is, at the very least, open to question.

7

"The Twisted Animals Have No Land beneath Them"

> To begin with: there are bodies and there are places.
> —Edward S. Casey, *The Fate of Place*

> Derrida asks . . . "Does the animal produce representations?"
> —Lily Dog, in Kathy High, *Lily Does Derrida*

TOWARD THE END of *A Thousand Plateaus*, Gilles Deleuze and Félix Guattari characterize the works of "nomad art" that they admire in these terms: "The twisted animals have no land beneath them; the ground constantly changes direction, as in aerial acrobatics; the paws point in the opposite direction from the head; the hind part of the body is turned upside down" (see Figure 7.1).[1]

The task of this final chapter is to pursue some twists and turns of its own. Where earlier chapters offered a relatively descriptive account of particular artworks and of the views of the artists responsible for them, the approach here is more speculative. The bulk of the chapter takes the form of three fairly lengthy "speculations" about the ways in which animals figure (or do not figure, or might figure) in contemporary art. They address, respectively, the *place* of art's animals, the *form* of art's animals, and the *medium* of art's animals, drawing partly on the evidence of artworks presented earlier in the book. These exploratory perspectives are not the building blocks of a "theory." They could be regarded as continuing to pursue the relevant questions that Isabelle Stengers sees as the prerequisite for arriving at good answers, but they shouldn't be mistaken for an attempt to frame those answers. The title of the chapter is not "Contemporary Animal

Figure 7.1. Dave Bullock, *Hare and Buzzard no. 9,* 2004. Mixed media on paper. Photograph by Neil McDowall.

Art: The Answers." To begin, however, a few examples and ideas encountered in the later stages of working on this book are presented, because it's these that have, unexpectedly, prompted and shaped the speculations that follow. The first concerns an artist with a specific interest in things that "twist and work side by side."

Complex Entanglements

Fieldwork, an artist monograph showcasing the work of the young Finnish artist Sanna Kannisto, whose substantial body of photographs was comparatively little known, was published in 2011.[2] Kannisto makes all her work in tropical rain forests, and *Fieldwork* presents photographs from the

eight lengthy trips she had made since 2000 to the forests of Brazil, French Guiana, and Costa Rica, where she worked alongside scientists in biological field stations for two or three months at a time.

Kannisto is clearly fascinated by scientific procedures and the history of scientific representation, but she describes herself as trying through her photographs "to reflect the opposite perception of the world to the scientific. The forest is present as something that we cannot quite reach or explain. It's uncontrolled and chaotic."[3] In this respect her concerns differ significantly from those of the biologists she meets in the rain forests: "Field science is a lot about measuring things," she notes wryly.[4] Her attention seems instead to be on what slips away, or with what only just remains in the frame, which even when "caught" there may not be quite what it seems.

Phasmidae, for example, is a photograph taken in the artist's portable "field studio" (Figure 7.2). This forms a temporary work station that packs down as a pile of Plexiglas plates and can easily be put up either in the forest under a tarpaulin or indoors in the field station. She describes it as "an isolated space that has the feeling of a laboratory, and a white background." The black velvet curtains to either side cast shade on the plants, animals, and scientific paraphernalia that she briefly places there to photograph, and they deliberately enhance the stagelike theatricality of the space. *Phasmidae* has a strong sculptural quality not uncommon in Kannisto's photographs. The thin branches look almost as though the forest itself were pacing out the space available to it, figuring out just how little it would take to fill and to appropriate the artist's space—a neat reversal (or mirroring) of her own traversal of the space of the forest on her long daily walks through it. And the two stick insects—all too easy to overlook despite the title *Phasmidae*—set up further scaled-down echoes of the branches, elusive even in the glare of the studio lights.

Even in the case of photographs showing fragments of the forest without the "framing" device of the field studio, viewers cannot always reliably judge what they are seeing, or the extent to which the artist may have had a deliberate hand in it. Her 2006 photograph *Abandoned Study,* by its title alone, stages a set of expectations only to frustrate them. What sense could begin to be made of its tangled mass of undergrowth and

Figure 7.2. Sanna Kannisto, *Phasmidae,* 2003. Photograph.

wiring that a praying mantis has apparently happened upon? As Kannisto muses: "Abandoned study, study left behind, study that fell into decay: it's not serving its original function any more; it's mocking the exactitude of science."

A similarly playful approach can be seen in *Private Collection,* one of seven photographs since 2000 in which the artist herself figures prominently (Figure 7.3). With a brightly illuminated sheet suspended from branches in the forest night, it gives the impression of an open-air reconstruction of the space of the portable field studio. Here, however, it's not only moths and other insects that are caught in silhouette in the light, against the white rectangle of the sheet, but also the artist. And despite the lamp on her head and the hard-to-identify subject of her "scientific" gaze, her pose at that instant makes it look as though she were caught up in a

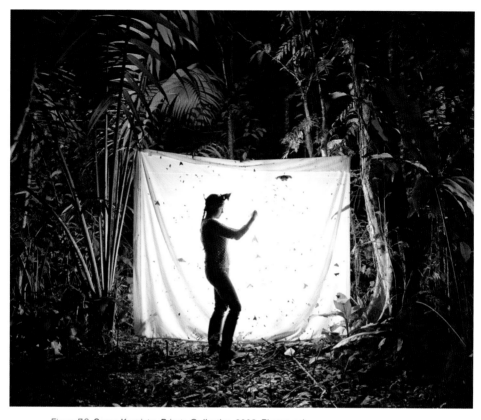

Figure 7.3. Sanna Kannisto, *Private Collection,* 2003. Photograph.

dance with the insects, a nocturnal revel. The image is one of benevolent containment, framed above by the arch of palm fronds and branches, and below by the arc of the sheet's folds.

Of her own presence and calm attention in some of these photographs, she comments: "When you are quiet, calm, perceptive, you can see hidden things. The knowledge I have gained is not just about how different habitats, plants and animals are interacting. It's a kind of instinct, or being animal-like yourself." It's the taking on of a degree of imperceptibility, like the stick insects, or the praying mantis in *Abandoned Study*—a photograph that deals "with situations where natural processes and something made by humans tangle up with each other." It's a reflection on (and

a picturing of) the way that binaries such as "chaos and reason" often "twist and work side by side."

Twistings and entanglements pervade Kannisto's work, as does the delicate balance she maintains between the claims and the methods of art and of science. As she says, "I see equal efforts there, equal determination. . . . I guess in my work I want the two approaches to be able to live side by side—where else but in art would that be possible?"

In contrast to the relentlessly specialized inquiries of the scientists Kannisto works alongside, however, her own determination to improvise some kind of holistic inquiry that might even begin to acknowledge the "overwhelming" diversity of the forest feels much closer to research in fields such as complexity science and biosemiotics, which emphasize the value of viewing organisms and ecosystems as complex wholes. As Fritjof Capra explains, "human hierarchies, which are fairly rigid structures of domination and control" are "quite unlike the multi-levelled order found in nature." He continues: "The web of life consists of networks within networks. . . . In nature there is no 'above,' or 'below,' and there are no hierarchies. There are only networks nesting within other networks."[5]

This is very much what Kannisto's images depict. Even the photographs in which she herself figures prominently are not so much self-portraits as another way to picture the forest itself. In a sense, all of her photographs show the same thing: the totality of the forest and the condition of its representation. And in that sense her work, as much as the rain forest itself, is a recursive living system, renewing itself by reworking itself.

Kannisto brings an entire history of representation into play in this forest imagery. In her 2010 photograph *Chlorophanes spiza*, for example, the shapes of the clamp and the leaves and the green honeycreeper's beak echo back and forth across the image, but the whole construction held by the clamp—bird, leaves, and blossoms—has the clarity and simplicity and flatness of a margin illustration from an illuminated medieval manuscript (Figure 7.4). "It is inevitable . . . that my work has something in common with the history of photography, early natural history illustrations, or the traditions of still-life painting," she has stated. "In this way my images are not alone in the world."[6]

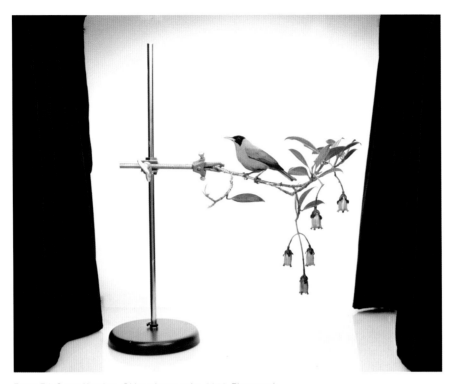

Figure 7.4. Sanna Kannisto, *Chlorophanes spiza*, 2010. Photograph.

Images That Might Count as Art

Kannisto's question "where else but in art would that be possible?" recalls both Eduardo Kac's observation that if artists don't "raise questions about contemporary life, who is going to do that?" and Sue Coe's insistence that "before art can be a tool for change, it has to be art."[7] These are three subtly different points, but each stands as a reminder of how contemporary artists see the responsibilities of *making art,* as distinct from the responsibilities of making statements about the more-than-human world by other means.

These observations are indirectly prompted by James Elkins's on-line essay "Why Art Historians Should Learn to Paint," which addresses his conviction that "art history would be written very differently if most of its practitioners were also practising artists."[8] It centers on an exercise that

Elkins regularly sets for his art history class. Over a fifteen-week period, each student is required to make as exact a copy as they can of an old master painting in the Art Institute of Chicago, working their way through the creative arc "from enthusiasm to boredom to exasperation to fascination" as the weeks pass.[9]

The essay presses for a keen and inquisitive looking that relates to how artists themselves look at the world. While acknowledging that for many art historians it is significantly "harder to think about studio problems" than to explore theoretical perspectives that are safely "bounded by philosophical concerns," Elkins nevertheless argues that "it is possible to notice what goes unnoticed in art history. To some degree it is a simple matter of looking closely, up to the point where generalities no longer hold sway." In this, vitally, he takes the experience of artists seriously, in order modestly to suggest "how easy it is to begin to pay attention differently."[10]

But two of the conclusions (tucked away, oddly, in image captions) that Elkins apparently draws from the student exercise are more problematic. In saying, "There isn't any reason why art historians should paint *well*," he points to the limits of any exercise in mere copying. More seriously, in adding, "There isn't any reason why art historians should try to make actual artworks—images that might count as art," he seems seriously to undermine a crucial dimension of the case he might have been expected to make.[11] In the context of contemporary art (where painting *well* isn't necessarily the most urgent concern, and where some artists might go along with Adam Phillips's view that "doing something properly is a way of not doing it differently"),[12] to invite art history students to make artlike objects without needing to engage with the difficult questions of *whether and why and how these may or may not "work" as art* is to risk failing to engage with a vital aspect of the working experience of the contemporary artist.

Questioned directly about his rather surprising view that "there isn't any reason why art historians should try to make actual artworks—images that might count as art," Elkins responded as follows: "I meant 'art' in a wider sense, having to do with received social significance. I meant that it's not something to . . . worry about, while trying to experience what marking might be."[13] For an artist and writer with a long-standing commitment to the practices of painting and drawing, that emphasis on *not worrying*

about the conceptual status of mark making "while trying to experience what marking might be" is wholly understandable.

As to why art historians *should* "try to make actual artworks," it's certainly the case that making artwork can be a way to pay attention to what other artists do, a way to take them seriously—but it cannot *only* be that. In a parallel to the assertion in the present book's introduction that creativity cannot be untrusting, it is tempting to add that art cannot be calculating. More precisely, artworks made simply as a calculating way to learn from other artists or about other artists would be of severely limited interest, as they would seem to have little *of their own* to offer to viewers. Artworks are things that have to find and to secure their own necessary form, their own integrity, their own forward momentum. This had not really occurred to me until I started—rather unexpectedly, having made no new work of my own for many years—to make a series of animal-themed works in the later stages of researching and writing this book.

In 2009, a year before reading Elkins's online essay, I began making a series of photographic works under the title *Norfolk Roadkill, Mainly*. In taking the liberty of describing aspects of that series here, the intention is not to make any claims to the worth or interest of the work itself. It is, instead, to show exactly how this work engaged me—accidentally but perhaps inevitably—in considering in a new light some of the questions addressed in this book.

This ongoing series has a simple standardized format. In each "stacked diptych," as Susan McHugh has called them, two photographs are juxtaposed.[14] One of each pair shows roadkill encountered and photographed while cycling the country lanes of Norfolk, a largely rural county in the east of England with a particularly rich medieval heritage, to which I had recently moved. Each such image is paired with another photograph taken in the area, though there is no necessary connection between the two other than the geographic proximity of their subject-matter (Figure 7.5). Roadkill is ubiquitous on Norfolk's roads, even on its quiet country lanes, but prior to noticing the strikingly twisted and flattened form of one particular rabbit's body in June 2009 on the winding road between the villages of Ranworth and Woodbastwick—a body that I cycled past but then turned back to photograph, without quite knowing why—I'd had no thoughts of making work on the subject.

Figure 7.5. Steve Baker, *Untitled*, 2009. Photograph from the series *Norfolk Roadkill, Mainly*.

Having started to notice roadkill, and to think about bringing it to the attention of others, it became apparent that the decisions I'd be drawn into, in making such work, would almost inevitably have something in common with the kinds of formal and "ethical" decisions being made by some of the artists I was writing about, who use or create animal imagery that can be controversial or distressing or violent looking, but is never intended to be gratuitously shocking. This was an intriguing prospect, but it also involved the recognition that I'd be doing two distinct things that were probably irreconcilable. As I acknowledged to McHugh: "A pseudo-academic investigation (that happens to be conducted by making imagery myself) into how other artists make decisions about their own animal imagery may not sit easily alongside (or map itself on to) the simultaneous desire to make a body of work that stands up on its own terms."[15]

The initial decision not to present the individual roadkill photographs as artworks in themselves was made for two reasons. First, and probably most importantly, it just didn't seem sufficient. (That others, including the environmental artist Bob Braine, had done so did not seem relevant.) Second, I didn't want the work to be read (as seemed likely) either as gratuitously gory, sensationalist, and exploitative, or else as didactic, moralizing, and sentimental. How to figure out the formal decisions that might discourage such "obvious" readings was a key concern and is one of the factors that led to the pairing and stacking of images. These less than self-explanatory pairings aimed to open up the available readings of the depicted animal remains without directing viewers toward any specific interpretation of the imagery (Figure 7.6).

In putting together the pairings it soon became apparent that formal questions predominated. Much as Robert Adams wrote of W. Eugene Smith's experience as a combat photographer, I found myself "looking at bodies first as elements in a composition."[16] This seemed neither odd nor inappropriate. Encountering those bodies (especially just-killed bodies) on the road was in some cases extremely distressing, but the work of photographing them and of subsequently finding images with which to pair them was entirely about formal decision-making. "Ethical" questions, if they figured at all, seemed to look after themselves. This experience may correspond to points made about other artists in previous chapters, but here it was learned directly.

Figure 7.6. Steve Baker, *Untitled*, 2011. Photograph from the series *Norfolk Roadkill, Mainly*.

In *What Is Posthumanism?* Cary Wolfe makes the point that Niklas Luhmann's "redefinition of form"—especially in his book *Art as a Social System*—"uncouples the question of form from the humanist project of moral edification and ethical education," and that this is the sense in which it offers a "posthumanist" account of form.[17] I wouldn't presume specifically to call *Norfolk Roadkill, Mainly* a posthumanist project—it has already been suggested in chapter 5 that most contemporary artists probably veer at times between humanist and posthumanist modes of operation—but the series certainly aims to distance itself from anything like "moral edification" and to frustrate readings that seek to recuperate it for such purposes. In practice this is attempted (if not always achieved) by avoiding or rejecting pairings of images that might invite "easy" readings—readings that manage to find unintended symbolic or sentimental or even narrative connections in the pairings. And in that sense I certainly recognized the value of Luhmann's own observation that "art aims to *retard* perception and render it *reflexive*. . . . Art communicates by *using perceptions contrary to their primary purpose*."[18]

One unanticipated formal consequence of the decision to pair the images was the effect of dilution. On their own, unanchored and uncontextualized, the roadkill photographs may have looked gratuitous, but they were also at their most blunt, brutal, and uncompromising. Paired with a detail of a painted medieval rood screen, or a close-up of the contents of a rock pool, that effect was undoubtedly diluted. Working out how to avoid having the nonroadkill image in the pairing serve simply as a compensatory image, offering the eye a refuge from the gore, and getting it instead to begin to draw out something different (perhaps even beauty) in how the roadkill might be seen, was a slow process. It certainly made me more aware of the skilful balancing acts in, for example, Angela Singer's jewel-studded taxidermy, Lucy Kimbell's use of warm language to communicate harsh truths, and Sue Coe's occasional juxtaposition in *Sheep of Fools* of brutal and caring practices on facing pages. It also made me realize much more clearly that with much animal subject-matter, the artist's role is partly to weigh *and to temper* the emotional heft of the material.

In the course of making *Norfolk Roadkill, Mainly*—a series that records and marks the violent deaths of particular individual creatures—I gradually came across at least a little of the art and literature on roadkill,

from Bob Braine's photographs to Barry Lopez's essay "Apologia."[19] Lopez calls his own actions on encountering roadkill—moving it off the road and in some cases burying it—"a technique of awareness."[20] I, on the other hand, photograph it, leave it exactly where it is, and cycle on, though I'd like to think of the subsequent putting-together of the pieces in the series as a technique of *inviting* awareness.

The work has its shortcomings, of course. My severely limited skill and experience as a photographer is the most obvious of these.[21] There is also, perhaps, a stiltedness to some of the pieces that's not simply a consequence of their standardized layout. I always liked the comment that John Cage made about one of Robert Rauschenberg's early paintings: "This is not a composition. It is a place where things are."[22] Here, however, despite photographing things exactly as they are and where they are, the resulting pieces are rather conventional compositions. The highly charged question of aesthetic conventionality in animal representations resurfaces, in relation to other artists, at the end of this chapter and in the afterword.

Animals, Locations, and Dislocations

On the evening of September 28, 2010, Sophie Utting's video footage of Elena Italia's performance *Untitled: Orange Overall, Seabass* was projected on three walls of the main L-shaped space at Stew, an artist-run gallery in Norwich. Each projection showed a different edited section from the filmed record of Italia's exhausting eight-hour barefoot walk around Norwich and its outskirts one day in June 2010, dressed in an orange overall and carrying a fairly large farmed European seabass in her hands, which left her with rashes on her arms as the fish gradually liquefied in the heat of the day.

In conversation some time after the screening, Italia described the June performance as a kind of "purification" ritual that involved simultaneously "forgetting" and "flagellating" her own body. The route she followed, with which she was not familiar in advance, had been designed by a colleague with research interests in psychogeography. Dressed as what she called "a pariah," Italia experienced both "power *and* humiliation" as onlookers responded in various ways to her passage through the city, from drawing their fascinated children away from her to calling the police. Italia

seemed to invest the fish itself with symbolic significance, though it was hard to gauge the specific importance of that symbolism to the resulting performance. At any rate, the seabass had been selected as a "common fish" rather than as an identifiably exotic one, and she spoke of carrying it in a "weird gesture of pride."[23]

In the present context, the interest of this performance has less to do with the artist's own intentions and experiences and more to do with the effect of the screening at Stew. Seeing the footage of her carrying the fish through familiar settings such as the woods on Mousehold Heath, or the fields behind the Sainsbury Centre on the university campus, or city center streets lined with medieval buildings that were easily recognized (see Figure 7.7), and hearing the much-amplified noise of traffic and the voices of pedestrians on the soundtrack, the element that seemed most obviously out of place here was not the artist's orange overall or her bare-footedness but the fish—that large, liquefying seabass. As a spectator in the gallery,

Figure 7.7. Elena Italia, *Untitled: Orange Overall, Seabass,* 2010. Video still.

that out-of-place-ness contributed significantly to a heightening or a *thickening* of the experience of places that I already knew well.

The question of exactly how a fish might create that striking and lasting effect is addressed later. But it took that performance to prompt me to think more specifically about the places and spaces inhabited by animals in contemporary art, and to raise that question in relation to the art discussed in preceding chapters. Only later did it become clear that this question had already begun to take shape in my thinking about Kannisto's work and my own roadkill project, both of which tie their depictions of animal life to a very particular sense of place.

It was noted in the introduction that a characteristic of much contemporary art that deals with animals is "its refusal of symbolism" and its related insistence in some cases on "carving out a space in which the physical body of the animal—living or dead—can be present as itself." Little has been said in the intervening chapters, however, about either the nature or the effect of that space. Since it can be both conceptual (the "space" of art) and actual (the places in which animals are seen, or in which art is seen), little hangs on the distinction between space and place for present purposes.[24]

It's evident, however, that even specific physical locations can have a significant conceptual dimension. While a majority of the artworks discussed in previous chapters do their utmost to avoid anthropocentric symbolism, and engage with real animal bodies or at least the remains of those bodies, the space in which those artworks are experienced is another matter altogether.

Stephen Bann offers a useful perspective on this issue in *Ways around Modernism*—a book already mentioned in chapter 3. As noted there, he insists that the distinct and privileged "art" space in which confrontationally literal objects such as Rauschenberg's *Monogram* with its tattered and tyre-encircled taxidermic angora goat were encountered "was in no significant sense 'real.' It was a symbolic space that had been secured by the efforts of the nineteenth-century avant-garde, who first succeeded in validating the concept of an exhibition space apart from the official Salon—a 'Salon des Refusés.'"[25] As Marcel Duchamp's readymades in the early twentieth century would confirm, this new symbolic space could act in striking ways on the manner in which its objects would be perceived.

Yves Le Fur begins his short essay "Displaced Objects on Display" with the following statement: "I never understand it when people say that objects in museum galleries or collections are dead because they no longer exist in their original context. I rather feel that every piece or fragment has its own sight and voice, history and future."[26] Is the animal in art's contemporary "symbolic" spaces out of context, displaced, *dislocated*? Or does it find its own new "sight and voice" there?

A brief review of the contexts in which animals have been seen in previous chapters may be helpful in considering those questions. Kim Jones's rats were seen in a cagelike wire-metal hatbox on the floor of a university gallery space. Marco Evaristti's goldfish swam in small circles in Moulinex blenders placed on a table in a number of gallery settings. Olly and Suzi place great emphasis on their immediate encounters with animals in their natural habitats, but generally draw and paint them in isolation on the white ground of the paper, because their attempts to depict them in a landscape setting have "never worked," according to Suzi. Lucy Kimbell imagines but does not depict rats in the "closed environment" of her *Rat Evaluated Artwork* drawing, and via descriptions of rats in the human-centered contexts of laboratories and rat fairs she uses her performance lecture to present her audience with the reality that neither they nor she can have the rats (or the experience) that the title of her lecture had promised.

Catherine Chalmers's *Impostors* series places disguised cockroaches in artificial settings in order to ask "what's natural now anyway?" while maintaining an equally improbable ad hoc animal ecosystem in the studio in which she makes these works. Eduardo Kac conjures a family photograph of four transgenic mammals of more than one species, which can neither be made nor seen because one of the four is either dead or adrift in a laboratory on another continent. His work, as he has noted elsewhere, is "not about location."[27] Mircea Cantor presents two peafowl in the bare space of an elaborate gilded cage that's too large for the gallery that houses it (but that nevertheless calls to mind Jones's wire hatbox). The unannounced location in which Mary Britton Clouse poses with her chickens is her backyard (Figure 7.8), where she just occasionally achieves the fine visual balance of artist, animal, and environment that is more markedly the subject of Kannisto's rain forest works.

Figure 7.8. Mary Britton Clouse, *Cecilia,* 2008. Sepia photograph.

In a silent video projection in a gallery, Catherine Bell ingests squid ink and discards squid bodies on the darkened stage of a disused theater. The visual narrative of Sue Coe's *Sheep of Fools* evokes the passage of particular animals through particular spaces and places while weaving a sense of the historical context and material trappings of their journey into the pages of the book. Britta Jaschinski's photographs veer between showing animals in their immediate surroundings and showing them (in most of the photographs from *Dark*) isolated from those surroundings. As she enigmatically puts it: "For me, the location is not important—except when it is."[28] And when it is, as in *Ghostly Cheetah* (Figure 6.10), it draws her into an uncharacteristically symbolic reading of her work, associating the cheetah's being at the border of the photograph with its being on the brink of extinction.

Angela Singer's recycled taxidermy, once accused of turning "gallery walls into open graves," is generally shown in conventional gallery settings. Her concern is to memorialize particular animal lives, and where possible to glean specific information about how the animals she works with had been hunted and killed, but that information is not included as text in the gallery. In *Fieldwork,* Sanna Kannisto's photographs create a particularly accomplished meshing of artist, animal, and environment, but neither the dates of photographs nor the particular locations they depict are identified in the book. And the route of Italia's filmed performance with a seabass was not planned by her and hardly seems central to her intentions for the piece, so viewers either will or will not recognize its location.

To add one more example, illustrated earlier but not discussed until now, the paintings in Dave Bullock's 2004–5 *Hare and Buzzard* series (Figure 7.1) had their starting point in the artist's direct observation of an unusual proliferation of both species around his isolated cottage in Wales one particular day in 2004. Showing little interest in the pursuit of the animals' naturalistic representation, despite the fact that the paintings "still relate back to that day," Bullock notes that "it's through the process of working on the painting" that "the relationship between the two figures" emerges, and asks himself: "Where are they hanging? Is that anything to do with a landscape?"[29] The resulting spatial dislocations of hare and buzzard in each painting seem in at least some cases to exemplify Deleuze and Guattari's contention that "the twisted animals have no land beneath them."

The general impression created by this quick review is that the animal in its natural habitat is not the major concern of most of these artists, even though—in their very different ways—a majority of them are conscious of and are concerned with the quality of individual animals' actual lives. There seems to be a greater interest in trying to create new and unfamiliar spaces for seeing and thinking about animals.

It's clear enough why artists have been inclined to make this move—not least to distance themselves from what so often look like the easy consolations of wildlife painting and wildlife photography, with their reassuring certainties about the respective places of humans and animals in the wider world. But might contemporary art's animal bodies be in some manner impoverished or generalized—reduced to "the animal *in general,*"

as Jacques Derrida puts it—when presented in isolation in the safe white cube of the gallery and in other such symbolic spaces?[30] What does symbolic space do to the nonsymbolic animal body?

This may not be a productive line of thought, because it veers close to the notion that certain spaces are "wrong" spaces and that art's spaces may be among them. But that perception should not be dismissed out of hand. For some readers, the animal in the zoo or the lab or even the gallery will be emphatically regarded as being in the "wrong" place. And from a rather different perspective, Miwon Kwon has argued that for artists and academics, the international biennale and conference circuit has created a "logic of nomadism" in which a sense of self-worth "seems predicated more and more on our suffering through the inconveniences and psychic destabilizations of ungrounded transience, of not being at home (or not having a home). . . . Whether we enjoy it or not, we are culturally and economically rewarded for enduring the 'wrong' place."[31]

Such experiences can be found uncomfortably close to home. When her grotesque hybrid *Portrait of a Naturalized New Zealander* (Figure 6.11) was vandalized during an exhibition, Singer reflected: "I was quite upset that . . . all the trophy animals in *Naturalized New Zealander,* that had suffered so much when hunted should now have more violence directed at them, their bodies vandalized by humans, in a space in which I thought they would be respected and protected."[32]

Nevertheless, there is a widespread sense among artists that art can constitute a secure and identifiable location, a "home." In chapter 2 Kimbell was seen to explain the presence of the word *art* in the title of her performance lecture by saying, "I'm ultimately claiming this as an art project and therefore there is a home for it. I'm not saying it's philosophy—it has a home, so I name that home." This makes a difference. As Jones saw in the 1970s, burning rats *as an artist*—for him, at least—would not be the same thing at all as burning them a few years earlier as a soldier, and he wanted to know what it would be like. In the more homely territory of Kathy High's 2010 *Lily Does Derrida: A Dog's Video Essay* (of which there's more to follow), her dead dog Lily's observation that "Derrida asks . . . 'Does the animal produce representations?'" is not at all the same thing as Derrida himself asking, "Does the animal produce representations?" Loping around

the house and garden, peering at the camera with her one remaining eye, and making the occasional disparaging remark about the two cats with whom she and High shared a home, Lily displays a casual domesticity that brings to mind two last examples relating to animals and place, both of which deal with animals' marked absence from particular places.

In Snæbjörnsdóttir/Wilson's *(a)fly: (between nature and culture)*,[33] the publication that relates to their project *a fly in my soup*, the section "environs" reproduces thirty-two captioned photographs of rooms in houses in inner-city Reykjavik (see Figure 7.9). The rooms are empty, but in each case the photograph's focal point shows the place where the household's one or more domestic animals choose to spend most of their time. The captions name the animals.

This set of images is the central element in a more complex art project, and Snæbjörnsdóttir has described her and Wilson's approach to the photographs in the following terms:

> The dwellings within dwellings that we photographed in *(a)fly* are those chosen by the non-human animal and accepted by the human animal. When we arrived at the homes to photograph, we asked to be shown to "the place where the animal relaxes when no one is showing it attention." . . . By photographing these dwellings in the way we did for this project, and by juxtaposing the images with the given name of the animal, a space is created for the projection of our own reflection onto the haunting animal absence.[34]

Here the animal's absence is far more striking than the human's. A photograph of an empty domestic room does not ordinarily draw attention to the absence of humans; knowing that an animal is absent seems to create a different quality of curiosity.

A final take on place: in one of the most rewarding examples of his own art practice, the philosopher David Wood's art-philosophical photo essay *Mirror Infractions in the Yucatan* takes the form of a reflective reworking of Robert Smithson's 1969 *Incidents of Mirror-Travel in the Yucatan*. As Wood notes, Smithson's piece recorded "a journey through the Yucatan, and its Mayan sites, while laying mirrors whose multiple images frustrate

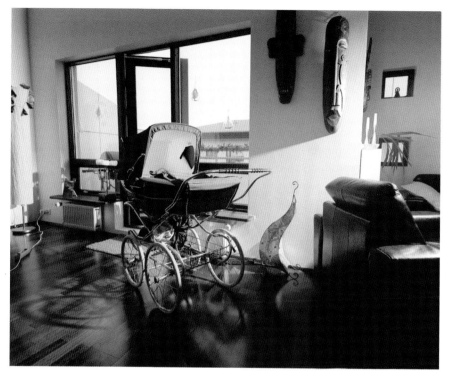

Figure 7.9. Snæbjörnsdóttir/Wilson, *Fiby*, from *(a)fly*, 2005. Lambda print.

our natural impulse to appropriate the sites in question." Wood's own piece re-created Smithson's journey in 2005 and set out to restage "both his artistic engagement with Mayan culture, and the terms of his philosophical reflections on the possibilities of art." More specifically, Wood interrogates Smithson's understanding of "the question of art's 'frame,' and of its necessary 'detachment' from 'nature.'" Wood's direct but never overstated interest is in "the various forms of interruption of art (and human 'vision') wrought by animals, their worlds, their visions, and their 'spaces.'"[35]

Of the piece's nine "mirror displacements," it is the third that perhaps addresses this interest most directly: "at Uxmal, guarding at least one of the sides of a temple, a lizard. In cautiously placing a mirror to double him or her, it scuttled off into a crack in the rock. . . . His droppings remained,

traces of lizard, the presence of absence." Asking "what to make of this," and
seeing an opportunity to articulate art's distance from philosophy, Wood
notes that Martin Heidegger would seem "to know the answer in advance.
But we need to slow down." Reflecting directly on the photograph he cap-
tions "Lizard *in absentio*" (Figure 7.10), he continues:

> Here we have the "absence" of a lizard, a mirror-image of his home-site. . . .
> And yet we still do not know what we are seeing. We *do* know that the liz-
> ards we are seeing predate Mayan civilization by many orders of time, that
> they watched as the temples were being built, and as the jungle reabsorbed
> them. . . . And we know, if we have the eyes-behind-eyes to see, that the
> worlds of other animals present to us a challenge to our taken-for-granted
> world for which we otherwise rely on . . . art.[36]

Figure 7.10. David Wood, "Lizard *in absentio,*" 2005.
Photograph from *Mirror Infractions in the Yucatan.*

To the limited extent to which Wood seems to have a target here, it is less Heidegger's all-too-familiar denial of "world" to the lizard than it is Smithson's lost opportunity in overlooking or excising evidence of the Yucatan's animal life from his own "mirror-travel."[37]

In a comment prompted by another of Wood's Smithson-referencing mirror displacements, at a pyramid at Uxmal—a comment that he would know to be just as applicable to the white cube of the gallery and other symbolic spaces of contemporary art—he asks: "Is our taste for geometry a quite properly protected space in which creativity can flourish, or a refusal of dirt 'or anything else which is vile and paltry' that ultimately condemns what it enables to insipid abstraction and irrelevance?"[38] If there's a parallel here to the question posed earlier about whether contemporary art's nonsymbolic animals might in some way be diminished by the symbolic spaces in which they are seen, that question now seems less outlandish. The forms of those animals' resistance to "abstraction and irrelevance"—and more specifically the forms of their "interruption of art"—are the subject of what follows.

The Animal-Object-in-Art

Discussing Cantor's installation *The Need for Uncertainty,* Ron Broglio has observed: "It seems to me that the animal is doing all the heavy lifting in this art piece."[39] It's a good phrase in this context, "heavy lifting," and it's probably useful that it has no necessary connection to the artist's intentions. Italia's performance *Untitled: Orange Overall, Seabass* could be described in similar terms: it's the passage of the carried seabass (rather than the carrying artist) through the space of the city that lends the piece its particular resonance. But to an extent, at least, Italia was aware of this. The fish was specifically chosen for its relatively large size: "I wanted it to be a *weight,*" she said.[40]

Damien Hirst made a similar observation in relation to the remaking his famous preserved tiger shark installation, *The Physical Impossibility of Death in the Mind of Someone Living.* Originally made in 1991, having been commissioned by Charles Saatchi, it featured the preserved body of a fourteen-foot tiger shark, floating in a glass tank full of formaldehyde solution. But because the body itself had not been injected with formaldehyde,

over time it began visibly to decompose and to turn the solution in the tank murky. A decision was made by Saatchi's curators to remove the shark, skin it and stretch the skin over a fiberglass mold before replacing it—a decision that didn't satisfy Hirst. When the piece was bought by an American collector in 2004, Hirst took the opportunity to replace the shark, commissioning the killing of a new shark in 2005. Press coverage of the improved preservation process being used on the new (and slightly smaller) shark in 2006 predictably played on the question of whether the finished piece would still constitute the "same" work of art as the 1991 version, and repeated the widespread tendency to regard Hirst as a conceptual artist, and this work to be a piece of conceptual art.[41] More revealing, however, was Hirst's own comment in 2006 about the unsatisfactory renovation of the first shark: "It didn't look as frightening," he said. "You could tell it wasn't real. It had no weight."[42]

Italia and Hirst both use the word *weight* in a less than wholly literal manner. They are addressing something about the animal's presence, or force, or impact in the space of art. There's something here of Mieke Bal's description of Louise Bourgeois's *Spider* as "dense in meaning, and exuberantly visual, yet difficult to 'read' and far from 'beautiful'"—except that Bal then chooses to characterize this dense and exuberant physical presence "as a *theoretical object*." She explains that "this term refers to works of art that deploy their own artistic and, in this case, visual, medium to offer and articulate thought about art." In doing so, they adopt "not so much a method as an *attitude*"—an attitude that entails "looking *at* art in the sense of looking *to* art for an understanding of what art is and does." A theoretical object undertakes and performs "*work*."[43] There is much to admire in Bal's characterization of the seriousness and distinctiveness of art's work, but the term *theoretical object* is not adopted here because it seems to risk rendering the animal-object-in-art wordy rather than weighty.

Susan Shaw Sailer has noted the tendency of postmodern artworks, "unlocatable or unstable" as their points of view may be, to "register themselves with intensity."[44] That seems to be all the more true of what is here being called—with deliberate awkwardness in acknowledgment of its perplexing particularity—the animal-object-in-art. Most of my writing over the past fifteen years has been an exploration of the characteristics of this

animal-object-in-art. And perhaps the most striking thing I have learned more recently from my own roadkill work is how *visually uncontainable* its animal material proved (and proves) to be, spilling over, as if with an afterlife of its own. Two brief examples from the work of other artists perhaps show this effect of animal overspill more clearly.

In 1976 Carolee Schneemann staged a revised version of her performance *Up to and Including Her Limits* at The Kitchen in New York. At one end of the space the artist swung from a harness creating drawings on the paper-covered floor and walls around her, while a live video relay at the opposite end of the room left viewers to shift at will between the performance and its representation. Projected on another wall was a loop of her film *Kitch's Last Meal*. But her cat Kitch had died the day before this particular performance, and the dead body was carefully laid out in the performance space just a few feet from the artist.

As a photograph of this performance clearly shows, the counterpoint established between artist and animal turns the performance into an improvised memorial, the acting-out of the artist's mourning for the cat who had featured in some of her filmmaking and of whom she would later movingly write that "her steady focus enabled me to consider her regard as an aperture in motion."[45] Here the artist renders acutely visible the cat who had, in turn, taught her a particular way of seeing the world. Kitch's presence here is in no way diminished by her lack of life, and that presence (even if not strictly part of the performance) spills out and appropriates the whole space (Figure 7.11).

The dead animal, at least in art's spaces, won't stay dead, stay down, stay still. "I'm dead," announces Lily near the start of High's *Lily Does Derrida* video. (Lily speaks in the voice of a human male, to dislocate things just a little further.) As she pads around the High family household, she muses on her condition: "I've been reading a lot these days, and Jacques Derrida has caught my interest. Too bad he died, but then—I'm dead too, by the way." And she amuses herself with *his* condition: "'The animal,' he says, 'which is at unease with itself.' We are not so *uneasy*. What is it about human animals which is so *uneasy* with us animal types?" A little later, she says of High: "She—the she who makes this video for me—she doesn't know the answers, so she will show you some examples."

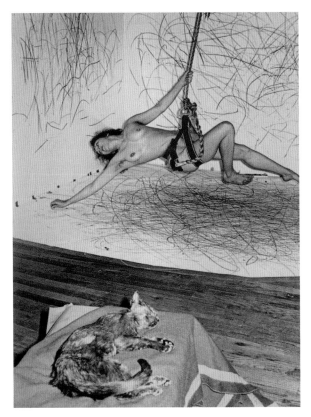

Figure 7.11. Carolee Schneemann, documentation of one performance
of *Up to and Including Her Limits*, 1976, with the artist's dead cat
Kitch in the foreground.

On to the screen comes the first section of the video's roadkill foot-
age (Figure 7.12). A small mammal lies in the road, dead, it seems, its
mouth full of maggots, though an arrow momentarily appears on-screen
to point to its twitching back leg, as a large fly feasts on its face. And roll-
ing across the screen, as if to caption the spectacle, come Derrida's words,
simultaneously voiced in Lily's male American accent: "Derrida asks, 'Does
the animal dream?' Another way of asking, 'Does the animal think?' 'Does
the animal produce representations?'" And a string of others: "Does it die?"
"Does it invent?" and so on. But far from the words framing how the ani-
mal imagery is seen, that blistering image of the roadkill and the insects

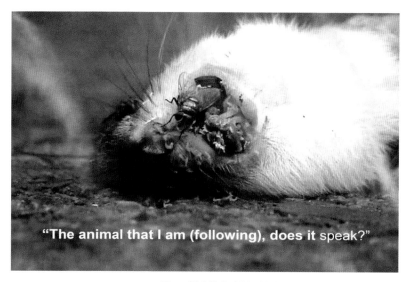

"The animal that I am (following), does it speak?"

Figure 7.12. Kathy High, *Lily Does Derrida,* 2010. Video still.

spills over unstoppably into Derrida's text, as does Lily's voice, now lurking in its pages for future readers. Lily does Derrida over.

Lily's question "What is it about human animals which is so *uneasy* with us animal types?" prompts others. What is it about animal bodies and animal materials that lends the animal-object-in-art such *clout*? What is it about their play of attraction and repulsion? Their loadedness? Their intensity? Earlier chapters have offered numerous (and very differently motivated) examples of art's powerful engagement with that animal unease, that *animalséance*:[46] Jones's tortured rats, the thin disguise of Chalmers's cockroaches, the brooding imagery of Britton Clouse's not-chosen photographs, Bell's prolonged squid ritual, Coe's stark depiction of mulesing, and Singer's terrible trophies.

The very considerable power of this singular art imagery has been noted at particular points in those earlier chapters, but it can of course elicit a range of apparently incompatible reactions. In repeatedly writing about its importance over many years, it's become difficult to judge whether or not, and to what extent, I may have become desensitized to how others see it. For example, what I characterized admiringly as the "abrasive"[47] visibility of the animal forms in certain contemporary artworks

was seen very differently by Jonathan Burt, a reader generally sympathetic to my concerns, who regarded those particular works as "bleak and figuratively transgressive."[48] Those same striking forms are still to the fore in many of the works discussed here, not least in the context of Singer's insistence that this art "should be done strongly."

The characteristics of these strong animal forms have something in common with what Deleuze and Guattari find in the "nomad art" that *they* admire: "The whole and the parts give the eye that beholds them a function that is haptic rather than optical. This is an animality that can be seen only by touching it with one's mind."[49] In art, this is perhaps uncomfortably close to the imagery that Elkins warns of being of such "sheer visceral power" that it may "poison whatever is around it."[50] And it's perhaps where Mark Cousins's intriguing idea of a boundary enabling the bodily separation of an "art of danger" from a "politics of safety" begins to break down.[51]

Elaine Scarry's classic study, *The Body in Pain* (which I've discussed elsewhere in relation to Singer's recycled taxidermy),[52] is highly relevant here. Contemplating opened human bodies in the context of wartime injuries, and opened animal bodies in the context of sacrificial rituals, Scarry tries to work out *how* they acquire meaning. "The wound is empty of reference," she insists, seeing this as a more extreme instance of "the referential instability of the body." It's that instability that allows the body, and more particularly the opened body, "to confer its reality" on whatever ideas lie closest to hand. This is very much about seeing, and looking: "The visible and experienceable alteration of injury has a *compelling and vivid reality*" that enables it to "substantiate" or to "lend force and conviction" to anything with which "the open bodies are juxtaposed." The observer "sees and touches the hurt body of another person (or animal) juxtaposed to the disembodied idea, and having sensorially experienced the reality of the first, believes he or she has experienced the reality of the second."[53] She goes on to explain:

> It is as though the human mind, confronted by the open body itself (whether human or animal) does not have the option of failing to perceive its reality that rushes unstoppably across his eyes and into his mind, yet the mind so flees from what it sees that it will with almost equal speed perform the countermovement of assigning that attribute to something

else, especially if there is something else at hand made ready to receive the rejected attribute, ready to act as its referent.[54]

The reference to the unstoppable rush of this effect certainly seems to find parallels in the operation of the animal-object-in-art. But in terms of the singular power of this imagery, Scarry has more to say.

Her hugely ambitious aim is to imagine some manner in which it might be possible to bring an end not to human conflict but to the large-scale killing of humans in the context of war. What is called for is an "imagined ritual," a "form of substitution" so resonant,[55] so indisputably *real*, that it would have a chance of being sustained as a genuine alternative to that killing.

Her hesitant proposal, which she apologetically offers "only for the purpose of structural clarification" because it would be so "ghastly to contemplate," is as follows. On the peaceful resolution of a (previously warlike) international conflict, in which there would still need to be an acknowledged "winner," in all of the countries involved "multitudes of individuals" would have to "gather in large groups throughout their homelands" and "would each hold up or simply hold onto an animal organ or entrail" to signal and to substantiate the agreed outcome as "real." She envisages "a universally shared species shame at picturing ourselves engaged in so atavistic, so primitive a ritual." But she argues that "in almost all arenas of human creation, the work of substantiation originally accomplished by the interior of the human body has undergone a hundred stages of transformation, but the first stage, the first step was the substitution of the human body with an animal body." And war, she asserts, is one of the very few arenas "in which this very first form of substitution has never occurred." In defense of her proposal, and against "the inner voice that protests" at this imagined ritual, she maintains that "the displacement of human sacrifice with animal sacrifice . . . has always been recognized as a special moment in the infancy of civilization."[56]

The point of introducing Scarry's argument here is not for a moment to lend credence to that particular conclusion. But in signaling her "ghastly" proposal as the only one she can identify as having the remotest chance of being powerful enough to work, *she makes a very strong case indeed for the singular power of the nonhuman animal body in the human*

eye and the human mind. In the context of the cultural heritage that Scarry describes, contemporary artists may be hard-pressed successfully to secure something of that power for nonanthropocentric forms of representation, or presentation, or performance, but their continuing efforts to do so are unsurprising.

Animal as Medium

Allison Hunter's *Untitled #3* (Figure 3.1), discussed briefly at the start of chapter 3, now calls for further comment. A digital chromogenic print measuring thirty by fifty inches, it feels more like a painting, and is an image of singular formal rigor. No other contemporary animal image immediately comes to mind that allows the depicted deer to stand simultaneously as itself and as a purely formal, compositional device. This has to do both with Hunter's creation of the wash of warm beige that digitally replaces the photographic record of this deer's immediate environment, and with the compositional placement of the animal in that field of color.

The piece powerfully recalls—not through resemblance but through effect—those large Jules Olitski color-field paintings from the mid- to late 1960s where (as Michael Fried put it) "all relatively well defined bursts of colour and variations in value are restricted to the vicinity of the edges and corners of the canvas." In those paintings, "the framing-edge" is where all the work gets done, those marginal smears of color wresting control of the entire field. For Fried, who regarded Olitski's works of that period as among "the finest Modernist painting of the past several years," it was crucial that "they are wholly devoid of depicted shape."[57]

The rather remarkable achievement of Hunter's *Untitled #3* is to create the possibility (deliberately or not) of some animal edge-work that acknowledges and maintains the formal impact of Olitski's focus on edges and corners while reintroducing the "depicted shape" of what I have been calling the animal-object-in-art. Here the animal *articulates* the field, activates it, makes it available, makes it visible. The deer is not adrift in this space or "placed" in it as if by an outside hand. The effect, on the contrary, is that much like Olitski's framing-edge, *the deer itself holds and shapes the space*. It perhaps even addresses the space. Body-shape certainly matters here, the horizontal of the deer's spine and near-vertical of the front leg

creating a smaller rectangle that echoes that of the larger field, but there's more to it than that.

The piece works between registers: figuration and abstraction, photography and painting, even species identity (the creature is clearly a deer, but isn't there a hint of something close to fish scales in the sunlit glint of its coat?). Above all, the "depicted shape" that from a formalist perspective has no place in the work is the very thing that—in the present reading— has created the space and now commands it. I use this example to introduce the third and final exploratory perspective on the presentation and representation of animals in contemporary art.

Early in 2011, in the question period after a paper called "Spaces of Uncertainty in Contemporary Western Animal Art" delivered to an audience of art historians who had no specific engagement with animal-related matters,[58] I was asked a question I had not anticipated. The paper had touched on aspects of the work of several of the artists discussed in this chapter and others, and the question came from David Hulks, who asked whether my interest was in the animal *as medium*. Is the animal the *medium* in which these artists are working?

This very productive question was asked specifically with reference to Rosalind Krauss's *"A Voyage on the North Sea": Art in the Age of the Post-Medium Condition*—a small book with which I was familiar, but had not previously used in the context of my own writing. In it, Krauss tries out some characteristically complex art historical moves to create a shift of focus better suited to the needs of contemporary art. Not the least of the book's complexities is her decision to discuss what she asserts to be the postmedium condition of contemporary art while maintaining the term *medium* to characterize that new condition.

Writing at the end of the 1990s, Krauss located the historical emergence of the postmedium condition in the late 1960s and early 1970s, as a reaction against the "militantly reductive modernism" associated with Clement Greenberg. In the 1960s, Krauss notes, Don Judd had already realized that "painting had now become an object just like any other three-dimensional thing. Further . . . with nothing any longer differentiating painting from sculpture, the distinctness of either as separate mediums was over." From the end of that decade to the present, she writes: "Whether it calls itself installation art or institutional critique, the international spread

of mixed-media installation has become ubiquitous." The hugely influential "advent of video into art practice" at around the same time would further "shatter the notion of medium-specificity," leaving Krauss in no doubt that "we now inhabit a post-medium age." Or again, subtly differently, that "we inhabit a post-medium condition."[59]

She makes the case that "the post-medium condition of this form traces its lineage ... to Marcel Broodthaers." His "four-year enterprise called 'Museum of Modern Art, Eagles Department'" involved gathering a multiplicity of representations of eagles in all manner of media and subjecting them, through the form of their collective display, to a "principle of levelling" that transformed them into "the figure, the mark ... of pure exchange." Noting what Broodthaers "called an 'identity of the eagle as idea and of art as idea,'" Krauss writes: "Broodthaers's eagle ... announces not the end of Art but the termination of the individual arts as medium-specific."[60]

In the present context, the decision to explore the idea of the post-medium condition has nothing directly to do with Broodthaers happening to create that condition by means of an animal, an eagle, because that eagle generally functioned for him as no more than an emblem for conceptual art, as Krauss acknowledges. What then is the particular attraction of the idea? Perhaps it's the prospect of getting closer to what Luhmann means—though his rhetoric is often more compelling than his meaning—when he writes: "In working together, form and medium generate what characterizes successful artworks, namely, *improbable evidence*."[61] Presenting the animal-object-in-post-medium-art as "improbable evidence" is the task valuably undertaken by many of the artists discussed here. It is Krauss's discussion of medium rather than Luhmann's that shapes the present discussion, however, because she employs greater art historical attentiveness and precision in reconfiguring the use of the term.

Distancing herself specifically from the modernist insistence that particular art media such as painting, sculpture, and drawing should be "about nothing but their own essence," which meant that they were "necessarily disengaged from everything outside their frames," and that the idea of the work's medium was reduced to its mere material support, Krauss aims to imagine what a more fruitful understanding of medium might now look like. It would "involve the relationship between a technical (or material) support and the conventions with which a particular genre operates

or articulates or works on that support." She goes on: "The conventions in question . . . might be exceedingly loose or schematic. But without them there would be no possibility of judging the success or failure" of its operation or improvisations.[62]

She envisages a "layered, complex relationship that we could call a *recursive structure*—a structure, that is, some of the elements of which will produce the rules that generate the structure itself." And she notes "that this recursive structure is something made, rather than something given, is what is latent in the traditional connection of 'medium' to matters of technique."[63] In this regard, her reference to "success" (and Luhmann's too, in all probability) should be understood to be less about the artwork's critical acclaim than about the artist's ability to get it to *work,* and to undertake its work, in more or less the manner intended.

There seems to be considerable scope, in relation to the kinds of work discussed in the present book, for thinking productively about the animal (and here it *is* some sense of "the animal," and not of "animals") as the medium in which these artists may be working. How might that thinking hesitantly begin? How would it apply to the work already discussed? What would *follow from* its application to that work?

One immediate temptation might be to read animal-as-medium rather literally, and to focus, at least at first, on the questions that raises in relation to artists who work, hands on, with animal materials, or animal bodies, or living animals. That would draw together a provocatively varied range of the book's examples, from Jones to Kac to Cantor to Bell to Singer. And it raises interesting questions of groupings and exclusions. It would appear not to rule out the symbolic use of animal bodies (Hirst's shark, for example), though animal symbolism has played little part in the book's project. But it might exclude forms of representation that maintain a respectful distance from those bodies (Coe's graphic work and Jaschinski's photography, for example), which have been central to that project, as well as Wood's mirror infractions, which are certainly pertinent to it.

Other cases are interestingly awkward. Pieces of Olly and Suzi's work that include the imprint of the animal might be in (see Figure 7.13), but their photographs and other drawings and paintings might be out. Britton Clouse would be out in terms of the JAAG's policies, but in because of the manner in which she makes the *Portraits/Self-Portraits* series. Kannisto

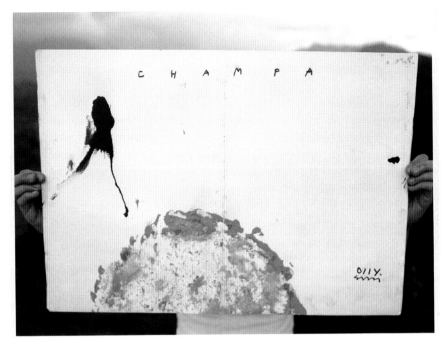

Figure 7.13. Olly and Suzi, *Champa Kali Footprint,* Nepal, 2001. Acrylic, mud, and graphite on paper. The semicircular shape at the bottom of the image is the muddy footprint left by the elephant who walked across the paper.

and Chalmers make photographs, as does Jaschinski, but unlike her they would be in because of their actual handling (albeit with very great care, like Britton Clouse) of the animals in those images. The case of Kimbell, whose project is in many respects the most conceptual of those discussed in the main chapters, could be argued either way, as her research certainly involved handling the rats. And while, as noted earlier, Singer's opened animal bodies would certainly be in, my own and High's graphic roadkill imagery might not make the cut.

Other questions arise, too. If the animal is the medium in which these artists are working, are others working in that same medium? Are professional taxidermists and some scientists doing so, for example? That line of thought threatens to run riot and prompts a necessary clarification. The postmedium condition—as Krauss understands it—is a condition of

contemporary art. Therefore, however the idea of animal-as-medium might be framed, and whether or not it is framed around animal bodies and materials, the idea is more properly expressed as animal-as-*art*-medium.

Such an assertion needs to be handled with considerable care, of course, because a key characteristic of art in the age of the postmedium condition is precisely the very *tenuousness* with which it distinguishes itself from the world at large, while remaining very much "tied to the totality of the world," to borrow Roland Barthes's memorable phrase.[64] Snæbjörnsdóttir/Wilson's video work *the naming of things* serves well to illustrate that tenuousness (Figure 7.14).

The video is one element in a much larger project by the artists called *between you and me*. Describing the work at the time it was first exhibited in Australia, they explained that *the naming of things* "follows the taxidermising of a seal" by a taxidermist in Reykjavik over a three-hour period. "When filming we had two cameras and studio lights—the setting was the taxidermist's workshop. As in most of our artworks we did not change or manipulate the setting. Filming was close up focusing on the 'animal' and the hands of the taxidermist." Only in the editing suite did it become clear to them that the film was "too close to being a documentation of the activity itself":

> Thus we decided to focus on selected sequences in which a meeting between the human skin (the hands of the taxidermist) and the animal skin was foregrounded. When slowing these shots down, the emphasis in the work changed, from showing the purposeful, methodical act of a craftsman to a kind of dance . . . between the two.

In that process, that dance, the seal specimen "becomes part of its own creation." And in the slowing of the film, they suggested, the work allowed them and perhaps also their audience "the space to think through and thus challenge . . . the consequences of the abbreviated forms"—the animal; the human—"with which we populate our intellect and our experience."[65]

As Snæbjörnsdóttir wrote elsewhere of this video, and of their collaborative practice more generally: "Part of this enquiry will involve taking

218

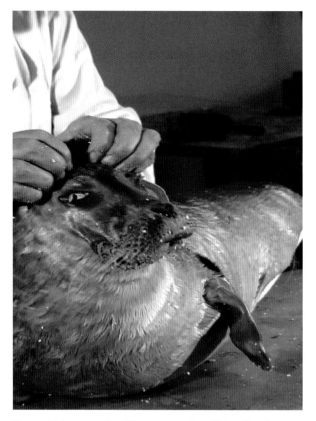

Figure 7.14. Snæbjörnsdóttir/Wilson, *the naming of things* (from the installation *between you and me*), 2009. Video still.

wrong turns, a natural consequence of exploring 'reality' and our understanding of it through the making of art."[66] In *the naming of things*, it's principally the unexpected effect of the small but initially unanticipated move of slowing the video footage that takes it out of documentary mode and into a piece of work in the medium of the animal.

Two further details of Krauss's account of the postmedium condition might usefully be brought into play now, largely because of the imaginative prospects thrown open by her words. One is her reference to the way that early postmedium artists began to see scope "to transform the whole project of art from making objects . . . to articulating the vectors that connect objects to subjects." The other is her characterization of such practices

as "practices of rampant impurity."⁶⁷ Both seem to have productive reso-
nances for thinking about the animal-as-medium.

The articulation of vectors connecting objects to subjects, or artists
to animals, or animal subjects to art objects, and so on, might be a way to
describe much of the art considered in this book, not least both Snæbjörns-
dóttir/Wilson's *the naming of things* as a work in itself and as the vector
connecting its site of intervention to its site (or sites) of effect. In a wider
social context, but one that applies equally to art practice, those connec-
tions and their effects are well caught in Donna Haraway's account of the
"figure," parts of which happen to echo Snæbjörnsdóttir/Wilson's words:

> Figures are not representations . . . but rather material-semiotic nodes or
> knots in which diverse bodies of meaning coshape one another. . . . figures
> are at the same time creatures of imagined possibilities and creatures of
> fierce and ordinary reality; the dimensions tangle and require response. . . .
> The partners do not precede the meeting; species of all kinds, living and
> not, are consequent on a subject- and object-chasing dance of encounters.⁶⁸

But Krauss's reference to "practices of rampant impurity" (which Haraway
would likely endorse) might more effectively be taken on board by con-
sidering another work, not mentioned so far, that deals rather differently
with its animals.

As Robert Filby explains, "The photographic series *Work & Co.*
documents a range of work in the company of cats."⁶⁹ The documented
"work" principally takes the form of small-scale plaster or ceramic sculp-
tures, placed on the floor, and each cat photographed "low down, cat
height" in the company of one of these works has been borrowed from
a friend. The photographs are taken while the cat is exploring the work
at will or, just as often, ignoring it (Figure 7.15). At the time of writing,
the ongoing series *Work & Co.* comprises sixteen photographs, and the
"& Co." (as in the abbreviation widely used in the names of small British
businesses) comprises six different cats. Naming the sculpture but not the
cat, the titles of individual photographs take the form *Blumentopf & Co.*,
Glossy Rabbit & Co., and so on.

David Lillington describes Filby's work as "a continuous questioning
of sculptural issues practical and theoretical," but there are good reasons to

Figure 7.15. Robert Filby, *Glass & Co.*, 2006. Color photograph.

see Filby as an artist working firmly in the context of the postmedium condition, as his own comments on the work attest. The photographs "have more to do with sculpture than photography." But "when I'm making work I might find it difficult to think 'I am being a sculptor, I am sculpting.'" And in any case: "Photographs are sculptures." He acknowledges, further, that he is "making both sculpture and photographs—in which both claim to be *the* work. In which both deliberately problematize the relationship." The art-or-not-art status of the cats in the photographs is, similarly, something of an open question: "Another way to approach the photographs is that they are simply documentation of the work, with the cat as a common denominator, also giving scale, but unconnected to the work itself. This is true and not of course."

Filby also characterizes with some clarity the effect of "& Co." on the photographed work. He is particularly aware of "the cat's lack of interest in the hierarchical value or status of an object." In this sense, he suggests, the photographs "illustrate a sentient engagement prompted by the cat," and the cat offers "a way of looking at the work which is not according to our usual interpretive habit."

He is not being falsely modest about his sculptural work when he seems almost to present the cats of "& Co." as his ideal audience: "The cat asks so little of the object, it has no will to find anything beyond it. The photographs nearly present this as a guiding principle, that the only reliable, immediate and practical consequences of the work are in the space it takes up." The "work" is distinguished from its surroundings, carefully, sculpturally, *but barely*. The work of the cats is to note that, to signal that, and to slough at least some of the work's claims to special treatment.

In one particularly revealing statement, Filby notes: "Part of the appeal in introducing the cat is as in opposition to the work's preciousness, and in corrupting the presentation. . . . A way of letting the work go, into the world, or as a way of acknowledging it is of the world." His reference to the cat's "corruption" of the work, from within, might be linked to Wood's notion that the lizard's presence (or even absence) in his mirror infractions constitutes an "interruption" of Smithson's own "mirror-travel" as an animal-free zone. It also, of course, stands both as a contemporary instance of Krauss's "practices of rampant impurity" and as a reminder of Michael Fried's fear-driven claim in the 1960s that mixed-media work such as Rauschenberg's *Monogram* exemplified the point at which "*art degenerates*."[70] Over forty years separate *Monogram*'s taxidermic goat from *Work & Co.*'s living cats, but both offer ways of continuing to acknowledge, as Filby puts it, that the work "is of the world."

This art that precisely marks the absence of secure boundaries recalls Kannisto's fascination "with situations where natural processes and something made by humans tangle up with each other." And the interspecies revel pictured in her photograph *Private Collection* (Figure 7.3), where elements are temporarily borrowed from the world and provisionally "framed" on a white ground before their return to the undifferentiated forest night, itself recalls what Wolfe, in an only slightly different context, has characterized as "an effort to think 'detotalized totality.'"[71]

Private Collection points also to another take on the idea of working in the medium of the animal: the depiction of situations where *humans* "and something made by humans tangle up with each other." These are situations where the artists *mark their implication in the animal-as-medium by signs of their own presence in the work*. There have been plenty of those signs in the foregoing pages.

Here, as a reminder, are some of them. Jones noted of the rats he burned in 1976: "When they were burning and screaming, I bent down and screamed with them. I don't know whether it helped them or not. Probably, it didn't mean anything to them, but it meant something to me. It was my way of connecting with them somehow."[72] The initial photographic record of Olly and Suzi's drawings and paintings, made on the spot, in the bush, frequently shows their fingertips holding the work at its corners, and allows—as in *Bull Moose* (Figure 7.16)—a glimpse of the location around the edges, showing that the work (as Filby has it) "is of the world." Kimbell, too, asserts her own "holding" in her performance lecture: "I held science in my hands"; "What I had to do . . . was hold open a place

Figure 7.16. Olly and Suzi, *Bull Moose,* Arctic Sweden, 2008. Sepia and acrylic on paper.

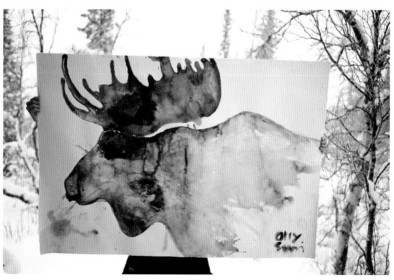

of ambiguity and be there in it." Of the two famous photographs of Kac's rabbit Alba, the only reliable one has him holding her, and even there it's the terrible jazzy wallpaper (who would think to fake *that*?) that's the real guarantor of the truth of that moment in which he avowedly recognizes his responsibility toward her (Figure 7.17).

Britton Clouse's portrait juxtapositions and fusions stumble almost by accident out of the world and into her work. Bell, besuited in the thin guise of her father and the faux-garb of Joseph Beuys, creates and maintains an unexpectedly permeable boundary between dead squid and living human. Hunter notes of her *New Animals* series that in each case the animal "was looking at the human photographer—not to say that the animal was complicit but that I was 'there,' and the animal was alive and present in the

Figure 7.17. Eduardo Kac holding Alba, France, 2000. Photograph by Chrystelle Fontaine.

experience."[73] Whether or not British-born Singer has a place in this unruly list depends very largely on whether, by its title alone, her *Portrait of a Naturalized New Zealander* can legitimately be read, at least in part, as a self-portrait.

The earliest of Kannisto's rain forest photographs in which she herself figures prominently is called *Untitled (Self Portrait),* and shows her face-to-face with the smoky jungle frog that she has temporarily placed in her portable field studio. The reflection of Kannisto's face in its clear front panel is directly juxtaposed with that of the large frog. In a recent strand of my own roadkill work that considers anew how its key elements (road, bike, death, and perhaps beauty) might be compressed into single images, the shadow of a bicycle wheel or the edge of a pedal finds itself juxtaposed with the animal body, intimating the presence of a photographer who in all likelihood was not the cause of the depicted death but is somehow more than a detached observer of it (Figure 7.18).

And in *Lily Does Derrida*, although Lily narrates her own story, High (as "the she who makes this video for me") can herself occasionally be heard—"Lily, does that hurt?"—or her legs glimpsed from a dog-level camera as her slippered feet cross the kitchen. And that "Never apologize for your art" fridge magnet is certainly hers rather than Lily's—although, with a dog capable of appropriating the question "Does the animal produce representations?" the case could be argued either way.

What kind of work, in the medium of the animal, is undertaken by artists implicating themselves in their work in this way, placing themselves in juxtaposition with its animals? It might connect with that associated with Derrida's single use (in "The Animal That Therefore I Am") of the evocative term "being-huddled-together" [*être-serré*] with the animal.[74] Or with Heidegger's notion of "going-along-with" the animal for the sake of "directly learning how it is with this being."[75] Or indeed with Haraway's "dance of encounters." More immediately and more directly, it stands as the *visible refusal* of that key lamentable characteristic of mainstream wildlife photography that Matthew Brower has addressed so pointedly: "a separation of human and animal that positions animals on the far side of a nature-culture divide." Brower sees in the banishing of the human from this genre of imagery "a redeployment of the Garden mythos which envisions nature as pure and human beings as fallen and corrupting. Wildlife

Figure 7.18. Steve Baker, *Roadside XII,* 2011. Photograph.

photography posits a vanishing nature corrupted by human traces that the photographer must work to overlook."[76] Animal-as-medium neither defines its animals along those lines nor even defines its animals.

One additional and perhaps related advantage of exploring the idea of animal-as-medium is that it helps to level the playing field by offering an alternative to the unstated perception that there is *a hierarchy of media* and that animal-themed work in fields such as bio-art or botched taxidermy can in and of itself be regarded as more radical and more worthy than work in an established medium such as bronze, for example. The troubling ramifications of that perceived hierarchy of media for art that deals with animal life is the subject of the afterword.

Having considered here just two possible readings of animal-as-medium (one focused on materials and bodies, the other on artists' implication in their work), it would be easy enough to allow differently articulated readings of the idea to proliferate. Perhaps, elsewhere, they will. Just one further aspect of Krauss's account of what "medium" might involve in the

age of the postmedium condition is worth noting here, and that is her fo-
cus on *conventions*. She lays considerable emphasis on "how the conven-
tions layered into a medium might function. For the nature of a recursive
structure is that it must be able, at least in part, to specify itself." She sees
this as the problem of how to articulate a particular field of activity *as a
medium*: "For, in order to sustain artistic practice, a medium must be a
supporting structure, generating a set of conventions, some of which, in
assuming the medium itself as their subject, will be wholly 'specific' to it,
thus producing an experience of their own necessity."[77]

It may be best left to others to consider the conventions that might
sustain the animal-as-medium as a productive hypothesis. As possible leads,
I would point only to the recursive playfulness of Kannisto's photographic
strategies and to the faint answer to Lily's (rather than Derrida's) question
"Can the animal produce representations?" that might be heard in Snæ-
björnsdóttir and Wilson's comment on their video *the naming of things*:
"We wanted to capture the process of a sanitized dead body being moulded
into a representation of itself."[78]

Afterword
Art in a Post-Animal Era?

> Play makes an opening. Play proposes.
> —Donna J. Haraway, *When Species Meet*

DRAWING IN THE EVIDENCE of the preceding chapters, a few last thoughts on the place of contemporary art in the wider project of the posthumanities are in order. In his essay "Invisible Histories: Primate Bodies and the Rise of Posthumanism in the Twentieth Century," Jonathan Burt argues that aspects of the sometimes overlooked history of actual animals (and of experimentation on them) offers "a parallel history to that of posthumanism: the pathway by which we have moved into the post-animal era, which in certain areas of human–animal interaction we have actually been living in for a while." It is Burt's only use of that striking phrase, *the post-animal era*. Googling the phrase late in 2011, as this afterword was written, it did not seem to have gained a wider currency. Its relevance in the present context becomes clearer from his further comment: "It seems to me that the time when the post-animal stage is really reached is when it is animal matter rather than the animal body that is hooked up into technical apparatus, the body becoming irrelevant. The MEART project . . . is one of the best examples of this."[1] This, of course, was the SymbioticA art project discussed in chapter 2, of which Burt had earlier noted that in its "radical hybridization of rat and machine" the animal body had been so "completely disarticulated" that "it probably makes little sense to talk of the rat in this instance."[2]

Is there a case, following Burt's line of thought, for saying that certain developments in contemporary art suggest that art may indeed be

moving into a post-animal era, in which the animal body is "becoming irrelevant"? The artists directly associated with SymbioticA are far from alone in exploring questions of animal life through more conceptual or curatorial or scientifically oriented practices and collaborations that put considerably less emphasis on the "look" of the animal body. The principal representation of such approaches in the present book is in the discussion of Eduardo Kac's and Lucy Kimbell's practices, but a different book might have focused entirely on compelling examples of animal-oriented contemporary art, many of them simultaneously responsible and controversial, in which the animal body hardly appeared.

The emphasis here, however, has been on the continuing task of articulating the animal-body-in-art as a thing "dense in meaning, and exuberantly visual, yet difficult to 'read' and far from 'beautiful,'" as Mieke Bal puts it.[3] Exuberantly visual and abrasively visible. The look of the nonhuman animal is still very much contested territory in contemporary visual culture,[4] and (to borrow Kac's apt words from a rather different context) if *artists* aren't going to engage critically with the representation of animals, *who is going to do that?*

The look of the animal, the visual representation of the animal, still matters, still figures, and it's the thing that art (with its visual fluency and skill and experience of subverting its own conventions) can handle most persuasively. It can *play* its own forms and conventions, extend them, render them tenuous and porous. To do this, the "figure" of the animal-body-in-art needs the ability to move back and forth across the place where art's boundary may be thought (or best guessed) to be, seeping through, overspilling, and generally making a bit of a mess of things. And to do that, it needs contemporary art's openness. Robert Filby holds open the extent to which the cats in his photographs may or may not be part of the art. Mary Britton Clouse holds open the scope for imagery that didn't start out as part of her art practice to become part of it. Olly and Suzi's work exemplifies what Wendy Wheeler calls "an openness to life." Kac made a "concerted effort" to keep his *GFP Bunny* project "indeterminate enough":

> to remain truly open to the participants' choices and behaviours, to give up
> a substantial portion of control over the experience of the work, to accept

the experience as-it-happens as a transformative field of possibilities, to learn from it, to grow with it, to be transformed along the way.[5]

And Kimbell found that she had to "hold open a space of ambiguity and be there in it." In the case of David Wood's mirror infractions and Snæbjörns-dóttir/Wilson's *the naming of things,* it's a mere change of pace that creates this openness, recalling Gilles Deleuze and Félix Guattari's observation that creative becomings may be a matter of establishing "a calm and stable 'pace' (rather than a form)." This is art's work, the work of improvisation: "One launches forth, hazards an improvisation. But to improvise is to join with the World, or meld with it."[6]

This mode of attention seems, to say the least, to stand at some distance to what Cary Wolfe sees as Niklas Luhmann's distinctively "posthumanist" take on art and form. He writes: "Luhmann explains, 'a work of art must distinguish itself externally from other objects and events, or it will lose itself in the world'; it 'closes itself off by limiting further possibilities with each of its formal decisions.'"[7] These views, however, seem to find Luhmann at his most aesthetically conservative. They evoke nothing so much as Clement Greenberg in the 1960s worrying that unlike painting, sculpture found itself "where everything material that was not art also was." This was the unruly territory in which mixed-media art would thrive, and which Michael Fried at that time judged to be the grounds on which "*art degenerates.*" What Fried regarded as "the authentic art of our time" was to be found elsewhere, securely demarcated on the symbolic space of the gallery wall.[8]

For all the subtlety and range of Luhmann's complex analysis, in the quarter century between the end of the 1960s and the first publication of his *Art as a Social System* in German in the mid-1990s—precisely the period that saw the emergence of the art of the postmedium condition—he does not seem closely to have tracked the trajectory of contemporary art. This is a rather specific and minor criticism of his ambitious undertaking, but it means that his analysis is not always a good "fit" in a contemporary context. For example, Wolfe again quotes Luhmann as saying, "'The function of art is to make the world appear within the world . . . *a work of art is capable of symbolizing the reentry of the world into the world because*

*it appears—just like the world—incapable of emendation.'"*⁹ But that idea of the artwork as "incapable of emendation" is a poor fit indeed with the various "open" works mentioned a couple of paragraphs ago. Incapable of emendation? Incapable of correction or improvement? This hardly sounds like a persuasive description of the flawed and tentative animal-body-in-art, or of the mode of attention with which contemporary artists engage with it. ¹⁰

Rereading Wolfe on Coe

In Wolfe's own principal contribution to these debates—his widely published essay juxtaposing the work of Sue Coe and Kac, which appears most recently as a chapter in *What Is Posthumanism?*—he sets up his comparison of their approaches in a manner that brings with it some unwarranted assumptions. ¹¹ The rereading of that chapter that is offered here can be taken either as an alternative interpretation that complements but differs from Wolfe's own reading of the material or as a direct challenge to Wolfe's reading that contests the terms of his engagement with Coe's work in particular. It's intended as both.

Toward the end of that chapter (which is addressed here while keeping very much in mind Burt's reference to animal bodies so "completely disarticulated" that it makes little sense still to speak of them as animals), Wolfe writes that "Kac subverts the centrality of the human and of anthrocentric modes of knowing and experiencing the world by displacing the centrality of its metonymic stand-in, human (and humanist) visuality." There are two points to note here: the activity of displacement (to which I return), and the association of the visual with humanism. The second point is central to Wolfe's essay and runs through it like a refrain: "a certain humanist schema of the scopic and the visual," "the visual and its (humanist) centrality," and "the very humanist centrality of vision." As Wolfe acknowledges at the start of the following chapter, his "critique of the humanist schema of visuality" is a significant theme in *What Is Posthumanism?* ¹²

It's tempting to call this, bluntly, a strategy of *dissing the visual*. The visual is too present, too obvious. Wolfe writes, "In Coe's work, *nothing is hidden* from us," and complains that it's all about "the 'melodrama of visibility.'" Whereas with Kac, "When we leave behind the technical and logistical

aspects of the piece . . . to address the work's intellectual, ethical, and social implications, we enter another order of complexity."[13] This reflects a more widespread academic and aesthetic rhetoric: a taste—often for good reasons—for the decentered, deconstructed, distributed, and displaced (which is neatly caught in the title of the 1990s journal *de-, dis-, ex-.*).[14] Extended to the animal-object-in-art, it amounts more troublingly to the view that the "disarticulated" body is more sophisticated, edgy, *contemporary* than the articulated (even if differently articulated) body.

Wolfe positions Coe's work as humanist because it's too visual, and Kac's as posthumanist because it's so much less visually oriented, or so much more than merely visual. More than this—and despite a professed interest in exploring "how particular artistic strategies *themselves* depend upon or resist a certain humanism that is quite independent of the manifest content of the artwork"—the visual is presented as irretrievably mired in humanist values.[15] Wolfe doesn't say as much, but it looks as though Kac is seen as resisting humanism by casting his art *as philosophy*: "philosophy in the wild," as Kac himself puts it.[16]

Wolfe's attack on art—for that, at least, is what it is open to being read as—results from a mode of attention that is, perhaps like Luhmann's, distinctly different from that of the contemporary artist. As a result, he misses things, by not looking enough. In a different context, Jean-Luc Nancy has asked: "Is listening something of which philosophy is capable? . . . Isn't the philosopher someone who . . . neutralizes listening within himself, so that he can philosophize?"[17] The equivalent questions here might be: Is looking something of which posthumanist theory is capable? Is it capable of finding (in John Szarkowski's words) "the courage to look . . . with a minimum of theorizing"?[18]

There are several interconnected elements to the misleading reading of Coe's work in Wolfe's chapter. The first (though the order is immaterial) is the assertion that Coe's graphic and painted work depicting the treatment of living and dead animals in factory farms and slaughterhouses "invites a single, univocal reading." Elaborating on the point, Wolfe writes: "Coe's painting aspires to the condition of writing, but writing understood . . . as the direct communication of a semantic and as it were external content, of which the artwork is a faithful . . . enough representation to didactically incite ethical action."[19] This extraordinary claim not only reduces

Coe's work to crude propaganda but also apparently denies the legitimacy (and the material *work*) of her chosen medium. Part of the problem could be said to lie in his lack of interest in Coe's own reflections on her practice. Her comments (quoted in chapter 6) on the continuous need to undercut and frustrate her own facility at drawing and to "sabotage" her instincts, for example, combined with a vivid awareness that her work gets nowhere near the "flow" she admires in Japanese printmakers, suggests a constant vigilance on Coe's part in negotiating her work's necessary clumsiness and thick materiality. Combined with her clear declaration that at the point when she's making the work she cannot reliably judge *how* it will work, this hardly corresponds to Wolfe's picture of her working with the uncritical sense that a communicative transparency might ever be achievable.

The second point concerning Wolfe's account of Coe's practice has to do with ethics and with artists' ethical implication in their own work. Wolfe notes admiringly that Kac's projects "ethically intervene in our received views of the human/animal relationship and, beyond that, in the question of posthumanism generally." Of Coe, however, he writes: "The almost nightmarish, infernal scenes of violence before us *hide nothing*, and for that very reason, the artist, as it were, has no blood on her hands."[20] This is a particularly troubling claim, because in using language that seems to position the artist at a distance from her subject matter, Wolfe opens himself to being read as contrasting Kac's ethical posthumanism not just with Coe's alleged humanism but with her *unethical* humanism.

Third, Wolfe contends that in Coe's work a huge amount hangs on "a certain rendering . . . of the face." This seems to have little to do with close scrutiny of Coe's work and more to do with a conflation of available philosophical ideas of visibility and "faciality." It allows Wolfe—not always entirely clearly—to argue that Coe's "'melodrama of visibility' . . . is calculated to 'give the animal a face,'" and that "Coe's melodramatic renderings themselves harbour a more fundamental (and a more fundamentally comforting) representationalism, a signifying regime whose best name might well be 'faciality'—even if that faciality extends across species lines."[21]

This needs to be challenged. There are animal faces aplenty in Coe's work, not least the prominent faces on the covers of her books *Pit's Letter* and *Sheep of Fools*. And her unpublished sketchbooks show her ongoing attempts, by drawing animals from firsthand observation, to individualize

the faces that will appear in "finished" pieces where animals appear en masse, as they do in *Sheep of Fools*. But an ability (and determination) to render faces in this manner does not equate to humanism. Notwithstanding the difference that the medium undoubtedly makes, it's the direct equivalent of Jacques Derrida's opposition to philosophy's engagement with "the animal *in general*,"[22] and of his verbal struggle to persuade readers of the irreducible reality of one particular cat he writes about. These, of course, are characteristics of Derrida's writing that Wolfe and others quite reasonably regard as posthumanist.

In addition, the face is not the visual focus of Coe's campaigning imagery. In *Animal Rites*, Wolfe refers to Deleuze and Guattari's "critique of the regime of 'faciality,'" which he characterizes as "a fetishized localization of desire whose aim is fixity and identity," and he quotes their uncompromising sentence, "The face itself is redundancy."[23] But in charging Coe with acquiescing to this regime of faciality, as he does in *What Is Posthumanism?* he fails to see that the face is largely incidental, if not entirely redundant, in the operation of Coe's imagery. In a play of configuration and disconfiguration that is more complex than Wolfe allows, and is anything but "univocal," it is *bodies*, not faces, that do the work.

There is no shortage of evidence. In the depiction of mulesing in *Sheep of Fools* (Figure 6.1), it is the diagonal line of bright red bloody wounds, the two pairs of blood-soaked shears, and the gratuitous human kick that the viewer's gaze recoils from. The one "screaming" sheep's face in the line of prone bodies offers secondary support, at best. Cover that face with the fingers, and the image loses none of its dreadful impact. Mark Cousins recognizes (albeit with immediate reference to humans rather than animals) the need to focus diligently on *danger to the body* in such circumstances. Noting that from Kant onward "the central issue of ethics . . . has been rights," and explaining that he is "suspicious of the language of ethics . . . because it deals with the soul and not the body," he writes, with specific reference to torture: "There is something too dreadful about being held in a room, having your body rather than your rights assaulted."[24] It's that particular "something too dreadful" that Coe is concerned to depict.

Arguably, the defining images in *Sheep of Fools* are on pages 24–25, which show details from Coe's drawing *Goats before Sheep* (Figure 6.4). Here the emphasis is on body shapes, not faces: specifically the sheep's

bodies that are pictured jumping from the "high rise building" of the burning ship in an image that inexorably calls to mind the terrible 9/11 imagery of human bodies falling from the burning Twin Towers. Coe acknowledged that the drawing was "definitely" a nod toward the indelible memory of those photographs. Asked about the drawing's close stylistic and iconographic similarity to her own earlier Twin Towers drawing, called *WTC 911*, she said: "I never thought of that before, but that's true."[25] In *Sheep of Fools* the drawing has some of Judith Brody's text superimposed on the sky, including the line "10,000 sheep packed Auschwitz tight," which reinforces a human comparison with the fate of the depicted nonhuman bodies.

The direct referencing of instances of human torture and terror in this way should not, of course, be read as further evidence of Coe's alleged humanism. The clearest reason for this is that it stands as a visual equivalent, once again, of a move made in Derrida's philosophical thinking on animals, most directly in his much-quoted uncompromising observation that contemporary forms of violence against animals (of very much the kind that Coe depicts) constitute "violence that some would compare to the worst cases of genocide."[26] Wolfe has praised that particular remark as "flatly (and accurately)" describing the situation.[27] Further, in *What Is Posthumanism?* he diagrammatically positions Derrida at the furthest contemporary reach of "posthumanist posthumanism," as the thinker whose work clarifies what "fatefully binds us to nonhuman being in general, and within that to nonhuman animals."[28]

The conscious pictorial echoing of human and animal body forms and shapes is a key characteristic of Coe's art and is abundantly evident in all her books.[29] In *Sheep of Fools* it's seen, for example, in the complementary overlapping shapes of the sheep and sheep shearer (Figure 6.2), which themselves seem close to the echoed and overlapping forms of rescued dog and activist in her *Terrorists or Freedom Fighters?* poster (Figure 6.5). "They're both done with gentleness," she says. Both reflect her attempts to convey pictorially the sense that human and animal bodies are locked into each other's rhythms and, in *Dead Meat* in particular, her concern truthfully to record the humanity of exploited workers caught up in industries of animal abuse. As she says, "There's a neutrality in how I depict the human beings, I hope."[30]

Wolfe reads this rather differently, asserting that the faces of the slaughterhouse workers "are often 'beastly' or 'animalistic' in the traditional, speciesist sense of the word."[31] This overstates the case, but despite Coe's aim for "neutrality" it's true that there are a few caricatured and unquestionably unpleasant depictions of humans (and not just of human actions) in her work. In *Sheep of Fools,* this is perhaps especially evident in the depiction of individuals engaged in scenes of ritual slaughter in the book's closing pages. And notwithstanding the biblical allusion, there's something similarly uncomfortable going on in the rhetoric of a title such as *Goats before Sheep,* given to a drawing that depicts only humans and sheep (Figure 6.4).

So yes, there are compromised bodies and compromised rhetorics to be found in Coe's work, which is not clear-cut, but is *there in the world,* tied to the totality of the messy and less-than-always-posthumanist world. Her work has its humanist moments—but so too does that of Kac. Both artists are working in the medium of the animal. Both make work that is, at least at times, characterized by (and welcoming of) contradictions, failures, uncertainties, and ambiguities. Both work at the blurry boundary of art and on further blurring that boundary.

If that claim doesn't immediately sound as though it corresponds to what Coe is doing, it's worth returning to aspects of Rosalind Krauss's account of the postmedium condition explored in the previous chapter. These were her references to postmedium artists seeing the scope "to transform the whole project of art from making objects . . . to articulating the vectors that connect objects to subjects," and her characterization of the results as "practices of rampant impurity."[32]

It will be readily acknowledged that much of Kac's work—not least the *GFP Bunny* project and the posters of the follow-up *Paris Intervention* (Figure 3.4)—continue to work in something close to this manner. But Coe's work can also be seen in this light. Hybrid forms and practices run through her work. *Sheep of Fools* appeared as a *"Blab!"* book from Fantagraphics, a publisher of comic book art. During the 2000s much of Coe's output appeared in eight- or twelve-page sequences in successive issues of *Blab!* magazine, where it occasionally found itself in strange and lurid company. For Coe this was a way to get her work out to "kids,

pre-adulteration," and to animal activists, whom she continues to see as her primary audience. She explicitly contrasted this welcomingly diverse context for trying out new sequential ideas to her earlier practice of placing individual captioned drawings in magazines such as the *New Yorker*, where "the context renders it like instant pudding." The choice is part of her larger aim of "keeping the vision *mobile*, so I can go anywhere."[33] It's also a means, in Krauss's words, of "articulating the vectors that connect objects to subjects."

Coe's books are still objects made by an artist, but not exactly art objects in the usual sense of that term. Her own sense seems to be that they are highly compromised artifacts. Each one represents a revised attempt to combine image and text convincingly, and in her view "it's a failure in every single book I've done." In some cases it's the difficulty of "how to merge the two so that it doesn't look contrived," whereas in others it's down to the choice of typefaces that in retrospect "look *hideous*." In *Sheep of Fools* the square *"Blab!"* format didn't help, because the square is "not a perfect format for art," and most of the existing drawings used in the project had to be cropped to fit. Nothing here quite corresponds to Wolfe's notion of "univocal" or transparent communication. Of her research, Coe speaks of "fascinating bits and pieces that I wanted to put together to make vague sense" and of loving the opportunity that art offers "to take these tangled threads and draw one out . . . and then just let it go."[34]

Practices of the Posthumanities

Overall, Wolfe's preference for Kac's work over Coe's seems to assume that work in new media is almost by its very nature more intellectually and aesthetically radical than work in traditional media or established genres of art. For Kac, he notes, "it is not simply a matter of new *forms* of visuality," but rather of recognizing that "visuality itself—as the human sensory apparatus *par excellence*—is now thoroughly decentered and subjected to a rather different kind of logic."[35] It's difficult to read Wolfe other than as saying that to be less visually oriented is to be more sophisticated, more posthumanist, and that the alternative is to be "stupid like a painter," as Marcel Duchamp's complaint from a century earlier had it.[36]

Yet that's not the case. Wolfe is clearly *not* hostile to contemporary art, including art that "represents" animals, in paint or any other medium.[37] How then does he come to take this particular line on Coe's work? Early in the chapter on Kac and Coe, he expresses interest in "what the relationship is between philosophical and artistic representationalism." Is it possible that something like an inadvertent sleight of hand has happened in those few words, so that representational art (or figurative art, or any other preferred term for nonabstract visual art) comes to be tarred with the same brush as representationalist modes of philosophical thought that keep the "familiar figure of the human at the center of the universe of experience," as Wolfe later puts it?[38]

In his invaluable book *CIFERAE: A Bestiary in Five Fingers,* Tom Tyler offers a clear assessment of some of the issues at stake here. Searching out alternatives to humanist thought wherever he can find them in Western philosophy, Tyler traces the anthropocentric heritage of Immanuel Kant's philosophy of representationalism and concludes that the characterization of knowledge as representation has been common to both realist *and* relativist epistemologies. Pragmatist epistemologies, on the other hand, offer an altogether more fruitful way forward. In particular, he suggests that "for pragmatism, knowledge is conceived as a practice, not a representation. It is something that one does rather than a collection of concepts or ideas which one has." From this perspective "knowledge is a matter neither of units of information in the brain nor structures and representations in the mind; knowledge is practice itself." Further, for pragmatism "as an antirepresentationalist epistemology, knowledge does not depict the world but instead makes possible modes of activity within the world."[39]

In the present context, this emphasis on *practice* is immensely helpful for two reasons. First, it is strikingly close to Francisco Varela's deliberately "nonmoralistic" notion of "ethical know-how," which explicitly acknowledges that "cognition consists not of representations but of *embodied action,*" which establishes its posthumanist credentials in insisting that "the ethical implies putting the status of the knowing subject into question," and in which actions are taken "in harmony with the texture of the situation at hand, not in accordance with a set of rules or procedures."[40] Second, the emphasis on practice fits well with what has been seen in preceding

chapters of the nature of contemporary art practice, including the practices of Kac and of Coe. If Wolfe finds Coe's work to be humanist, it is perhaps because he looks to that work for *what he expects to find there*: confident representationalist knowledge embedded in self-contained representations, rather than the hard-won and sometimes compromised outcomes of an ongoing and far-from-complacent practice.

Difficult questions remain about how Wolfe operates his distinction between humanism and posthumanism, positioning Coe on one side and Kac on the other. Toward the end of his chapter, he asserts that his comparison of the two artists "helps us to see, in the realm of art, the difference between . . . a humanist posthumanism and a posthumanist one." This is because he allows that "Coe may be viewed as a posthumanist in the obvious . . . sense that she takes seriously the ethical and even political challenges of the existence of nonhuman animals." However, having given with one hand he immediately takes away with the other, insisting that Coe's attempt through her work to bring to light animal abuses that are generally hidden from view casts her as a humanist "in the only sense that turns out to be fundamental to her work *as art*."[41] Coe may be posthumanist as a thinker, in other words, but she is judged humanist (and thus wanting, and *failing*) as an artist.

This is all about neat positioning, not about messy practices. It is all too easy to position Kac and Coe as poles apart. (Animal advocates with little interest in art do this all the time, and although Wolfe *inverts* that move, it's essentially the same move.) But attending to Coe's and Kac's messy practices, to their improvisations and their compromises, it is easier to propose a perspective from which their work might begin to be understood as similarly structured. Drawn as it stands, an apparently fixed boundary between humanism and posthumanism has serious consequences (even when refined with further boundaries distinguishing both humanist and posthumanist posthumanisms from both posthumanist and humanist humanisms).[42] Why? Because these boundaries are freighted with ethical as well as formal considerations. As noted earlier, Wolfe considers that Kac's projects "ethically intervene . . . in the question of posthumanism" (whereas Coe's do not). This is, it seems, to write (or read) posthumanism as a new ethics, but one that's nevertheless still a judgmental ethics.

These criticisms of Wolfe's exploration of "the animal question in contemporary art" in *What Is Posthumanism?* should not be mistaken for an attempt to undermine his valuable articulation of the wider field of the posthumanities,[43] and the ongoing conversation that it invites about its relation to animal studies. But, as Wolfe himself acknowledges, "to talk about art in the mode of doing theory and to talk about art as a practicing artist are two very different things."[44] If anything, the aim of the present book has been to work somewhere between those two perspectives, while generally holding significantly closer to the second of them.

It is from that practice-oriented perspective that a fashioning of the posthumanities that ends up positioning artists in relation to ethically freighted boundaries (even when they're counterintuitively drawn boundaries) comes to look like a missed opportunity. It feels as though it has lost sight of the satisfactions of fluidity, lightness, spontaneity, and attentiveness that are valued by thinkers like Varela and Isabelle Stengers, who speak—whether they know it or not—for artists' attentiveness and for attentiveness to art. Varela quotes Mencius saying, "'If one attends one gets it; if one does not, one does not,'" and emphasizes the ethical distance between that attitude and a reasoning that "consists mainly in the application of rules or principles."[45] For Stengers, ethics "is first linked with keeping alive the sense of wonder." The inquiring mind is concerned less with "defining" than "exploring" situations.[46] And her reference to "seeing in the dance how close together the double possibility of harmony and failure come" seems to sit comfortably enough with Haraway's view that "the partners do not precede the meeting; species of all kinds, living and not, are consequent on a subject- and object-chasing dance of encounters."[47]

What might a reading of the work of Kac and Coe look like if envisaged less as working toward a distinction between them and more as establishing a dance of encounter? Might it allow that the strange and exuberant and sometimes terrible animal-bodies-in-art that each of them puts forward might *together* attest to the animal body's not "becoming irrelevant," and to the time of the posthumanities not necessarily constituting a "post-animal era"?

Notes

Introduction

1. Anthony Julius, *Transgressions: The Offences of Art* (London: Thames and Hudson, 2002), 144, 143.

2. Randy Malamud, "Americans Do Weird Things with Animals, or, Why Did the Chicken Cross the Road?" in *Animal Encounters*, ed. Tom Tyler and Manuela Rossini (Leiden: Brill, 2009), 79, 74.

3. Etienne Benson, review of *Animal Encounters, Jac* 30, nos. 3–4 (2010): 832.

4. Iris Murdoch, *The Fire and the Sun: Why Plato Banished the Artists* (Oxford: Clarendon Press, 1977), 2.

5. See Carol Gigliotti, "Leonardo's Choice: The Ethics of Artists Working with Genetic Technologies," in *Leonardo's Choice: Genetic Technologies and Animals*, ed. Carol Gigliotti (Dordrecht: Springer, 2009), 63; and Lynda Birke, "Meddling with Medusa: On Genetic Manipulation, Art, and Animals," in Gigliotti, *Leonardo's Choice*, 107–22.

6. Wendy Wheeler, *The Whole Creature: Complexity, Biosemiotics, and the Evolution of Culture* (London: Lawrence and Wishart, 2006), 146.

7. Paul Auster, *Travels in the Scriptorium* (London: Faber, 2006), 1.

8. Furthermore, as Stephen Bann has argued, the contemporary art gallery is itself "a symbolic space that had been secured by the efforts of the nineteenth-century avant-garde": see his *Ways around Modernism* (New York: Routledge, 2007),

110. This issue will call for fuller exploration in the closing chapter of the present book.

9. Martin Harries, "Regarding the Pain of Rats: Kim Jones's *Rat Piece*," *TDR: The Journal of Performance Studies* 51, no. 1 (2007): 160.

10. Kim Jones, e-mail correspondence with the author, January 12, 2011.

11. Harries, "Regarding the Pain of Rats," 160.

12. Jones, e-mail correspondence with the author, January 12, 2011.

13. Kim Jones, quoted in Harries, "Regarding the Pain of Rats," 161–62.

14. Ibid., 162.

15. Kim Jones, *Rat Piece: February 17, 1976* (1990), 7. This 123-page book was self-published by Jones with support from the John Simon Guggenheim Memorial Foundation. It collects news articles, correspondence, legal documents, essays, and photographs relating to the performance and its aftermath. I am grateful to Jones for providing me with a copy of the book.

16. Kim Jones, quoted in Stephen Maine, "In Conversation: Kim Jones with Stephen Maine," *Brooklyn Rail: Critical Perspectives on Art, Politics, and Culture*, November 2006, http://brooklynrail.org/2006-11/art/kim-jones.

17. Ibid.

18. Kim Jones, quoted in Linda Weintraub, "Inventing Biography—Fictionalized Fact and Factualized Fiction: Kim Jones," in *Making Contemporary Art: How Today's Artists Think and Work* (London: Thames and Hudson, 2003), 213, 208.

19. Ibid., 213.

20. Ibid.

21. Harries, "Regarding the Pain of Rats," 164.

22. Ibid., 165.

23. Ibid., 164.

24. Weintraub, "Inventing Biography," 213.

25. Steve Baker, *The Postmodern Animal* (London: Reaktion Books, 2000), 20, 61–62, and passim.

26. See the discussion of the work of Catherine Chalmers and of Eduardo Kac in chapter 3, and of Catherine Bell in chapter 5. Chalmers kept and cared for the animals that featured in some of her artworks in her studio; the diet of some of those creatures comprised other live animals, and the artist took responsibility for providing them with that diet. Kac's actions in creating the transgenic rabbit Alba inadvertently brought about her eventual death in a French laboratory, despite his concerted efforts to secure her release. And Bell commissioned

fishermen to line-catch forty squid so that she could use their bodies in a complex performance piece; the work included their subsequent consumption as food.

27. Robert Storr, "Acting Out," in *Mudman: The Odyssey of Kim Jones*, ed. Sandra Q. Firmin and Julie Joyce (Cambridge, Mass.: MIT Press, 2007), 94.

28. Kristine Stiles, "Teaching a Dead Hand to Draw: Kim Jones, War, and Art," in Firmin and Joyce, *Mudman*, 56.

29. Max Kozloff, quoted in Stiles, "Teaching a Dead Hand to Draw," 56.

30. Donald Judd, quoted in Thierry de Duve, "The Monochrome and the Blank Canvas," in *Reconstructing Modernism: Art in New York, Paris, and Montreal, 1945–1964*, ed. Serge Guilbaut (Cambridge, Mass.: MIT Press, 1990), 272.

31. Harries, "Regarding the Pain of Rats," 162.

32. Karen Hanson, "How Bad Can Good Art Be?" in *Aesthetics and Ethics: Essays at the Intersection*, ed. Jerrold Levinson (Cambridge: Cambridge University Press, 1998), 205.

33. Keith Hall, "Artist Fiddles, Rats Sizzle, but Audience Fails to React," reproduced in Jones, *Rat Piece*, 20.

34. Hanson, "How Bad Can Good Art Be?" 215, 204.

35. John Cage, quoted in Ursula Meyer, *Conceptual Art* (New York: Dutton, 1972), viii.

36. Donna J. Haraway, *When Species Meet* (Minneapolis: University of Minnesota Press, 2008), 340.

37. Harries, "Regarding the Pain of Rats," 163.

38. Ibid., 162, 163.

39. Weintraub, "Inventing Biography," 213.

40. Isabelle Stengers, "The Challenge of Complexity: Unfolding the Ethics of Science (In Memorium Ilya Prigogine)," *Emergence: Complexity and Organization (E:CO)* 6, nos. 1–2 (2004): 97.

41. Jones has seen this chapter, including this paragraph. When I contacted him in January 2011 I made it clear that while I welcomed his comments on any aspect of the chapter, I was only specifically requesting him to correct any factual inaccuracies or comments that he considered misleading in my account of his work and its reception. He restricted himself to clarifications of specific details of the performance and its immediate aftermath: see notes 10 and 12 for this chapter.

42. Mark Dion, "Some Notes towards a Manifesto for Artists Working with or about the Living World," in *The Greenhouse Effect*, ed. Ralph Rugoff (London: Serpentine Gallery, 2000), 66.

43. I first wrote about the conjunction of Dion's, Evaristti's, and Singer's ideas in "Animal Rights and Wrongs," *Tate: The Art Magazine*, no. 26 (2001): 42–47, but some of the detail of the present account of the installation also draws on Giovanni Aloi, "Marco Evaristti: *Helena*," in *Antennae: The Journal of Nature in Visual Culture*, no. 5 (2008): 30–31, http://www.antennae.org.uk, and on the report "Liquidising Goldfish 'Not a Crime,'" http://news.bbc.co.uk (accessed April 24, 2010). Singer's comment appeared in Sarah Boxer, "Metaphors Run Wild, but Sometimes a Cow Is Just a Cow," *New York Times*, June 24, 2000.

44. Peter Singer, e-mail correspondence with the author, June 8, 2001.

45. For Aloi's announcement and the entire subsequent discussion thread, see http://www.h-net.org/~animal. Parts of the thread were later reproduced as "The Goldfish Thread," *Antennae: The Journal of Nature in Visual Culture*, no. 5 (2008): 33–42, http://www.antennae.org.uk.

46. William Lynn, H-Animal thread, January 15, 2008; Rod Bennison, H-Animal thread, January 15, 2008.

47. Bryndís Snæbjörnsdóttir, H-Animal thread, January 25, 2008.

48. Carol Gigliotti, H-Animal thread, January 28, 2008.

49. Ralph Acampora, H-Animal thread, February 7, 2008; William Lynn, H-Animal thread, February 8, 2008.

50. Marion Copeland, H-Animal thread, February 4, 2008.

51. Nigel Rothfels, H-Animal thread, February 6, 2008.

52. Boria Sax, H-Animal thread, February 11, 2008.

53. Peter Meyer, quoted in "Liquidising Goldfish 'Not a Crime.'"

54. Ralph Acampora, H-Animal thread, February 8, 2008.

55. Kari Weil, H-Animal thread, February 7.

56. Marco Evaristti, quoted in the interview "Marco Evaristti: *Helena*," conducted by Erik Frank and H-Animal readers, in *Antennae: The Journal of Nature in Visual Culture*, no. 5 (2008): 32, http://www.antennae.org.uk.

57. Marco Evaristti, quoted in "Liquidising Goldfish 'Not a Crime.'"

58. Kim Jones, quoted in Julie Joyce, "Sunset to Sunrise: Kim Jones in Los Angeles," in Firmin and Joyce, *Mudman*, 29.

59. See Aloi, "Marco Evaristti: *Helena*," 31.

60. Marco Evaristti, quoted in Anna Karina Hofbauer, "Marco Evaristti and the Open Work," 2007, http://www.evaristti.com (accessed April 24, 2010).

61. Jim Dine, quoted in *Jim Dine: Walking Memory, 1959–1969*, ed. Germano Celant and Clare Bell (New York: Guggenheim Museum Publications, 1999), 108.

62. In 2011 Evaristti made another work featuring swimming goldfish, called *Forgive Me Helena*, but despite its title it's in no clear sense an apology for his earlier lethal installation. If anything, the title seems like a provocation finely judged to raise and then to frustrate the predictable expectations of "the moralist." See http://www.evaristti.com (accessed December 7, 2011).

63. Stephen Farthing, *An Intelligent Person's Guide to Modern Art* (London: Duckworth, 2000), 44.

64. Viktor Shklovsky, quoted in Iain McGilchrist, *The Master and His Emissary: The Divided Brain and the Making of the Western World* (New Haven, Conn.: Yale University Press, 2009), 412.

65. Matthew Calarco, *Zoographies: The Question of the Animal from Heidegger to Derrida* (New York: Columbia University Press, 2008), 4.

1. An Openness to Life

All unattributed quotations from Olly and Suzi in this chapter are drawn from the author's unpublished interview with them, London, August 2005.

1. The body of work to which the drawing belongs, which the artists describe as having offered them "the opportunity to travel into the very fabric of matter and physical form" during their period as artists-in-residence at the museum, is briefly discussed in their monograph *Olly & Suzi: Arctic, Desert, Ocean, Jungle* (New York: Abrams, 2003), 236.

2. For a discussion of some of this earlier work, see Steve Baker, *The Postmodern Animal* (London: Reaktion Books, 2000), 8–17, 19–20, 130–32, 169, 173, 175.

3. Jonathan Burt, "Animals in Visual Art from 1900 to the Present," in *A Cultural History of Animals in the Modern Age*, ed. Randy Malamud (Oxford: Berg, 2009), 180.

4. Garry Marvin, "Guest Editor's Introduction: Seeing, Looking, Watching, Observing Nonhuman Animals," *Society and Animals* 13, no. 1 (2005): 3.

5. Ibid., 5, 6.

6. Ibid., 5.

7. Sidney I. Dobrin and Sean Morey, "Introduction: Ecosee: A First Glimpse," in *Ecosee: Image, Rhetoric, and Nature*, ed. Sidney I. Dobrin and Sean Morey (Albany: State University of New York Press, 2009), 8.

8. Sean Morey, "A Rhetorical Look at Ecosee," in Dobrin and Morey, *Ecosee,* 37.

9. Cheryce Kramer, "Digital Beasts as Visual Esperanto: Getty Images and the Colonization of Sight," in *Thinking with Animals: New Perspectives on Anthropomorphism*, ed. Lorraine Daston and Gregg Mitman (New York: Columbia University Press, 2005), 141, 143.

10. Ibid., 144, 157, 145.

11. Ibid., 166.

12. Ron Broglio, *Surface Encounters: Thinking with Animals and Art* (Minneapolis: University of Minnesota Press, 2011), 100.

13. Donna J. Haraway, speaking during the question period following her public lecture, "A Companion Species Manifesto," Lancaster University, UK, March 12, 2003.

14. The shark photograph had also been reproduced on the cover of my book *The Postmodern Animal*.

15. Wendy Wheeler, *The Whole Creature: Complexity, Biosemiotics, and the Evolution of Culture* (London: Lawrence and Wishart, 2006), 146.

16. Ibid., 147.

17. Ibid., 147, 117.

18. Ibid., 63.

19. Thomas A. Sebeok, quoted in Wheeler, *Whole Creature*, 121–22.

20. Wheeler, *Whole Creature*, 147.

21. Francisco J. Varela, *Ethical Know-How: Action, Wisdom, and Cognition* (Stanford, Calif: Stanford University Press, 1999), 31, 33.

On Drawing an Aardvark

1. James Elkins, *The Object Stares Back: On the Nature of Seeing* (New York: Harcourt, 1996), 96–97.

2. Sue Coe, unpublished interview with the author, upstate New York, February 2006.

3. Iris Murdoch, *The Sovereignty of Good* (Abingdon, UK: Routledge, 2006), 33, 42.

4. Ibid., 36, 58.

5. Ibid., 39–40.

6. Ibid., 63, 85.

2. Cycles of Knowing and Not-Knowing

All unattributed quotations from Lucy Kimbell in this chapter are drawn from the author's unpublished interview with the artist, London, March 2006.

1. Lucy Kimbell, http://www.lucykimbell.com (accessed January 24, 2011).

2. Those later presentations of the lecture were at the Rules of Engagement sci-art conference in York in 2005; at the Centre for the Study of Invention and Social Process at Goldsmiths College, London, in 2006; at the European Association for the Study of Science and Technology conference in Trento in 2010; and at the conference The Animal Gaze Returned in London in 2011.

3. For Kimbell's own recent critical reflection on this project from an organizational perspective, see Lucy Kimbell, "An Aesthetic Inquiry into Organizing Some Rats and Some People," *Tamara: Journal for Critical Organization Inquiry* 9, nos. 3–4 (2011): 77–92.

4. Lucy Kimbell, unpublished text of the performance lecture, *One Night with Rats in the Service of Art* (dated August 31, 2005), 13 pp. Author's copy. The quotation is from page 4 of the typescript.

5. Lucy Kimbell, responding to a question from the Goldsmiths audience after the performance lecture, London, March 8, 2006.

6. Kimbell, performance lecture typescript, 11.

7. Ibid., 2.

8. Ibid., 3.

9. Ibid.

10. Ibid., 3, 9.

11. Ibid., 9.

12. Ibid., 4.

13. Jacques Derrida, "The Animal That Therefore I Am (More to Follow)," trans. David Wills, *Critical Inquiry* 28 (2002): 373.

14. See report on "Freedom March and Rally," Oxford, July 2005, on the SPEAK campaign website: http://www.speakcampaigns.org (accessed July 31, 2007).

15. Kimbell, performance lecture typescript, 7–8.

16. Ibid., 3, 7.

17. Veronica Simmons, "Rat Art in North London," *Pro-Rat-a* 149 (2005): 13–14.

18. Kimbell, responding to a question from the Goldsmiths audience after the performance lecture.

19. Simmons, "Rat Art in North London," 13.

20. Ibid.

21. Kimbell, performance lecture typescript, 12.

22. Ibid., 2.

23. Jonathan Burt, *Rat* (London: Reaktion Books, 2006).

24. Jonathan Burt, unpublished interview with the author, London, March 10, 2006.

25. *MEART* project, http://www.fishandchips.uwa.edu.au/project.html (accessed January 24, 2011).

26. Burt, *Rat,* 110–12.

27. Burt, unpublished interview with the author.

28. See Richard G. Morris, "Developments of a Water-Maze Procedure for Studying Spatial Learning in the Rat," *Journal of Neuroscience Methods* 11 (1984): 47–60.

29. Kimbell, performance lecture typescript, 13.

30. Isabelle Stengers, "The Challenge of Complexity: Unfolding the Ethics of Science (In Memorium Ilya Prigogine)," *Emergence: Complexity and Organization (E:CO)* 6, nos. 1–2 (2004): 96–97.

31. Kimbell, performance lecture typescript, 3, 6.

32. Ibid., 4, 6.

33. Burt, *Rat,* 134–35.

34. Kimbell, performance lecture typescript, 5, 3.

35. Ibid., 3.

36. Nigel Thrift, "Practising Ethics," in *Using Social Theory: Thinking through Research,* ed. Michael Pryke, Gillian Rose, and Sarah Whatmore (London: Sage, 2003), 114, 106, 108.

37. Ibid., 108, 115, 119.

38. Ibid., 114.

39. Ibid., 13.

40. Ibid., 9.

41. Ibid., 12.

42. Burt, unpublished interview with the author.

43. Thrift, "Practising Ethics," 119.

44. Kimbell, performance lecture typescript, 4.

On "Ethics"

1. Alain Badiou, *Ethics: An Essay on the Understanding of Evil*, trans. Peter Hallward (London: Verso, 2001), 28.

2. Jacques Derrida, "And Say the Animal Responded?" trans. David Wills, in *Zoontologies: The Question of the Animal*, ed. Cary Wolfe (Minneapolis: University of Minnesota Press, 2003), 121.

3. Jacques Derrida, "'Eating Well,' or The Calculation of the Subject: An Interview with Jacques Derrida," in *Who Comes after the Subject?* ed. Eduardo Cadava, Peter Connor, and Jean-Luc Nancy (New York: Routledge, 1991), 117, 118.

4. Badiou, *Ethics*, 3.

5. Ibid., 1, 3, 7, 24–25.

6. Ibid., 33, 35.

7. See Jacques Derrida, "The Animal That Therefore I Am (More to Follow)," trans. David Wills, *Critical Inquiry* 28 (2002): 39.

8. Jean-François Lyotard, *The Postmodern Condition: A Report on Knowledge*, trans. Geoff Bennington and Brian Massumi (Manchester: Manchester University Press, 1984), 81.

3. Vivid New Ecologies

Unattributed quotations from Catherine Chalmers in this chapter are drawn from the author's unpublished interview with her, New York, February 2006, and those from Eduardo Kac are from the author's unpublished interview with him, Chicago, May 2006.

1. Branka Arsić, "Regarding New Animals: Photographs by Allison Hunter," in *Simply Stunning: Allison Hunter*, 511 Gallery exhibition leaflet (New York: 511 Gallery, 2006), unpaginated.

2. Ibid.

3. Catherine Chalmers, *American Cockroach* (New York: Aperture, 2004).

4. Robert Adams, "Reconciliations with Geography: Minor White," in *Beauty in Photography: Essays in Defense of Traditional Values* (New York: Aperture, 1996), 93, 92, 96.

5. Catherine Chalmers, quoted in Steve Baker, "Impostors," in Chalmers, *American Cockroach*, 39.

6. Eduardo Kac, e-mail correspondence with the author, September 2001. For a fuller discussion of the idea, see Steve Baker, "Philosophy in the Wild? Kac and Derrida on Animals and Responsibility," *New Formations* 49 (2003): 90–98.

7. Eduardo Kac, *Telepresence and Bio Art: Networking Humans, Rabbits, and Robots* (Ann Arbor: University of Michigan Press, 2005), 264.

8. Eduardo Kac, personal website, http://www.ekac.org/genointer.html (accessed February 8, 2011).

9. Kac, *Telepresence and Bio Art,* 264.

10. Wendy Wheeler, "The Biosemiotic Turn: Abduction, or, The Nature of Creative Reason in Nature and Culture," in *Ecocritical Theory: New European Approaches,* ed. Axel Goodbody and Kate Rigby (Charlottesville: University of Virginia Press, 2011), 512.

11. Fred Vargas, *Seeking Whom He May Devour,* trans. David Bellos (London: Vintage, 2005), 66–67.

12. Steven Stern, review of *Safari, Time Out (New York),* October 26, 2006, http://www.catherinechalmers.com/press.

13. Eugene Thacker, "Biopoetics; or, a Pilot Plan for a Concrete Poetry," *Electronic Book Review,* October 2007, http://www.electronicbookreview.com.

14. For a fuller assessment of both the strengths and the shortcomings of the project, see Baker, "Philosophy in the Wild?" passim.

15. Neil Shubin, *Your Inner Fish: A Journey into the 3.5-Billion-Year History of the Human Body* (London: Allen Lane, 2008), 201.

16. Wheeler, "Biosemiotic Turn," 518–19.

17. Fran Bartkowski, *Kissing Cousins: A New Kinship Bestiary* (New York: Columbia University Press, 2008), 67.

18. Adam Phillips, "A Stab at Hinting," in *The Beast in the Nursery* (London: Faber, 1998), 88.

19. Bartkowski, *Kissing Cousins,* 8, 60.

20. Donna J. Haraway, *When Species Meet* (Minneapolis: University of Minnesota Press, 2008), 4.

21. Stephen Bann, *Ways around Modernism* (New York: Routledge, 2007), 106, 110.

22. John Cage, quoted in Ursula Meyer, *Conceptual Art* (New York: Dutton, 1972), viii.

23. Bann, *Ways around Modernism,* 112–13.

24. Ibid., 114.

25. Ibid., 115, 120.

26. Haraway, *When Species Meet*, 24.

27. Ibid., 19.

28. Barbara Smuts, quoted in Haraway, *When Species Meet*, 26.

29. Gerald Schatten, quoted in James Meek, "ANDi, First GM Primate. Will Humans Be Next?" *Guardian*, January 12, 2001, 1.

30. Tom Robbins, *Fierce Invalids Home from Hot Climates* (New York: Bantam, 2000), 21, 63.

31. Chalmers, quoted in Baker, "Impostors," 39.

32. Ibid., 40.

33. Ibid., 40, 41.

34. Gilles Deleuze and Félix Guattari, *A Thousand Plateaus: Capitalism and Schizophrenia*, trans. Brian Massumi (London: Athlone, 1988), 262.

35. Hélène Cixous, *Vivre l'orange/To Live the Orange*, adjacent French and English texts (1979), reprinted in *L'Heure de Clarice Lispector* (Paris: Des Femmes, 1989), 76.

36. Verlyn Klinkenborg, *Timothy; or, Notes of an Abject Reptile* (New York: Knopf, 2006), 18.

37. For an account of its ongoing development, see Jessica Wapner, "Ant Thrills: Seeing Leaf-Cutter Ants through an Artist's Eyes," *Scientific American*, June 10, 2011, http://www.scientificamerican.com/blog.

On Artists and Intentions

1. Walter Benn Michaels, "Neoliberal Aesthetics: Fried, Rancière, and the Form of the Photograph," *nonsite.org* 1 (2011), unpaginated, http://nonsite.org (accessed March 1, 2011).

2. Roland Barthes, *Camera Lucida: Reflections on Photography*, trans. Richard Howard (London: Jonathan Cape, 1982), 55.

3. Félix Guattari, *Chaosmosis: An Ethico-Aesthetic Paradigm*, trans. Paul Bains and Julian Pefanis (Sydney: Power Publications, 1995), 131.

4. Victor Burgin, "Seeing Sense," in *Language, Image, Media*, ed. Howard Davis and Paul Walton (Oxford: Blackwell, 1983), 239.

5. Ibid.

6. Michael Baxandall, *Patterns of Intention: On the Historical Explanation of Pictures* (New Haven, Conn.: Yale University Press, 1985), 42.

7. Ibid., 40, 42.

8. Ibid., 62–63.

9. Wendy Wheeler, *The Whole Creature: Complexity, Biosemiotics, and the Evolution of Culture* (London: Lawrence and Wishart, 2006), 147.

10. See the exhibition catalog *Animal Nature*, ed. Lane Hall, Lisa Moline, and Jenny Strayer (Pittsburgh: Regina Gouger Miller Gallery, Carnegie Mellon University, 2005). The exhibition also included work by, among others, Chalmers, Kac, Angela Singer, and Olly and Suzi.

11. For an account of this collaborative project, see Edwina Ashton and Steve Baker, "The Salon of Becoming-Animal," *TDR: The Journal of Performance Studies* 51, no. 1 (2007): 169–75.

4. Of the Unspoken

1. Jim Dine, quoted in *Jim Dine: Walking Memory, 1959–1969*, ed. Germano Celant and Clare Bell (New York: Guggenheim Museum Publications, 1999), 108.

2. Camden Arts Centre, information sheet, February 2009: "Additional information: Mircea Cantor, *The Need for Uncertainty*."

3. Ibid.

4. Mary Britton Clouse, e-mail correspondence with the author, March 2009.

5. Mircea Cantor, quoted in Suzanne Cotter, "If You Hold Your Breath," in *Mircea Cantor: The Need for Uncertainty*, ed. Andrew Nairne et al. (Oxford: Modern Art Oxford, 2008), 21.

6. Mircea Cantor, quoted in Alessandro Rabottini, "Mircea Cantor: A Future World," *Flash Art* 251 (2006): 98.

7. Camden Arts Centre, information sheet: "Background."

8. Britton Clouse, e-mail correspondence with the author, March 2009.

9. Jan Creamer, quoted in "ADI Slams Animal Exploitation over the Use of Live Peacocks in 'Art' Exhibition," www.ad-international.org (accessed February 24, 2011).

10. Cantor, quoted in Cotter, "If You Hold Your Breath," 28.

11. Cary Wolfe, "On a Certain Blindness in Human Beings," in Paola Cavalieri, *The Death of the Animal: A Dialogue* (New York: Columbia University Press, 2009), 128.

12. Tim Stilwell, e-mail correspondence with the author, March 2009.

13. Laura Cumming, "Why It Pays to Be Alone with the Truly Great Works of Art," *Observer*, "Review" section, March 29, 2009, 6–7.

14. John Cage, quoted in Ursula Meyer, *Conceptual Art* (New York: Dutton, 1972), viii.

15. Luce Irigaray, *An Ethics of Sexual Difference*, trans. Carolyn Burke and Gillian C. Gill (London: Athlone, 1993), 77, 74.

16. Guattari, *Chaosmosis*, 131.

17. Jacques Derrida, "The Animal That Therefore I Am (More to Follow)," trans. David Wills, *Critical Inquiry* 28 (2002): 377.

18. Cora Diamond, "The Difficulty of Reality and the Difficulty of Philosophy," in Stanley Cavell et al., *Philosophy and Animal Life* (New York: Columbia University Press, 2008), 53.

19. Ibid., 49, 52, 80.

20. Ibid., 58, 57, 51.

21. Ibid., 56.

22. Adam Phillips, "Talking Nonsense and Knowing When to Stop," in *Side Effects* (London: Hamish Hamilton, 2006), 36, 40.

23. Linda Downs, "CAA Signs Anticensorship Amicus Brief for *US v. Stevens*," College Art Association, http://www.collegeart.org/news/2009/07/28/ (accessed March 18, 2011).

24. "Brief of the National Coalition Against Censorship and the College Art Association as *Amici Curiae* in Support of Respondent," *United States of America v. Robert J. Stevens* (July 2009), 11, 12, 18, http://www.collegeart.org/news/2009/07/28/ (accessed March 18, 2011).

25. Ibid., 19.

26. Ibid., 17, 18, 29.

27. Mary Britton Clouse, e-mail correspondence with the author, November 2000.

28. Mary Britton Clouse, e-mail correspondence with the author, June 2001.

29. Donna J. Haraway, *Simians, Cyborgs, and Women: The Reinvention of Nature* (New York: Routledge, 1991), 150.

30. See the exhibition catalog *House of Oracles: A Huang Yong Ping Retrospective*, ed. Philippe Vergne and Doryun Chong (Minneapolis: Walker Art Center, 2005).

31. Huang Yong Ping, quoted in *House of Oracles*, 34.

32. Anonymous text titled "Censorship" on the Walker Art Center website: http://visualarts.walkerart.org/oracles (accessed December 22, 2005).

33. Mary Britton Clouse, e-mail correspondence with the author, December 2005.

34. Mary Britton Clouse, writing on January 12, 2006, http://blogs.walkerart.org/visualarts.

35. Mary Britton Clouse, e-mail correspondence with the author, January 2006.

36. Mary Britton Clouse, unpublished interview with the author, Minneapolis, May 2006. All further unattributed quotations from the artist are drawn from this interview.

37. Mary Britton Clouse, e-mail correspondence with the author, February 2008.

38. Ibid.

39. Britton Clouse, unpublished interview with the author.

40. Britton Clouse, e-mail correspondence with the author, February 2008.

41. Diamond, "Difficulty of Reality and the Difficulty of Philosophy," 64.

42. Britton Clouse, e-mail correspondence with the author, February 2008.

43. Stephen Bann, *The True Vine: On Visual Representation and Western Tradition* (Cambridge: Cambridge University Press, 1989), 8.

44. Barbara Bolt, *Art beyond Representation: The Performative Power of the Image* (London: I. B. Tauris, 2004), 68.

45. W. S. Graham, *Selected Poems* (London: Faber, 1996), 48.

46. Mary Britton Clouse, e-mail correspondence with the author, April 2011.

47. Gilles Deleuze, *The Logic of Sense,* trans. Mark Lester (London: Continuum, 2001), 301.

48. Mary Britton Clouse, quoted in Annie Potts, "Framed! Vegan Artists for Animal Rights," *Vegan Voice* 36 (2008), http://veganic.net.

On Maddening the Fly

1. Anthony Julius, *Transgressions: The Offences of Art* (London: Thames and Hudson, 2002), 154.

2. Ibid., 145.

3. Robin Barrow, "On the Duty of Not Taking Offence," *Journal of Moral Education* 34, no. 3 (2005): 265–75, http://k1.ioe.ac.uk/pesgb/x/Barrow.pdf.

4. Richard Sennett, quoted in Chris Dillow, "Are Brits Too Quick to Take Offence and Condemn?" http://liberalconspiracy.org (accessed December 31, 2011).

5. Barrow, "On the Duty of Not Taking Offence."

6. Martin Rowson, *Giving Offence* (London: Seagull Books, 2009), 60.

7. Jacques Derrida, "'Eating Well,' or The Calculation of the Subject: An Interview with Jacques Derrida," in *Who Comes after the Subject?* ed. Eduardo Cadava, Peter Connor, and Jean-Luc Nancy (New York: Routledge, 1991), 117, 118.

5. Almost Posthuman

1. Catherine Bell, e-mail correspondence with the author, April 2007.

2. Catherine Bell, "Performing Animality: Swimming with Eels and Squid Ink Erasure," paper delivered at the conference Animals and Society II: Considering Animals, Old Woolstore, Hobart, Tasmania, July 5, 2007.

3. Catherine Bell, unpublished interview with the author, Hobart, July 2007. All further unattributed quotations from the artist are drawn from this interview.

4. Bell, "Performing Animality."

5. Michael Tucker, "Towards a Shamanology: Revisioning Theory and Practice in the Arts," 5, 9, http://imaging.dundee.ac.uk/reflections/pdfs/Michael Tucker.pdf (accessed October 21, 2009). The paper was initially delivered at the conference Exploring the Role of Theory in Creative Practice, Duncan of Jordanstone College of Art and Design, University of Dundee, April 2006.

6. Ibid., 11.

7. Gilles Deleuze and Félix Guattari, *A Thousand Plateaus: Capitalism and Schizophrenia,* trans. Brian Massumi (London: Athlone, 1988), 160; and Gilles Deleuze and Félix Guattari, *Kafka: Toward a Minor Literature,* trans. Dana Polan (Minneapolis: University of Minnesota Press, 1986), 13.

8. Catherine Bell, e-mail correspondence with the author, October 2009, drawing on her unpublished PhD thesis, "Liminal Gestures: Ritualising the Wound through Performance and Lived Experience" (Melbourne, Monash University, 2007).

9. Deleuze and Guattari, *Thousand Plateaus,* 312.

10. Tucker, "Towards a Shamanology," 10–11.

11. Deleuze and Guattari, *Thousand Plateaus,* 270.

12. Georges Braque, quoted in Tucker, "Towards a Shamanology," 1.

13. For my own elaboration of this idea in relation to contemporary art, see

in particular the chapter "The Animal's Line of Flight" in Steve Baker, *The Postmodern Animal* (London: Reaktion Books, 2000).

14. Catherine Bell, e-mail correspondence with the author, July 2011.

15. Cary Wolfe, *What Is Posthumanism?* (Minneapolis: University of Minnesota Press, 2010), 126.

On Cramping Creativity

1. Nigel Thrift, "Practising Ethics," in *Using Social Theory: Thinking through Research*, ed. Michael Pryke, Gillian Rose, and Sarah Whatmore (London: Sage, 2003), 107, 108, 115.

2. Ibid., 116.

3. Donna J. Haraway, *When Species Meet* (Minneapolis: University of Minnesota Press, 2008), 136.

4. Thrift, "Practising Ethics," 117, 119.

5. Ibid., 119, 120.

6. Iain McGilchrist, *The Master and His Emissary: The Divided Brain and the Making of the Western World* (New Haven, Conn.: Yale University Press, 2009), 433, 434.

7. The survey could be seen by those who were not CAA members on the Facebook wall of the Association of Academic Museums and Galleries, where it was posted on March 15, 2011.

8. Paul Jaskot, e-mail correspondence with the author, March 24, 2011.

9. Mark Dion, "Some Notes towards a Manifesto for Artists Working with or about the Living World," in *The Greenhouse Effect*, ed. Ralph Rugoff (London: Serpentine Gallery, 2000), 66.

10. Ibid., 66, 68, 69.

11. Brian Massumi, "Translator's Foreword: Pleasures of Philosophy," in Gilles Deleuze and Félix Guattari, *A Thousand Plateaus: Capitalism and Schizophrenia*, trans. Brian Massumi (London: Athlone, 1988), xiii.

12. Friedrich Nietzsche, *The Gay Science*, trans. Walter Kaufmann (New York: Vintage, 1974), 164.

6. Art and Animal Rights

1. Cary Wolfe, *What Is Posthumanism?* (Minneapolis: University of Minnesota Press, 2010), 152.

2. Kathie Jenni, "The Power of the Visual," *Animal Liberation Philosophy and Policy Journal* 2, no. 4 (2005): 1–21; Jonathan Burt, untitled review of *A Day in the Life of a Massachusetts Slaughterhouse* (PETA Videos, 1998), *Society and Animals* 13, no. 4 (2005): 347–51.

3. Jenni, "Power of the Visual," 1, 2.

4. Ibid., 12, 13.

5. Ibid., 16, 8.

6. Burt, untitled review, 347–48.

7. Ibid., 350.

8. James Elkins, *The Object Stares Back: On the Nature of Seeing* (New York: Harcourt, 1996), 108, 115, 110.

9. Ibid., 116.

10. Ibid.

11. Niklas Luhmann, *Art as a Social System,* trans. Eva M. Knodt (Stanford, Calif.: Stanford University Press, 2000), 149.

12. Jacques Derrida, "The Animal That Therefore I Am (More to Follow)," trans. David Wills, *Critical Inquiry* 28 (2002): 373.

13. Iris Murdoch, *The Sovereignty of Good* (Abingdon, UK: Routledge, 2006), 34.

14. Sue Coe and Judith Brody, *Sheep of Fools: A Song Cycle for Five Voices* (Seattle, Wash.: Fantagraphics Books, 2005).

15. Sue Coe, *Dead Meat* (New York: Four Walls Eight Windows, 1996); Coe, *Pit's Letter* (New York: Four Walls Eight Windows, 2000).

16. Jane Kallir, "Sue Coe: *Sheep of Fools,*" exhibition leaflet (New York: Galerie St. Etienne, 2005), unpaginated.

17. Sue Coe, unpublished interview with the author, upstate New York, February 2006. All further unattributed quotations from the artist are drawn from this interview.

18. Sue Coe, quoted in Susan Vaughn, "Staying True to a Unique Vision of Art," *Los Angeles Times,* April 1, 2001, http://graphicwitness.org/coe.

19. Peter Schjeldahl, quoted on the flyleaf of Sue Coe and Judith Brody, *Bully!*

Master of the Global Merry-Go-Round (New York: Four Walls Eight Windows, 2004).

20. Sue Coe, quoted in "Sue Coe Interview," *3 x 3: The Magazine of Contemporary Illustration,* no. 5 (n.d.), http://www.3x3mag.com/sue_coe.html (accessed September 4, 2009).

21. Randy Malamud, *Reading Zoos: Representations of Animals and Captivity* (New York: New York University Press, 1998); Linda Kalof and Amy Fitzgerald, eds., *The Animals Reader: The Essential Classic and Contemporary Writings* (Oxford: Berg, 2007).

22. Britta Jaschinski, *Zoo* (London: Phaidon, 1996); Jaschinski, *Wild Things* (London: Thames and Hudson, 2003).

23. Britta Jaschinski, unpublished interview with the author, London, May 2011.

24. Britta Jaschinski, unpublished interview with the author, London, August 2006. All further unattributed quotations from the artist are drawn from this interview.

25. Derrida, "Animal That Therefore I Am," 390.

26. Matthew Brower, *Developing Animals: Wildlife and Early American Photography* (Minneapolis: University of Minnesota Press, 2011), xvii.

27. Ibid., xviii, xxx.

28. Jaschinski, unpublished interview with the author, 2011.

29. Lady Lavona, *Lady Lavona's Cabinet of Curiosities,* http://ladylavona.blogspot.com (accessed September 4, 2009).

30. Angela Singer, e-mail correspondence with the author, March 2003. All further unattributed quotations from the artist are drawn either from her occasional correspondence with the author between 2001 and 2011, or from her unpublished interview with the author, Wellington, New Zealand, April 2010.

31. Angela Singer, quoted in Amrei Hofstatter, "My Dearest, Dearest Creature," *Belio* 27 (2008), http://www.angelasinger.com (accessed September 4, 2009).

32. Ibid.

33. Erica Fudge, "Renaissance Animal Things," plenary paper at Minding Animals: 2009 International Academic and Community Conference on Animals and Society, Newcastle, NSW, Australia, July 14, 2009.

34. Angela Singer, quoted in Giovanni Aloi, "Angela Singer: Animal Rights and Wrongs," *Antennae: The Journal of Nature in Visual Culture* 7 (2008): 13.

35. Ibid., 17.

36. Singer, unpublished interview with the author.

37. Coe, quoted in "Sue Coe Interview."

38. Singer, quoted in Aloi, "Angela Singer: Animal Rights and Wrongs," 17.

39. Angela Singer, quoted in Steve Baker, "'You Kill Things to Look at Them': Animal Death in Contemporary Art," in The Animal Studies Group, *Killing Animals* (Urbana: University of Illinois Press, 2006), 93.

40. Sue Coe, quoted in Elin Slavick, "Art◇Activism: An Interview with Sue Coe," *MediaReader Quarterly,* 2000, http://www.mediareader.org (accessed September 4, 2009).

41. Dale Jamieson, speaking in the "Discussion Panel: Does Philosophy Have Anything New to Say about Animals?" at Minding Animals: 2009 International Academic and Community Conference on Animals and Society, Newcastle, NSW, Australia, July 15, 2009.

42. Cora Diamond, "The Difficulty of Reality and the Difficulty of Philosophy," in Stanley Cavell et al., *Philosophy and Animal Life* (New York: Columbia University Press, 2008), 56.

43. Rachel Jones, "On the Value of Not Knowing: Wonder, Beginning Again, and Letting Be," paper delivered at the Kettle's Yard symposium On Not Knowing: How Artists Think, New Hall College, Cambridge, U.K., June 29, 2009.

44. Coe, quoted in Slavick, "Art◇Activism."

45. Francisco J. Varela, *Ethical Know-How: Action, Wisdom, and Cognition* (Stanford, Calif.: Stanford University Press, 1999), 32–34.

46. Coe, quoted in "Sue Coe Interview."

47. Wolfe, *What Is Posthumanism?* 115.

On Relevant Questions

1. Isabelle Stengers, "The Challenge of Complexity: Unfolding the Ethics of Science (In Memorium Ilya Prigogine)," *Emergence: Complexity and Organization (E:CO)* 6, nos. 1–2 (2004): 97.

2. Ibid., 93, 96.

3. Ibid., 97.

4. Ibid., 97, 98.

7. "The Twisted Animals Have No Land beneath Them"

1. Gilles Deleuze and Félix Guattari, *A Thousand Plateaus: Capitalism and Schizophrenia*, trans. Brian Massumi (London: Athlone, 1988), 494.

2. Sanna Kannisto, *Fieldwork* (New York: Aperture, 2011).

3. Birgit Eusterschulte, "A Conversation with Sanna Kannisto," exhibition catalog *Self-Timer* (Kassel: Kunsthalle Fredericianum, 2005), http://www.sanna kannisto.com.

4. Unless otherwise indicated, quotations from the artist are drawn from her e-mail correspondence with the author in June and July 2010.

5. Fritjof Capra, *The Web of Life* (London: Flamingo, 1997), 28, 35.

6. Sanna Kannisto, "Sanna Kannisto in an E-mail Conversation with Harri Laakso," *Framework: The Finnish Art Review* 4 (2005): 69.

7. Eduardo Kac, quoted in Steve Baker, "Philosophy in the Wild? Kac and Derrida on Animals and Responsibility," *New Formations* 49 (2003): 96; Sue Coe, quoted in Susan Vaughn, "Staying True to a Unique Vision of Art," *Los Angeles Times*, April 1, 2001, http://graphicwitness.org (accessed May 21, 2011).

8. James Elkins, "Why Art Historians Should Learn to Paint: The Case for Studio Experience," http://www.jameselkins.com (accessed April 7, 2011). The page on Elkins's website from which this twenty-six-page essay can be downloaded gives it the slightly different title "Why Art Historians Should Learn to Draw and Paint," and it is this particular page from which the present quotations (as well as those in note 11, below) have been taken.

9. Elkins, "Why Art Historians Should Learn to Paint," 9–10.

10. Ibid., 7–8, 23.

11. These quotations, as with those in note 8 above, are drawn not from the essay itself but from the related text on the page from which it can be downloaded, http://www.jameselkins.com.

12. Adam Phillips, *Terrors and Experts* (London: Faber, 1995), xiv.

13. James Elkins, e-mail correspondence with the author, April 2011.

14. Susan McHugh, "Stains, Drains, and Automobiles: A Conversation with Steve Baker about *Norfolk Roadkill, Mainly*," *Art and Research: A Journal of Ideas, Contexts, and Methods* 4, no. 1 (2011): unpaginated. See http://www.artandresearch.org.uk/v4n1/baker.php. As the reproductions included with that interview show, the paired photographs were initially placed on a white ground with a single caption below the images identifying the date

and road on which the roadkill was photographed. The simpler format seen in Figures 7.5 and 7.6 was introduced late in 2011.

15. Baker, quoted in McHugh, "Stains, Drains, and Automobiles."

16. Robert Adams, "Photographing Evil," in *Beauty in Photography: Essays in Defense of Traditional Values* (New York: Aperture, 1996), 71.

17. Cary Wolfe, *What Is Posthumanism?* (Minneapolis: University of Minnesota Press, 2010), 266.

18. Niklas Luhmann, quoted in Wolfe, *What Is Posthumanism?* 271.

19. On Braine's photographs, see Helen Molesworth, "This Car Stops for Road Kill," in *Concrete Jungle: A Pop Media Investigation of Death and Survival in Urban Ecosystems*, ed. Mark Dion and Alexis Rockman (New York: Juno Books, 1996). I am grateful to Julia Schlosser for pointing me toward this essay.

20. Barry Lopez, *About This Life: Journeys on the Threshold of Memory* (London: Harvill, 1999), 114.

21. Photography did not figure at all in the work I made and exhibited in the 1980s, and it figures less directly in installation-based projects that I've been developing recently in parallel with the roadkill work.

22. John Cage, *Silence: Lectures and Writings* (London: Calder and Boyars, 1973), 99.

23. Elena Italia, unpublished interview with the author, Norwich, January 2011.

24. For a discussion of contexts in which the distinction between space and place is of particular significance, see Edward S. Casey, *The Fate of Place: A Philosophical History* (Berkeley: University of California Press, 1997).

25. Bann, *Ways around Modernism*, 110.

26. Yves Le Fur, "Displaced Objects on Display," in *Compression vs. Expression: Containing and Explaining the World's Art*, ed. John Onians (New Haven, Conn.: Yale University Press, 2006), 6.

27. Simone Osthoff, "Eduardo Kac: Networks as Medium and Trope," in Dobrin and Morey, *Ecosee*, 114.

28. Britta Jaschinski, unpublished interview with the author, London, May 2011.

29. Dave Bullock, unpublished interview with the author, Norwich, August 2011.

30. Jacques Derrida, "And Say the Animal Responded?" trans. David Wills, in

Zoontologies: The Question of the Animal, ed. Cary Wolfe (Minneapolis: University of Minnesota Press, 2003), 128.

31. Miwon Kwon, *One Place after Another: Site-Specific Art and Locational Identity* (Cambridge, Mass.: MIT Press, 2004), 156–57.

32. Angela Singer, e-mail correspondence with the author, April 2003.

33. Snæbjörnsdóttir/Wilson, *(a)fly: (between nature and culture)* (Reykjavik: National Museum of Iceland, 2006).

34. Bryndís Snæbjörnsdóttir, *Spaces of Encounter: Art and Revision in Human-Animal Relations* (Göteborg: ArtMonitor, 2009), 95, 162.

35. David Wood, "Mirror Infractions in the Yucatan," unpublished manuscript, 1. I am grateful to Wood for sending me a copy of this seventeen-page Word file in 2008, and it is this version from which I quote here. A version of the essay was published in the *Journal of Visual Arts Practice* in 2010 (see below), but its opening footnote, "A General Note," has been completely rewritten and omits the useful lines quoted here.

36. David Wood, "Mirror Infractions in the Yucatan," *Journal of Visual Arts Practice* 9, no. 1 (2010): 74–75.

37. This point seemed to be made a little more directly in Wood's presentation "*Mirror Infractions in the Yucatan*—Why Should Flies Be without Art?" at the symposium The Animal Gaze (London Metropolitan University, November 21, 2008) than it is in the photo essay itself.

38. Wood, "Mirror Infractions in the Yucatan," 76.

39. Ron Broglio, e-mail correspondence with the author, April 2009.

40. Italia, unpublished interview with the author.

41. Hirst's work had been featured, for example, in Tony Godfrey's substantial book *Conceptual Art* (London: Phaidon, 1998), which lent credence to the extension of that term to aspects of the art of the 1990s.

42. Damien Hirst, quoted in Carol Vogel, "Damien Bites Back," *Observer,* "Review" section, November 19, 2006, 8.

43. Mieke Bal, *Louise Bourgeois' "Spider": The Architecture of Art-Writing* (Chicago: University of Chicago Press, 2001), 3, xiv, 5, 8.

44. Susan Shaw Sailer, "On the Redness of Salmon Bones, the Communicative Potential of Conger Eels, and Standing Tails of Air: Reading Postmodern Images," *Word and Image* 12, no. 3 (1996): 310.

45. Carolee Schneemann, unpublished text titled "Animal." The text is dated

2000, but the section quoted was first written in 1977. I am grateful to Schnee-mann for a copy of this text.

46. This is Derrida's neologism, characterizing a distinctly animal form of unsettling impropriety. See Jacques Derrida, "The Animal That Therefore I Am (More to Follow)," trans. David Wills, *Critical Inquiry* 28 (2002): 372.

47. Steve Baker, *The Postmodern Animal* (London: Reaktion Books, 2000), 62.

48. Jonathan Burt, *Animals in Film* (London: Reaktion Books, 2002), 26.

49. Deleuze and Guattari, *Thousand Plateaus,* 494.

50. James Elkins, *The Object Stares Back: On the Nature of Seeing* (New York: Harcourt, 1996), 116.

51. Mark Cousins, "Danger and Safety," *Art History* 17, no. 3 (1994): 418–23.

52. Steve Baker, "'You Kill Things to Look at Them': Animal Death in Con-temporary Art," in The Animal Studies Group, *Killing Animals* (Urbana: University of Illinois Press, 2006), 81–82.

53. Elaine Scarry, *The Body in Pain: The Making and Unmaking of the World* (New York: Oxford University Press, 1985), 118, 117, 121, 124.

54. Ibid., 126.

55. Ibid., 139.

56. Ibid., 138–39, 148.

57. Michael Fried, "Shape as Form: Frank Stella's New Paintings," in *New York Painting and Sculpture: 1940–1970,* ed. Henry Geldzahler (London: Pall Mall Press, 1969), 410, 403.

58. The paper was a contribution to the weekly World Art Research Seminar in the School of World Art Studies and Museology, University of East Anglia, March 2011.

59. Rosalind Krauss, *"A Voyage on the North Sea": Art in the Age of the Post-Medium Condition* (London: Thames and Hudson, 1999), 9, 10, 20, 24, 32.

60. Ibid., 12, 20.

61. Niklas Luhmann, *Art as a Social System,* trans. Eva M. Knodt (Stanford, Calif.: Stanford University Press, 2000), 119. The remark is also quoted in Wolfe, *What Is Posthumanism?* 273.

62. Krauss, *"Voyage on the North Sea,"* 11, 5, 6.

63. Ibid., 6–7.

64. Roland Barthes, *Mythologies,* trans. Annette Lavers (London: Jonathan Cape, 1972), 119.

65. Bryndís Snæbjörnsdóttir and Mark Wilson, "Glazing the Gaze: A Human Animal Encounter," paper delivered at the conference Minding Animals, Newcastle, NSW, Australia, July 2009.

66. Snæbjörnsdóttir, *Spaces of Encounter*, 226.

67. Krauss, *"Voyage on the North Sea,"* 26, 33.

68. Donna J. Haraway, *When Species Meet* (Minneapolis: University of Minnesota Press, 2008), 4.

69. Robert Filby and David Lillington, *Sculpture, Craft, Magic: Broccoli, Glass, Mariah, Pyramid, Stem* (Norwich, UK: Kaavous-Bhoyroo, 2010). All quotations from both Robert Filby and David Lillington are drawn from this unpaginated book, which also reproduces the *Work & Co.* series.

70. For a discussion of the implications of Fried's claim for subsequent animal art, see Baker, *Postmodern Animal*, 52–53 and passim.

71. Wolfe, *What Is Posthumanism?* 110.

72. Kim Jones, quoted in Linda Weintraub, "Inventing Biography—Fictionalized Fact and Factualized Fiction: Kim Jones," in *Making Contemporary Art: How Today's Artists Think and Work* (London: Thames and Hudson, 2003), 213.

73. Allison Hunter, e-mail correspondence with the author, June 2011.

74. Derrida, "Animal That Therefore I Am," 379.

75. For a discussion of the relevance of this idea in the context of contemporary art, see Steve Baker, "Sloughing the Human," in *Zoontologies: The Question of the Animal*, ed. Cary Wolfe (Minneapolis: University of Minnesota Press, 2003), esp. 159–61.

76. Matthew Brower, *Developing Animals: Wildlife and Early American Photography* (Minneapolis: University of Minnesota Press, 2011), xvii, 84.

77. Krauss, *"Voyage on the North Sea,"* 7, 26.

78. Snæbjörnsdóttir and Wilson, "Glazing the Gaze."

Afterword

1. Jonathan Burt, "Invisible Histories: Primate Bodies and the Rise of Posthumanism in the Twentieth Century," in *Animal Encounters*, ed. Tom Tyler and Manuela Rossini (Leiden: Brill, 2009), 163, 164.

2. Jonathan Burt, *Rat* (London: Reaktion Books, 2006), 110–12.

3. Mieke Bal, *Louise Bourgeois' "Spider": The Architecture of Art-Writing* (Chicago: University of Chicago Press, 2001), 3.

4. See Steve Baker: *Picturing the Beast: Animals, Identity, and Representation* (Urbana: University of Illinois Press, 2001), passim. On the relevance of contemporary art in this wider visual context, see page xxvi.

5. Eduardo Kac, www.ekac.org/gfpbunny.html (accessed June 8, 2011).

6. Gilles Deleuze and Félix Guattari, *A Thousand Plateaus: Capitalism and Schizophrenia*, trans. Brian Massumi (London: Athlone, 1988), 312, 311.

7. Cary Wolfe, *What Is Posthumanism?* (Minneapolis: University of Minnesota Press, 2010), 275.

8. Michael Fried, "Art and Objecthood," in *Minimal Art: A Critical Anthology*, ed. Gregory Battcock (New York: Dutton, 1968), 124 (quoting Greenberg), 141, 147.

9. Niklas Luhmann, quoted in Wolfe, *What Is Posthumanism?* 276.

10. The term *mode of attention* is Donna Haraway's. In *The Companion Species Manifesto: Dogs, People, and Significant Otherness* (Chicago: Prickly Paradigm Press, 2003), 5, she writes of "the ethic, or perhaps better, mode of attention" with which the cohabitings of different species should be approached.

11. For all three versions of the essay, see Cary Wolfe, "From *Dead Meat* to Glow in the Dark Bunnies: Seeing 'the Animal Question' in Contemporary Art," *Parallax* 38 (2006): 95–109; "From *Dead Meat* to Glow-in-the-Dark Bunnies: Seeing 'the Animal Question' in Contemporary Art," in Dobrin and Morey, *Ecosee*, 129–51; and (in a slightly different version) "From Dead Meat to Glow-in-the-Dark Bunnies: The Animal Question in Contemporary Art," in *What Is Posthumanism?* 145–67. Subsequent quotations, unless otherwise indicated, are from this most recent version.

12. Wolfe, *What Is Posthumanism?* 162, 147, 163, 164, 169.

13. Ibid., 152, 158.

14. This taste was embedded in intellectual life well before the 1990s, of course. In Malcolm Bradbury's *Doctor Criminale* (London: Picador, 2000), the fictional Francis Jay wittily sums up the lure, as a 1980s undergraduate, of the indiscriminate application of the principles of "the Age of Deconstruction": "We demythologized, we demystified. We dehegemonized, we decanonized. We dephallicized, we depatriarchalized; we decoded, we de-canted, we de-famed, we de-manned" (8). He later characterizes "intellectual convention" as "the most conventional form of convention there is" (238).

15. Wolfe, *What Is Posthumanism?* 146.

16. Eduardo Kac, e-mail correspondence with the author, September 2001. See also Baker, "Philosophy in the Wild?" 91–98.

17. Jean-Luc Nancy, *Listening*, trans. Charlotte Mandell (New York: Fordham University Press, 2007), 1.

18. John Szarkowski, quoted in John Pultz, *Photography and the Body* (London: Weidenfeld and Nicolson, 1995), 121.

19. Wolfe, *What Is Posthumanism?* 154, 151–52.

20. Ibid., 160–61, 154.

21. Ibid., 150, 152, 155.

22. Jacques Derrida, "And Say the Animal Responded?" trans. David Wills, in *Zoontologies: The Question of the Animal*, ed. Cary Wolfe (Minneapolis: University of Minnesota Press, 2003), 128.

23. Cary Wolfe, *Animal Rites: American Culture, the Discourse of Species, and Posthumanist Theory* (Chicago: University of Chicago Press, 2003), 228. The sentence from Deleuze and Guattari (which Wolfe slightly misquotes) is from *A Thousand Plateaus*, 168.

24. Mark Cousins, "Danger and Safety," *Art History* 17, no. 3 (1994): 421.

25. Sue Coe, unpublished interview with the author, upstate New York, February 2006.

26. Jacques Derrida, "The Animal That Therefore I Am (More to Follow)," trans. David Wills, *Critical Inquiry* 28 (2002): 394.

27. Wolfe, "From *Dead Meat* to Glow in the Dark Bunnies," 104. The words are from a sentence that does not appear in the version of this essay that is included in *What Is Posthumanism?*

28. Wolfe, *What Is Posthumanism?* 125, 126.

29. For a discussion of this aspect of Coe's work in *Dead Meat*, see Steve Baker, *The Postmodern Animal* (London: Reaktion Books, 2000), 114–17; on its use in *Pit's Letter*, see Baker, *Picturing the Beast*, xxiii–xxiv.

30. Coe, unpublished interview with the author.

31. Wolfe, *What Is Posthumanism?* 150.

32. Rosalind Krauss, *"A Voyage on the North Sea": Art in the Age of the Post-Medium Condition* (London: Thames and Hudson, 1999), 26, 33.

33. Coe, unpublished interview with the author.

34. Ibid.

35. Wolfe, *What Is Posthumanism?* 162.

36. Marcel Duchamp, quoted in *Conceptual Art: A Critical Anthology*, ed. Alexander Alberro and Blake Stimson (Cambridge, Mass.: MIT Press, 2000), 171.

37. The recognizable photographic image of a dragonfly on the cover of *What Is Posthumanism?* and Wolfe's enthusiastic support for the artist responsible for it should confirm this.

38. Wolfe, *What Is Posthumanism?* 146, 166.

39. Tom Tyler, *CIFERAE: A Bestiary in Five Fingers* (Minneapolis: University of Minnesota Press, 2012), 202, 207–8, 209.

40. Francisco J. Varela, *Ethical Know-How: Action, Wisdom, and Cognition* (Stanford, Calif.: Stanford University Press, 1999), ix, 17, 64, 31.

41. Wolfe, *What Is Posthumanism?* 166, 167.

42. The diagram in which Wolfe uses vertical and horizontal boundary lines to distinguish these categories, and in which he then meticulously positions the names of key philosophers and thinkers across this divided field (so that Derrida is seen to be marginally more of a posthumanist posthumanist than Haraway, for example), appears in *What Is Posthumanism?* 125.

43. Wolfe, *What Is Posthumanism?* 145.

44. Cary Wolfe, in conversation with the author, December 2011.

45. Varela, *Ethical Know-How*, 28.

46. Isabelle Stengers, "The Challenge of Complexity: Unfolding the Ethics of Science (In Memorium Ilya Prigogine)," *Emergence: Complexity and Organization (E:CO)* 6, nos. 1–2 (2004): 93, 96.

47. Ibid., 96; Donna J. Haraway, *When Species Meet* (Minneapolis: University of Minnesota Press, 2008), 4.

Index

STEVE BAKER is emeritus professor of art history at the University of Central Lancashire. He is author of *The Postmodern Animal, Picturing the Beast: Animals, Identity, and Representation,* and, with the Animal Studies Group, *Killing Animals*.